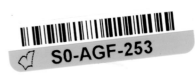

THE DRAWINGS OF **HENRY MOORE**

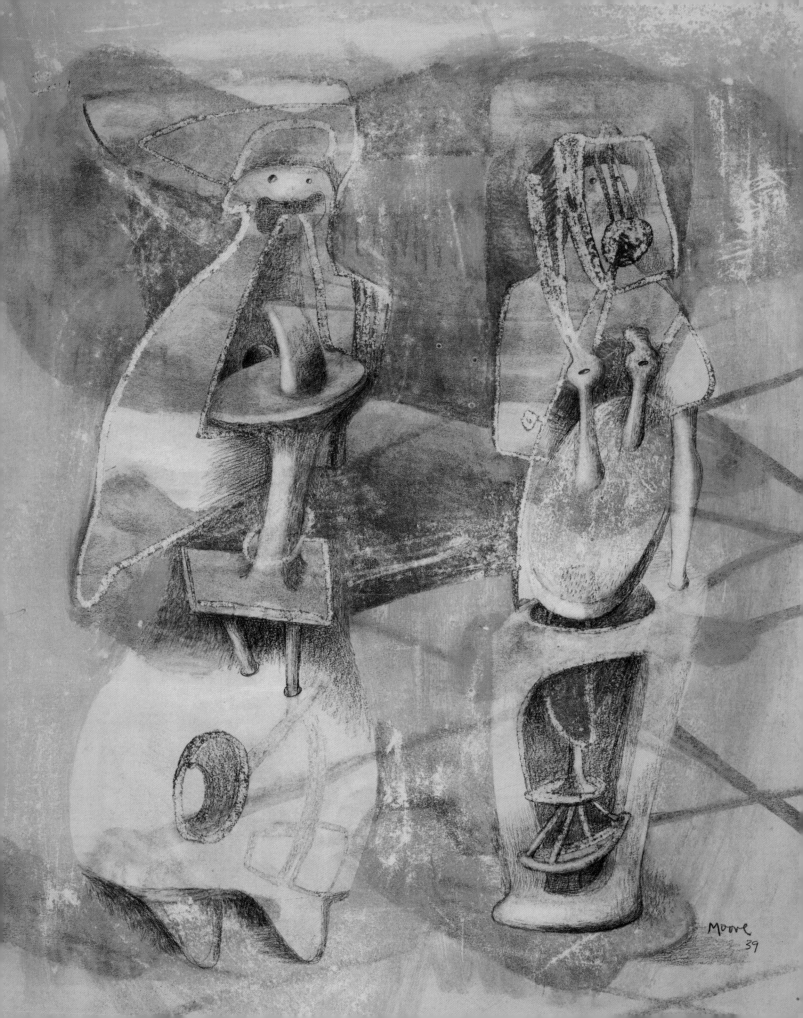

THE DRAWINGS OF **HENRY MOORE**

Andrew Causey

Lund Humphries

Abbreviations

HMF Henry Moore Foundation
ICA Institute of Contemporary Art
IWM Imperial War Museum
LH *Henry Moore. Complete Sculpture*, six volumes, Lund Humphries, 1944–88
RCA Royal College of Art
WAAC War Artists' Advisory Committee

First published in 2010 by Lund Humphries
Lund Humphries
Wey Court East
Union Road
Farnham
Surrey GU9 7PT

Lund Humphries
Suite 420
101 Cherry Street
Burlington
VT 05401-4405
USA

www.lundhumphries.com

Lund Humphries is part of Ashgate Publishing

British Library Cataloguing-in-Publication Data
Causey, Andrew.
 The drawings of Henry Moore.
 1. Moore, Henry, 1898-1986--Criticism and interpretation.
 2. Human figure in art.
 I. Title II. Moore, Henry, 1898-1986.
 741.9'42-dc22

 ISBN-13: 9781848220294

Library of Congress Control Number: 2009926647

Edited by Sarah Thorowgood
Designed by Andrew Shoolbred
Set in Dax Light
Printed in China
Front cover: *Family Group,* 1948. HMF 2504 (see plate 127)

Contents

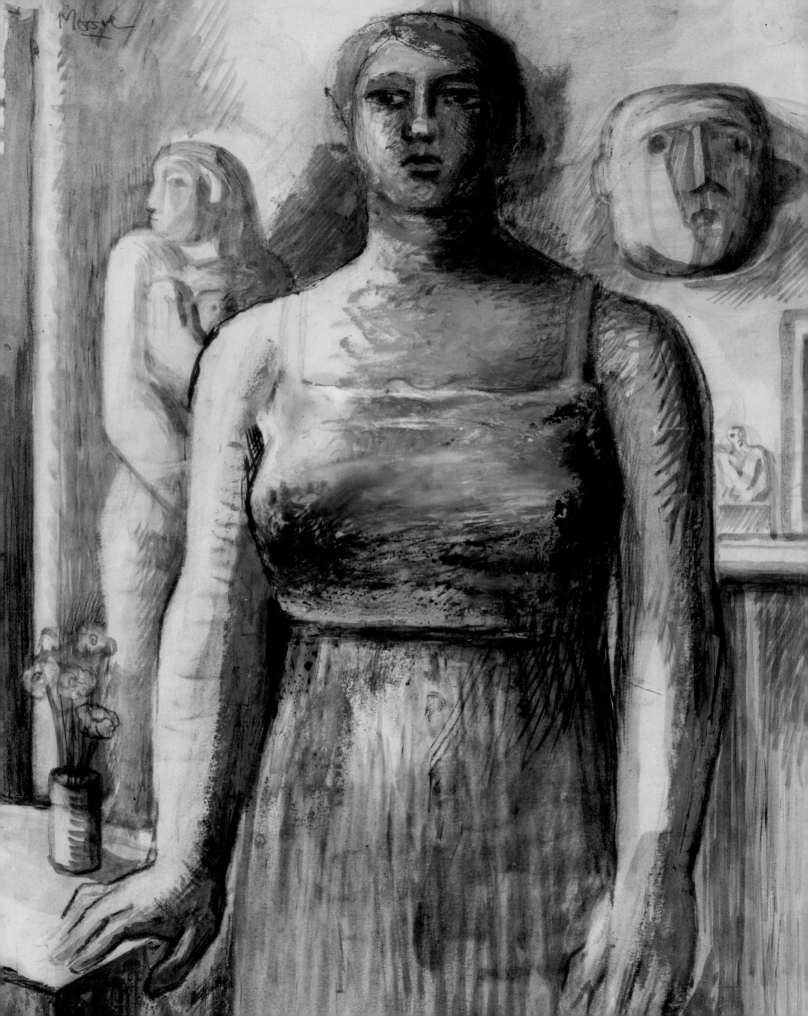

Introduction

What do Moore's drawings tell us about his objectives and the working of his mind? Do they tell the same story as the sculptures for which he is best known? Or, do they exhibit their own scheme of things, and, if so, what is the nature of the divergence between sculpture and drawing? Moore drew from life, from natural objects and from museum exhibits, as well as making sketches for sculpture. He did not use drawing to resolve parts of sculptures he planned to make: his drawings for sculpture are always of finished objects, and he rarely seems to have worked on sculptures with drawings around him, as if, once he had decided on the result he was looking for, drawing was no longer useful. To that extent drawing and sculpture were separate practices: one began where the other ended.

However, during a large middle section of Moore's career, in the 1930s and 1940s, he was exceptionally inventive in both sculpture and drawing, and the relationship between the two was not straightforward. Drawing became a central practice not just as a preliminary to sculpture, and the word 'drawing' gradually became less than adequate to describe the elaborate and highly coloured designs which, as several critics recognised by the end of the 1930s, were pictorial art and which began, tentatively, to be called paintings. The pictorial in Moore's work is also closely allied with Surrealism. The Surrealists' sense of strangeness and wonder was too elaborate and too literary to be encapsulated within traditional sculpture. Moore's generation acted under constraints that are absent today, now that sculpture is no longer bound to the same extent by rules that distinguish it from the pictorial arts or theatre. Around 1930, Moore recognised a new turn in European sculpture which was in effect a stage in the collapse of established boundaries between sculpture and the pictorial arts. This occurred within the Surrealist circle and especially in the work of Picasso and Giacometti. It was difficult to say at that moment whether Picasso was primarily painter or sculptor, as he moved deftly between the two, making both sculptures alone as well as introducing images of possible sculptures among the paintings he was working on. Giacometti took a different course, making sculpture itself more pictorial by creating horizontal, table top- or board game-shaped sculptures with the kind of internal spaces traditional in painting but not sculpture.

Around 1930 Moore looked carefully at both these artists and others in the Surrealist circle in Paris. As a sculptor, he was keen to understand Paris and develop new forms in his own work, but reluctant to abandon the traditional notion of sculpture as a single object. His approach was closer to Picasso's than Giacometti's in that he started, in drawings, to situate his own sculptural forms in pictorial space. Only briefly, in 1934, did he consider Giacometti's example – by breaking down his sculptures into separate parts and arranging the parts on a flat surface. Seven sculptures of this kind were made, of which the best known is *Four Piece Composition. Reclining Figure* (LH154) in the Tate. In 1946 Clement Greenberg, reviewing Moore's retrospective exhibition at the Museum of Modern Art, New York, placed him half way between the old and the new.[1] By the 'old' he meant the volumetric forms of Aristide Maillol and others, while the 'new' referred to Picasso's initiative with rods and metal plates that were welded together to create a more open sculpture that was closer to drawing. The latter was the innovation capitalised on by the American David Smith, who became Greenberg's paradigmatic modernist sculptor. Moore did not follow that lead, a decision that was clearly intentional: the proof of this being that what he was unwilling to do in sculpture, he was clearly ready to experiment with in drawing. Moore's 1930s drawings are packed with expressive sketches for sculptures that could only have been made in terms of forms, and with materials and techniques, Moore never used. Some of them follow the route Greenberg championed for modernist sculpture, and it could be said of some – with only slight exaggeration – that Smith could have made them into sculptures. There is a wealth of fantasy and imagination in Moore's drawings that was never realised in sculpture.

As a sculptor Moore was austere and quite cautious. As a carver in the first half of his career, he was dealing with materials that were slow to work and easily spoiled, discouraging excessive risk. As a draughtsman, pictorial artist, or perhaps even painter, as he should properly be thought of at this point in his career, Moore was able to work fast with ideas flooding onto the paper, ideas related to sculpture but which he elaborated and embellished with detail that was essentially pictorial. The problem was only partly that he knew he would never get round to converting more than a small proportion

of his designs into sculpture. Sculpture for Moore was a highly considered and perfected art, and he seems to have found, especially during the 1930s and 1940s, that pictorial art gave free range to his imagination more readily than sculpture did. Sculpture was his principal public face, while the drawings were not in the same way part of the public domain and he could use them to express whatever eccentricities and humourous asides he wanted.

While Moore's carved sculpture is close to nature in terms of both the materials used and the carver-sculptor's traditional role as craftsman, his mature drawings often have an urban feel and an engagement with the more unsettling issues of modern life. Pictorial art could reflect on the human condition by means of narratives developed through interaction of internal parts in a way that single-object sculpture could not and one is brought back, again, to Moore's relationship, as a pictorial artist, with Surrealism. Robert Melville, a critic with strong Surrealist leanings, organised a Moore drawings show in 1953 which he described as 'an attempt to isolate an aspect of Moore's art which in the past has been treated as the marginal activity of a great sculptor but which is, in fact, the unique revelation of the sinister, melancholy, serene and tragic life of sculptural communities in worlds of dream and reality which are uniquely strange.'[2]

Moore and Drawing

Moore's many interviews and published reflections give no hint as to what he thought of comments like Melville's. He discussed the technical problems of drawing and its relation to sculpture, but not its subjects (beyond the general issue of drawing the human figure, and with the further exception of the Second World War shelter drawings), nor ways in which it reflected human predicaments or emotions. Though in the course of his working life Moore made over 7,000 drawings, he had decided at an early age to be a sculptor and had no second thoughts. He described drawings as 'done mainly as a help towards making sculpture – as a means of generating ideas for sculpture, tapping oneself for the initial idea'. The drawings were primarily a 'way of sorting out ideas and developing them',[3] but they also served to document the stages by which a sculptural image was arrived at and which projects ended in cul de sacs or fell by the wayside through lack of time. They indicate all kinds of things that might have happened but did not; they suggest materials he might have used, and forms tested out and laid aside.

Many of Moore's notebooks survive, generally with pages missing and sometimes broken up after the pages were numbered. (Moore preferred 'notebook' to 'sketchbook', and his title is retained here.) At the beginning, at least, Moore carried a notebook with him when travelling, he drew

Opposite: Detail from Plate 103

museum artefacts, and explored the relative morphology of form in different found objects. Notebook images are often small but nonetheless detailed. He liked to crowd images on small sheets of paper, and he often wrote notes to himself relating to treatment and effect and the ways he might carry designs forward. Life drawings, which extend to the early 1930s but are rare later on, were generally made on larger sheets. From the late 1920s, washes of colour become more common and in the catalogue of his first one-man exhibition, at the Warren Gallery, London, in 1928, the words 'green' and 'pink' are included in picture titles. There was, therefore, already an independence of drawing from sculpture, as Moore never added colour to sculpture. He sketched ideas out quickly and profusely, often many to a page, as if he feared losing the connecting thread between the images if he did not get them onto paper fast enough. In the 1930s, especially, some sketches have an automatist character. Moore wanted to record families of ideas and forms without much conscious intervention. Drawing was a fast process and carving a slow one.

What do Moore's drawings show? The majority are involved in some way with the human figure. Moore insisted that any serious sculptor should know the human body inside out and numerous early drawings are figure studies unconnected with specific sculptures. From 1921, the year he arrived from Leeds College of Art as a student at the Royal College of Art in London, he drew from old master paintings and drawings, and from photographs, as well as making visual records of non-European art in the British Museum and reproductions in books. Most of these drawings date from the 1920s, though Surrealism renewed his interest in the primitive and he continued to copy and reflect on primitive artefacts by means of drawing, even if less intensely, until the 1950s. Moore also made sketches from flints and pebbles, bones and shells. He started visiting the Natural History Museum around 1925 – perhaps earlier – and then, or soon after, began collecting natural objects and around 1930 drawing from natural, found objects became for a few years a core concern. He was fascinated by the variety of natural forms, explaining to Herbert Read in 1944 that drawing 'keeps one visually fit ... and ... lessens the danger of repeating oneself. It enlarges one's form repertoire, one's form experience.[4]

Moore pointed out that 'sculpture compared with drawing is a slow means of expression, and I find drawing a useful outlet for ideas which there is not time enough to realise as sculpture'.[5] As variations on ideas for sculpture poured from his imagination, he would draw up to 30 sketches on a single sheet of paper, and he used a special mark, ※, to indicate a design he liked and wanted to make into sculpture. He stressed how different drawing was from carving, even if it fed into it,

explaining to the American curator James Johnson Sweeney in 1946 that the two practices needed to be kept apart:

Every few months I stop carving for two or three weeks and do life drawing. At one time I used to mix the two, perhaps carving during the day and drawing from a model during the evening. But I found this unsatisfactory – the two activities interfered with each other, for the mental approach to each is different ... Stone ... is so different from flesh and blood that one cannot carve directly from life without almost the certainty of ill-treating the material. Drawing and carving are so different that a shape or size or conception which ought to be satisfying in a drawing will be totally wrong realized as stone ... In my sculpture I do not draw directly upon my memory or observations of a particular object, but rather use whatever comes up from my general fund of knowledge of natural forms.[6]

Later, Moore came to the human figure in more round-about ways, through processes of metamorphosis that might start with a stone or bone form and then change into something recognisably figurative. Transformations of one kind and another are fundamental to the drawings. We see continually, as we turn notebook pages, one thing becoming another and maybe then reverting to an earlier identity. Inanimate objects like a bone or flint can become animate, even human, and human beings (one thinks of the Second World War shelter drawings) can seem to turn into barely animate forms.

Moore's drawings rarely show people in movement, and he searches for physical expression more through strength of form and relation of masses than through expressive gesture. Moore liked static forms, which occasionally led writers to criticise him for treating the figure as still life.[7] For Moore this did not necessarily represent adverse comment, because the blurring of boundaries between live nature and inanimate objects – still life – was his interest. Some of Moore's most engaging drawings are also those that are most remote from common reality – ritualised, theatrical and static – and leaving uncertainty as to whether one is looking at images of real people or drawings of sculptures.

When Moore titled a sheet 'drawing for sculpture' or 'ideas for sculpture', he did not mean a 'working drawing'. His drawings do not indicate stages of sculptural work or processes and they were not aids to making (as opposed to conceiving) sculpture. Whether the title is 'drawing for sculpture' or 'ideas for sculpture', there are likely to be many images on the page, each showing a notionally finished object. They will be variants of one another, not stages of a work in progress. Even if the sketches are only a few pen or pencil lines, they are complete ideas.

Whether or not 'ideas for sculpture' were adopted for individual finished works or not, from the early 1930s sculptural images in Moore's drawings began to acquire their own collective existence. The rivalry between painting and sculpture has a long history, going back to the Renaissance debates around *paragone*, which found that there were certain things sculpture could not do. Leonardo da Vinci defended the superiority of painting on the grounds that sculpture lacked the resources of colour and chiaroscuro, and had no way of representing distance. In Moore's drawings at this time, the artist became a resourceful colourist, using shading in a way that had nothing to do with the practice of carved sculpture, and he was also interested in landscape – considered the least sculptural of subjects because of sculpture's incapacity to indicate distance. Moore's designs became highly coloured and were often situated in specific rooms or out-of-doors environments, as the artist began to use drawing to achieve effects not accessible to sculpture. Moore himself seemed to acknowledge this, agreeing that numbers of his drawings were pictorial:[8] as with paintings, the space in his drawings is internal to the design, it is fictive space invented by the artist as he draws, as opposed to the real space of everyday life in which sculpture exists.

Kenneth Clark, close friend of Moore since 1938 and director of the National Gallery from 1933 to 1946, wrote that from about 1934 to 1948, these works 'have a life sequence of their own, and ... they reveal aspects of Moore's character as an artist that might not otherwise have been comprehensible'.[9] He cited the period of Surrealism and of Neo-Romanticism in the 1940s when both his drawings and his sculptures were highly innovative and were linked through related images, but when the drawings seemed, nevertheless, to be pointing in a different direction from the sculptures. Images in the drawings are still identifiably related to sculptures, but they seem to have soured, as if a dark and anxious shadow was cast over them but not over the sculptures. As has already been noted, Surrealism helped make the boundaries between the graphic arts and sculpture more porous, and Moore in the 1930s was far from alone in finding that the vividness he wanted from images, their capacity to surprise, to undermine expectations, and engender anxiety, needed pictorial expression. These needs could not be conveyed by sculpture alone.

The Second World War was a productive period for Moore as a pictorial artist because for more than two years (1940–42) he made virtually no sculpture. His commissioned drawings of Londoners sheltering from the Blitz in the London Underground and of miners at work make up most of his output. Moore was rigorous in his refusal of commissions unless

Opposite: Detail from Plate 3

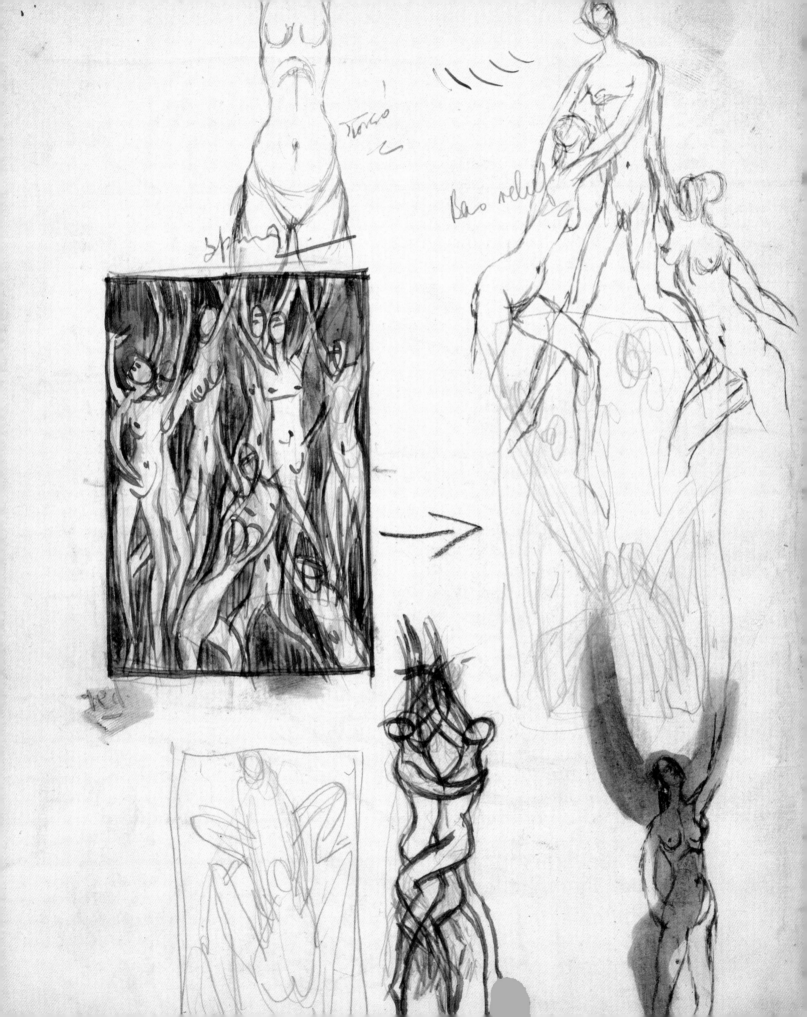

torso

bas relief

string

red

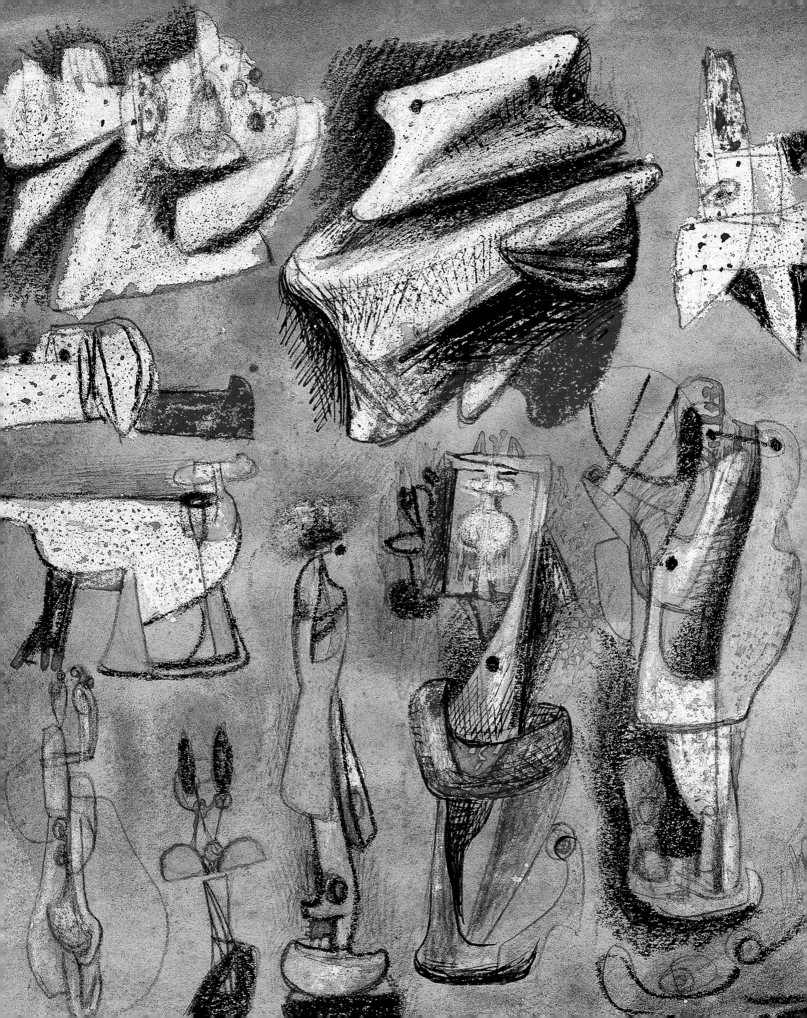

they complemented what he was already doing: by the outbreak of war he was already a pictorial artist and drawing images of Londoners in wartime fitted into and developed existing ideas. The shelter drawings have been misread as more transparent representations of what Moore saw than they actually were,[10] and their themes and imagery need to be seen as closely related both to Moore's 1930s work and other pictorial art he was making in the war years.

At an extreme, the people lying in the shelters become statuary in a reverse Pygmalion effect by which it is not the cold stone that the sculptor brings alive but real people whom he turns into funereal effigies. If transformation is a key principle in Moore's drawings, it is transformation for particular purposes: while many of the earlier drawings (especially 1930–33) are concerned with a universal principle of life shared between animate and inanimate things, and vitality itself is the issue, in later drawings the key is the cusp between life and death. Moore becomes preoccupied with the moment at which a person is reduced to an object or mere mechanism, and the different ways in which supposedly lifeless objects, like standing stones, can be personages. Moore was in many ways like T. S. Eliot: cautious of subjective expression and interested in creating a cast of characters – like the shelterers – who are drawn from reality but are also generic people who suffer and endure. The argument here emphasises continuity in his work, seeing connections between Surrealism and the reality of the shelters, and between the shelter drawings and the extraordinary immobility and death-like qualities of the 'figures in settings' that follow.

Moore's output of drawings decreased from 1950. As a sculptor, he chiefly modelled for casting in bronze, and found that working clay with his fingers was the equivalent of drawing, or at least obviated the need for it. In 1974, Kenneth Clark concluded a book on Moore's drawings at around the year 1950, thinking there was nothing further to say, only to find that Moore was busy drawing again. Moore's revived interest in drawing was connected with his greatly increased activity as a printmaker around 1970, and led Clark to add an epilogue.[11]

Exhibitions

In his early career, drawings were important both commercially and in establishing Moore's name. At his first one-man exhibition, at the Warren Gallery in 1928, he sold around 30 drawings at one pound each, with buyers including Jacob Epstein, Augustus John and Henry Lamb ('it was mostly other artists, and established ones, who bought, and that was a great encouragement to me'[12]). Though Moore did not meet Kenneth Clark, a future friend and supporter, until 1938, Clark bought the first two of his extensive collection of Moore draw-

ings from the 1928 exhibition. Up until the Second World War, the sale of drawings was an essential part of Moore's income. The first work of Moore to enter a public collection was a drawing (plate 5), given by Dorothy Warren of the Warren Gallery in 1927 to the Whitworth Art Gallery, Manchester. By the end of 1928 the gallery had acquired four Moore drawings by gift or purchase. At his first exhibition of drawings alone, at the Zwemmer Gallery, London, in 1935, Moore sold 27, at between 8 and 12 guineas each, to well known patrons and fellow artists including Sir Michael Sadler, Vice-Chancellor of Leeds University, whom he had met when he himself was a student in Leeds; the architect Serge Chermayeff; Jessica Dismorr, Mark Gertler, Graham Sutherland, Julian Trevelyan and Roland Penrose, among painters; the designer-photographer Ashley Havinden; the poster and graphic artist E. McKnight Kauffer; and the poet and writer Stephen Spender.[13] Drawings helped establish Moore's reputation and were widely seen not just as additions to sculpture exhibitions but complementary presences in their own right.

Moore invariably included drawings in his shows up to the 1950s (the 1960 exhibition at the Whitechapel Art Gallery, London, was his first retrospective without them). But, starting with the Zwemmer exhibition in 1935, there had also been shows of drawings alone during this period. In 1938 Kenneth Clark proposed a drawings show at Rosenberg and Helft, which tempted Moore because this was the London offshoot of the Paris gallery where he had seen Picasso's work in the early 1920s. However, Moore refused the suggestion because he already had a contract with the Mayor Gallery, London, for a drawings exhibition in 1939.[14] Moore's first New York exhibition, at Curt Valentin's Buchholz Gallery in 1943, was of drawings. The Arts Council had a drawings show in 1948, a London commercial gallery, Roland, Browse and Delbanco organised one in the same year, and this was followed by one at the Institute of Contemporary Arts in 1953. The ICA focus was on artists younger than Moore but the organisers obviously felt that his drawings represented Moore well in the context of the new avant-garde. This post-war cluster of drawings' shows was perhaps to be expected because it followed the war period when Moore was most intensely involved with drawing as a parallel practice to sculpture.

Apart from the shelter pictures, Moore rarely gave descriptive titles to drawings: in early exhibitions they tend to be called drawings 'for sculpture', 'from life', or 'for carving'. In the 1930s 'ideas for sculpture' is common, and there are sometimes indications of materials to be used. The title 'project for metal sculpture' was first used in 1931[15]: as there is no evidence that Moore was planning to work in metal at that point, the suggestion is that by then Moore's imagination realised in his drawings was running, in part, independently

Opposite: Detail from Plate 67

of his plans for sculpture. By the end of the decade, when his drawings had become increasingly elaborate in composition and further detached in form and subject from any sculptures he actually made or, indeed, could have made with the range of materials he customarily used, we find titles like 'pictorial ideas', 'ideas for drawings', 'settings for sculpture', and 'sculptural objects in landscape', all confirming what the drawings of this period plainly demonstrate – that Moore was a pictorial artist as well as a sculptor. He came to colour in drawings gradually, but used strong colour from 1937 and in the course of the later 1930s his drawings grow technically more complex, with ink and watercolour, charcoal, which was sometimes wetted and rubbed, and, by the 1940s, washes laid over resistant wax crayon. Moore's preference for generic rather than specific titles makes it more or less impossible to correlate known drawings with early catalogue entries, and as many signatures and most dates on the drawings were added much later, it is impossible, as Moore's drawings cataloguer Ann Garrould has made clear, to date his drawings with complete certainty to a particular year.[16]

Around the start of the Second World War, but before he started the shelter drawings in September 1940, a number of critics had already begun to think of Moore as a pictorial artist. Raymond Mortimer, not an enthusiast for Moore's sculpture, found an entrée into his work in this way. Writing in the *New Statesman* in February 1940, he described the drawings as 'mysterious and refined. I wonder … very impertinently whether Mr Moore may not be painter who has taken the wrong turning. For the merits of these drawings seem to me conspicuously picturesque rather than sculptural. Apart from the *mis en page* and the lovely use of colour, the smudges and squiggles are the handwriting of a natural painter'.[17] In 1944 the War Artists' Advisory Committee suggested to Moore that the committee should pay for sable brushes if he would continue war work as a painter.[18]

These views from Mortimer and Clark suggest that Moore need not be regarded as sculptor *or* painter, and that his imagination needed the expressive possibilities of both. Moore himself never thought it odd that his many interests in earlier art should have focused on painting more than sculpture: he claimed that the finest sculpture he found in Italy when he spent five months there in 1925 was Giotto's painting.[19]

Moore and his Critics

Since the 1940s, there has been critical discussion specific to Moore's drawings, and it is part of the purpose of this book to review and build upon earlier writing. The early war years witnessed Moore's almost exclusive concentration on drawing, and wartime Neo-Romanticism, to which Moore has been related,[20] was a graphic movement, involved with drawing and painting and hardly at all with sculpture. Clark edited the 'Penguin Modern Painters' series, and the book on Moore (1943) in this series was one of the first to be commissioned, even though Moore was already widely known as a sculptor not a painter. The author was Geoffrey Grigson, poet, anthologist, critic and a friend and supporter of Moore from the early 1930s. Grigson drew out the relationship between Moore's work and the natural world, with emphasis on his drawings of bones, pebbles and shells. In 1935, he had been the first to apply the word 'biomorphism' to the visual arts, chiefly with regard to Moore's work.[21] Grigson firmly rejected Roger Fry's formalism, looking to the origins of art in discourse related to anthropology and pre-history. An antiquarian interested in standing stones, Grigson was the first owner of *Drawing for Stone Sculpture* (plate 62). Grigson helped make Moore's intellectual platform more substantial. His last word on Moore in 1943 was a quotation from Thomas Hardy: 'Nature is played out [meaning 'finished'] as a Beauty, but not as a Mystery'.[22]

As chairman of the War Artists' Advisory Committee which employed Moore and many others, and as director of the National Gallery in London, where war art was shown while the permanent collection was in store, Kenneth Clark had a different relationship to Moore than that of Grigson. He was friend, patron and collector, highly effective in support, but he wrote on Moore only occasionally. His first comments were in a brief introduction to the Buchholz exhibition catalogue in 1943, and his main text on the drawings was in book form, published in 1974. Not, in general, an enthusiast for either Surrealism or abstraction, Clark nonetheless championed a small group of experimental artists, including Moore, Graham Sutherland and Paul Nash through the WAAC. Despite his reservations about radical art Clark was ambitious in relation to Moore, and the many Moore drawings in his collection included some of the artist's most complex and difficult (plates 63, 65, 117, for example).

Robert Melville wrote several times on Moore between the 1950s and the 1970s. Melville was deeply attached to Surrealism and, like Grigson, opposed formalist approaches to Moore. He took issue with the book Herbert Read wrote on Moore in 1965: 'My emphasis [as opposed to Read's] is upon the strangeness of Moore's work … I don't see formal solutions of problems, but strange presences, some of which are beautiful and some macabre'.[23] Melville's aim here is the same as Grigson's was in quoting Hardy. Melville's Moore resists the conventional association between art and beauty, but relates more specifically than Grigson's to Surrealism. He understood Moore's skeletal figures of the late 1930s as being related to the way Surrealism pointed inwards to the psychology of the individual as well as outwards to the world. Melville's introductory essay 'Communities of Statuary' for the

Opposite: Detail from Plate 26

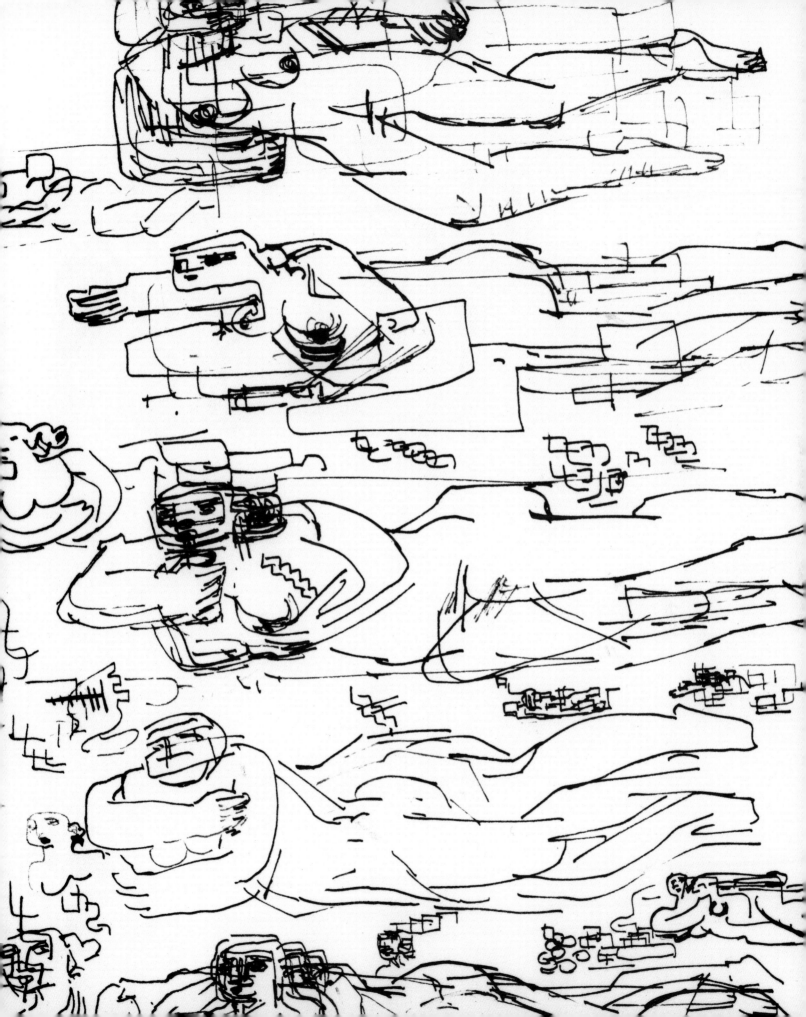

1953 ICA catalogue has already been quoted from, and his association of the melancholy with the macabre suggests that he saw a link between Moore and the Italian Metaphysical artist Giorgio de Chirico who, like Moore in his pictorial art, included sculpture in his paintings. Melville concluded his remarks on Moore's drawings by saying that they 'give the illusion of walking about inside the artist's vision'.[24] Melville titled his essay 'Communities of Statuary' to confront the fact that Moore's figure groups in drawings are both associations of sculptures and clusters of real people, suspended between animation and silence.

David Sylvester was briefly employed by Moore in the late 1940s in an administrative capacity and wrote about him regularly from 1948 with a uniquely comprehensive knowledge of his work. Over a long period Moore treated Sylvester as an intellectual mouthpiece, though Sylvester's analyses were not uncritical. Sylvester also came with a strong commitment to Surrealism, pinning down in his catalogue introduction to Moore's 1951 exhibition at the Tate – even more firmly than Grigson had – the centrality of the early 1930s drawings of inanimate natural objects, drawings which Sylvester clearly designated Surrealist on account of their demonstrating the central principle of metamorphosis.

Herbert Read was Moore's first and most sustained critical supporter, the author of the first monograph on him (1934) and editor of the first volume of the oeuvre catalogue of Moore's sculpture (1944). Though he also published the first article on Moore's drawings, in *Art in Australia* in 1941, Read's core commitment was to sculpture, both Moore's and sculpture in general. He saw the wartime shelter drawings as an interpolation in Moore's career as a sculptor. 'Eventually, as soon as materials permit, he will return to his sculpture; and that must be the desire of his admirers. For however great these drawings may be, as drawing they remain a minor art, an interlude in the career of an artist who has already shown himself a master in the most difficult, the most masculine, and the most sublime of all the plastic arts; in sculpture.'[25] History largely proved Read's predictions right: Moore did soon return to sculpture and gradually showed less interest in drawing. Even so, there is a problem with this judgement which shows not necessarily that Read mistook the nature of drawing in general, but that he felt that Moore's sculpture, which he held in the highest regard, would be diminished by ascribing particular status to the drawings.

Read thought of Moore as a humanist because, 'like the humanist sculptors of Greece and Italy, he expresses himself mainly through the human figure'.[26] But, whatever the formal influences of different periods of classicism on his sculpture, Moore's focus on the human figure – as he treated it after 1930, at least – does not reflect the wider concerns of Greece or Renaissance Italy that would justify Moore being called 'humanist'. Moore was concerned with the human condition, certainly, but in his mature work his drawings did not portray intelligent man searching for understanding of the world, nor man in control of his fate or environment. By the late 1930s, at least, man was portrayed as a victim, not so much 'doing' as 'done to', and by the 1940s man occupied a sunless, underground world, awaiting an unknown fate. Moore's drawings were truthful to the human condition at a time when there were few grounds for optimism.

The 1950s and 1960s were successful decades for Moore's reputation as a sculptor, but added little that was new to his drawing repertoire, and did not prompt significant new studies. Commentaries by friends and contemporaries conclude with David Sylvester's catalogue for the 1968 Tate exhibition, Robert Melville's 1970 book on the sculpture and drawings, and Kenneth Clark's in 1974 on the drawings alone.

Mystery surrounds John Hedgecoe's remark in 1968 that Moore, together with his wife Irina, had destroyed many drawings, possibly as many as a thousand.[27] It is unlikely that anywhere near this number was discarded, because Moore was like Picasso in that he wanted a comprehensive view of his work, appropriately dated and available to history. As he grew older, he would buy back drawings he particularly valued when they appeared on the market. After his marriage in 1929 to a fellow artist, Irina Radetsky, Moore respected her advice on matters of art. Wilkinson recalled Moore saying that sympathy with the model was essential and he had destroyed many life drawings because 'I haven't liked the personality in the drawing'.[28] If he destroyed drawings, they surely belong either to the only known category that no longer exists: the earliest drawings from casts and the figure that he made between 1919 and 1921 as a student in Leeds, as well, possibly, as other early life drawings.

The 1970s brought the first academic studies of Moore's drawings, by Alan Wilkinson. Wilkinson's work is especially valuable in its analysis of Moore's early notebooks, the extensive links established between Moore and the collections of non-European art in the British Museum, as well as the examination of Moore's drawings after old masters. Wilkinson also linked sketches with specific sculptures. Wilkinson's work was published in the catalogue of the exhibition of Moore's drawings at the Tate Gallery and Art Gallery of Ontario (1977–8) and his book *The Drawings Henry Moore* (1984). No need has been felt to cover the same ground here.

In 1970 Moore was 72 and keen that a full record of his work in all media should exist. A catalogue of his sculpture had been published in 1944 and greatly enlarged since then, and Moore was now thinking in terms of a full catalogue of drawings. The work was started by David Mitchinson, who, as

curator at the Henry Moore Foundation, has since then kept an overview of all the Henry Moore catalogues (sculpture, drawings, prints). Work on the drawings was continued in the second half of the 1970s by Juliet Bareau and was taken over in the 1980s by Ann Garrould who, following Moore's death in 1986, completed seven volumes for publication between 1996 and 2003.

Garrould knew Moore well and although the catalogue volumes were published after Moore died, they are founded on extensive discussions. Even though the published volumes reproduce the drawings small and mainly in black and white, this is a unique resource. Garrould took a practical approach, warning that 'in later life Moore adopted a somewhat cavalier approach to dating his earlier drawings, simply hazarding a guess at their date'.[29] She was able to distinguish between drawings dated when made and the much larger number dated – and often signed – later. The possibility that drawings are misdated of course remains, and Moore's use of generic titles makes early exhibition catalogues of little help. If some dates are wrong, it is probably only by a year or two. This matters most at points, especially the late 1930s, when it is not necessarily clear whether a drawing is *for* a sculpture or *after* it. These occasional problems will be noted where the argument is affected. Otherwise dates in the catalogue volumes have been re-used without discussion; titles, only a few of which were given by Moore himself, are also taken from the *catalogue raisonné*.

This book does not put equal weight on all aspects or periods of Moore's work, and only when there are specific points of interest to make, does it relate drawings to sculptures. There is no general discussion of Moore's graphic portfolios, though some of the drawings discussed in Chapter Five are connected with graphics projects. Nor is there any discussion of Moore as an illustrator. This was an important part of his work between 1944 and 1951, a fact reflected in a number of projects, the most important of which are *The Rescue* (1944) and *Prométhée* (1949–50). The first was a book illustrated by Moore that had started life in 1943 as a BBC radio play based on the last part of Homer's *Odyssey*; it was written by Edward Sackville-West, with a score by Benjamin Britten. The second was a version of Goethe's *Prometheus* (1773) in a new French translation by André Gide. Research on these has been published by David Mitchinson in his essay 'Henry Moore's *Prométhée* Lithographs' (2004) and the catalogue of the exhibition *Moore and Mythology* (2007), but there remains a need for a separate publication on Moore as an illustrator. Though most detailed attention is focused here on the 1930s and 1940s, an effort has been made to comment on all the most significant manifestations of Moore's art as a draughtsman in the first half of his career, up to 1950. The second half, from 1950 to Moore's death in 1986 is treated summarily, on the grounds that drawing (as Moore himself agreed) was much less the forum for innovation in his work than it once had been. The discussion of a small number of drawings in Chapter Five is not intended as a token but as a claim that at a particular moment drawing regained its centrality for Moore.

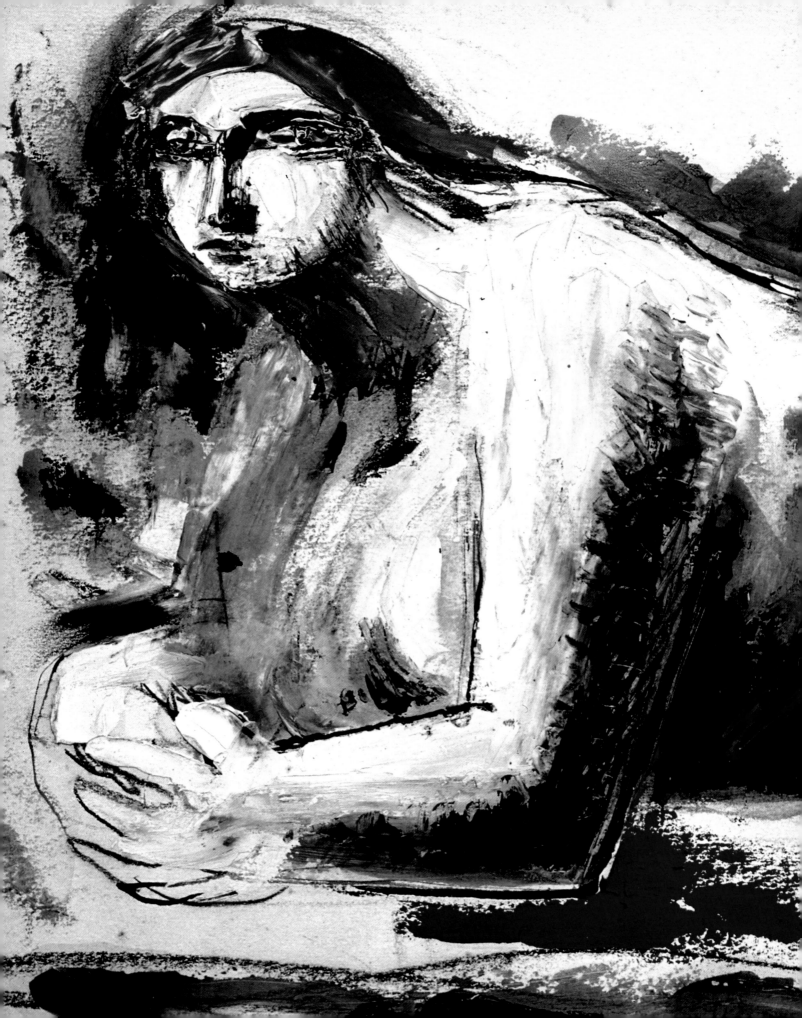

1 | The Human Figure

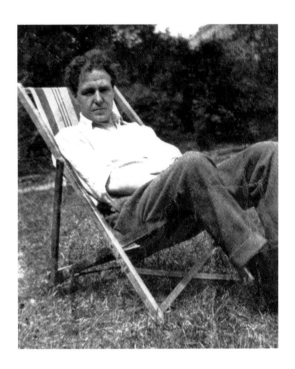

1 Henry Moore in the garden of the Royal College of Art, mid 1920s.

Opposite: Detail from Plate 20

Student

Moore became a student at the Royal College of Art, London, in September 1921 at the age of 23, after two years at Leeds College of Art, where he had found the teaching narrow and uninspired. He complained of Leeds that the models did not change and that students spent endless time on a single drawing. (Moore liked working quickly so that the vitality of the model was seen as liveliness in the drawing.) And although there were only six or seven sculpture students in his year at the Royal College and he had ample studio space, he was dissatisfied with the teaching of sculpture here too and recalled later, in 1968, that for this reason he used to do the required monthly composition in the painting school. This is why there exists a small group of early oil paintings by Moore.

The Newspaper Seller, 1921 (plate 2), was Moore's response to the set subject, 'the occupations of Londoners'. He recalled that in his first year at the RCA he read the two volumes of Wyndham Lewis' *Blast* (1914–15)[1], and the geometrical background of the *Newspaper Seller* is a legacy of Lewis' Vorticism, while the facial type – long face and short forehead – is one used by Lewis in early works. Moore came to art at the end of the first period of radical modernism, and explored ideas left over from the pre-war avant-garde which quickly disappeared from his art without trace. He recalled in 1968 that as a student 'I became involved in machine art, which in those days had its place in modern art. Although I was interested in the work of Léger and the Futurists, who exploited mechanical forms, I was never directly influenced by machinery as such'.[2] That was substantially true, but there is, even so, a sense that Moore in the late 1930s was interested in machines. Why else did he adopt the title *Mechanisms* (plate 77) for a work of 1938? The point here is that Fernand Léger and the Futurists were interested in machines as manifestations of modernity and saw them as mainly beneficial. By the late 1930s, as will be seen later, grounds for regarding the machine – and even modernity itself – in a positive light had severely diminished, and when Moore briefly looked again at the mechanical image it was as something disfunctional but threatening nonetheless.

In his first year Moore explored multi-figure compositions not directly connected with sculpture. The main sketch in *Figure Studies*, 1921–2 (plate 3), led on to a small drawing inscribed 'Homage to El Greco'. Moore was working simultaneously in the manner of El Greco's elongated figures and, after going to Paris in the spring of 1922, of Cézanne's bathers. This drawing, from the intertwined embrace of the figures in the centre at the bottom to the connection of the figures in the bottom left sketch, is joyous and celebratory and openly sexual. The small designs at the bottom of *Figure Studies* are uncharacteristic of later Moore where – especially in his late sculpture – there is an erotic resonance, but one that is sublimated so as to make it unspecific. Here, Moore is following the example of Jacob Epstein, many of whose drawings from *One of the Hundred Pillars of the Secret Temple*, c.1910, to *Totem*, c.1913 (plate 4), deal with embrace, copulation and birth. Moore remembered calling on Epstein with fellow student Raymond Coxon in their first student year with some trepidation and being courteously received.[3] After this first encounter, Epstein was as much an example to Moore of openness to world sculpture and courage in facing opposition as, in narrower terms, a formal influence.

Moore was critical of sculpture students who refused to do life drawing, attributing their reluctance to fear of being shown incapable.[4] He taught himself to draw the human

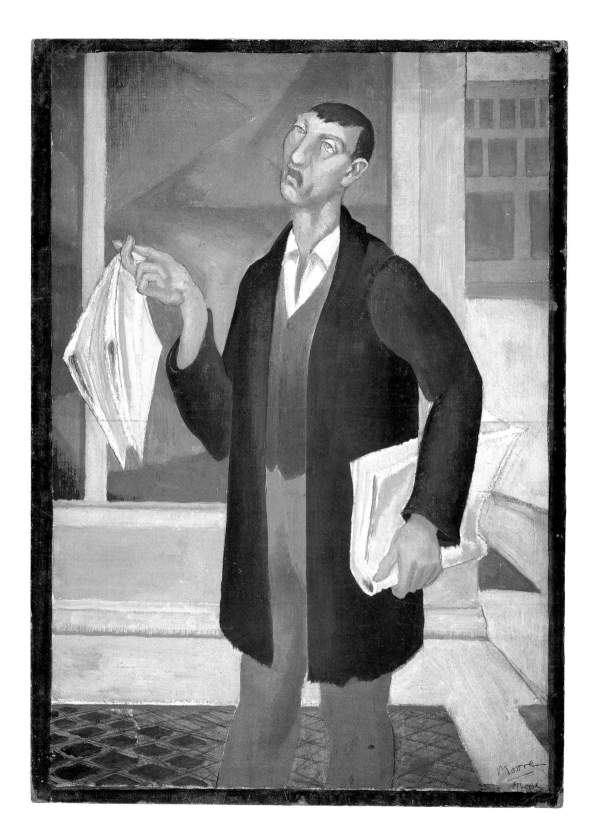

2 *The Newspaper Seller*, 1921. HMF 28.
Gouache, poster paint, pencil on
cardboard, 56.1 x 40.6 cm (22 x 16 in).
Henry Moore Foundation

3 *Figure Studies*, 1921–2. HMF 42
verso. Pencil, pen and ink,
22.5 x 17.5 cm (8 ⅞ x 6 ⅞ in).
Henry Moore Foundation

4 Jacob Epstein, *Totem*, c.1913.
Pencil and wash,
57.8 x 41.9 cm (22 ¾ x 8 ⅞ in).
Tate, London

figure in a way that reflected volume, achieving this not by laborious shading but by working quickly in a variety of materials. *Nude Study of a Seated Girl*, c.1924 (plate 5), is a good example. Moore admired Leon Underwood, instructor in drawing at the College from 1920–23, and recalled later Underwood's insistence that 'you had to know the laws of light falling on a solid object and reflecting it back to the human eye; and that being translated into a two-dimensional representation. You're not born with this understanding, you have to learn it, you have to be taught it'.[5] *Standing Nude Girl, One Arm Raised*, 1922 (plate 6), almost metallic in its light-reflecting surfaces, is an example of Underwood's influence. Moore and a few college friends continued to study privately

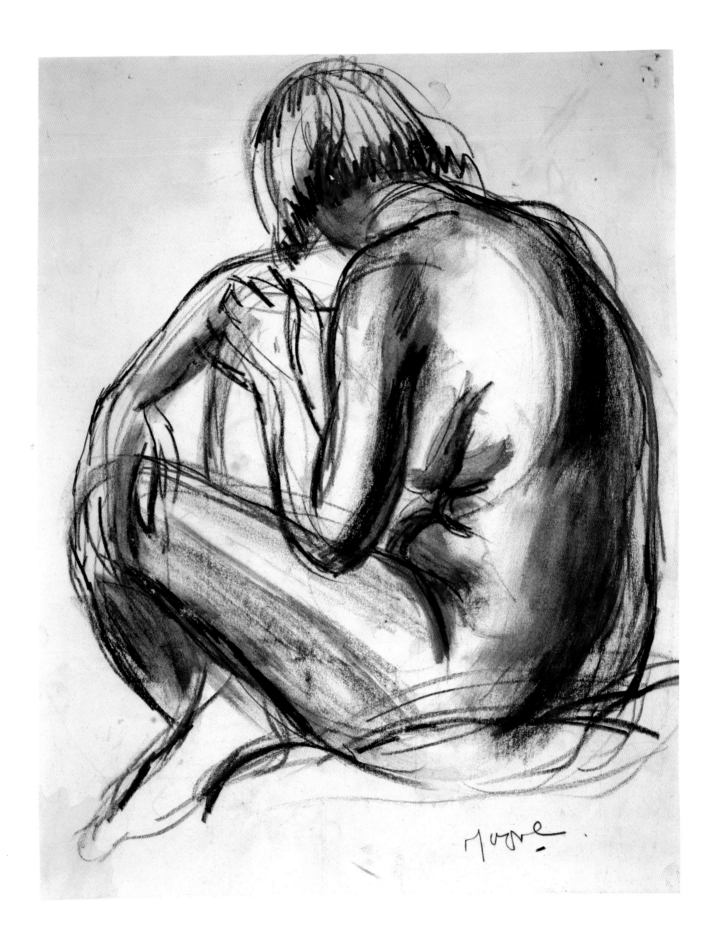

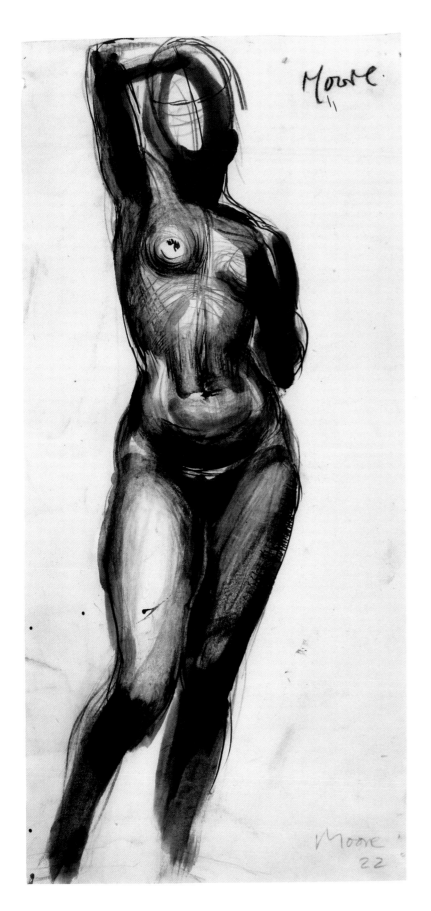

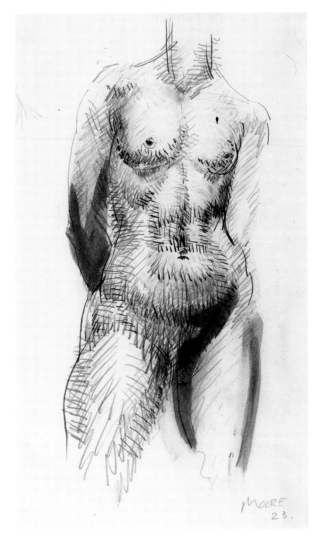

5 Nude Study of a Seated Girl, c.1924.
HMF 256. Chalk, watercolour,
42.5 x 35 cm (16¾ x 13¾ in).
Whitworth Art Gallery, University of
Manchester, presented by Dorothy Warren,
1927

6 *Standing Nude Girl, One Arm Raised*,
1922. HMF 78. Chalk, crayon, wash, pen
and ink, 33.5 x 15.5 cm (13¼ x 6⅛ in).
Henry Moore Foundation

7 *Standing Figure*, 1923. HMF 207.
Pencil, pen and ink, brush and ink, and
wash, 29.5 x 17.5 cm (11⅝ x 6⅞ in).
Henry Moore Foundation

with him after Underwood had left the College. Moore later came to take a different view of the function of figure drawing for a sculptor – or at least for himself – feeling that drawing and sculpture were essentially different, that one should not imitate the effects of sculpture in drawing.

Moore tried different approaches: in *Standing Figure*, 1923 (plate 7), he used hatching to build up the torso and reduced emphasis on outline. He rarely used outline alone in a way that was popular in Paris, and when he moved in 1924 from student to teacher at the College he discouraged students from adopting this approach because he felt such a summary technique should follow rather than precede mastery of more complex forms of representation.[6] Rare examples in his own work, like *Two Seated Figures*, c.1924 (plate 8), show how broken, chunky outlines, reminiscent of Gaudier-Brzeska's drawing style, help give weight to forms and avoid the slickness he believed smoother outline drawing could easily fall into.

Moore thought of drawing the human figure as a way of getting to know oneself, of feeling what it is like to be a body in the world. He recalled later, in 1961, that 'the construction of the human figure, the tremendous variety of balance, of size, of rhythm, all those things, make the human being much more difficult to get right, in a drawing, than anything else'. And he went on: 'It's not just a matter of training – you can't understand it without being emotionally involved, and so it isn't just academic training: it really is a deep, strong fundamental struggle to understand oneself as much as to understand what one's drawing.'[7] It was not that drawings were representations of self, but that Moore wanted to find out what made a drawn figure real. 'Reality' in that sense meant expressing vitality through organisation of form rather than directly imitative means, and was distinct in Moore's mind from realism. Influenced by Roger Fry, whose *Vision and Design* (1920) was, he agreed, iconic in his visual education,[8] Moore focused on formal problems. Notes in his third surviving notebook, dating from 1922–4, return repeatedly to the word 'masses'. Of one drawing (HMF 100 verso) he noted that it should be made 'probably totally without / features – solely in masses', another drawing (HMF 107) he identified as a 'composition of masses & spaces', and in a third example (HMF 110 verso) he was self-critical and wanted 'better masses. / & with more. / poise & play of mass'. 'Mass' was the watchword of Henri Gaudier-Brzeska, who had been killed in the war and among recent British sculptors meant most to Moore in terms of approach and technique. Moore would have read in the first issue of *Blast*, June 1914, Gaudier's statement: 'Sculptural energy is the mountain. / Sculptural feeling is the appreciation of masses in relation. / Sculptural ability is the defining of these masses by planes.'[9] In his memoir of Gaudier, published in 1916, Ezra Pound began by reprinting the whole of

Gaudier's article, which became talismanic for Moore through the 1920s.[10]

Moore's notes to himself in early sketchbooks show a consistent emphasis on the idea that an image, notably the human body, gains strength in drawing from being conceived in terms of mass. In a sense Moore thinks abstractly or, more precisely, he prioritises certain kinds of formal arrangement that stress organisation of mass, over representational accuracy. In that way vitality becomes an attribute of form not something brought in from outside to give the superficial effect of liveliness. Gaudier – more than Epstein – was Moore's mentor in this, but in the field of painting Moore found that similar lessons could be learned from Cézanne.

In 1922, on his first visit to Paris, Moore got to know Picasso's recent paintings of giant female figures.[11] Notebook No.3, which he had with him on the trip, contains *Figure Studies*, 1922–24 (plate 9), imitative of one of these and with Picasso's name inscribed on it. After the early 'El Greco' designs, Moore avoided gestures with the hands, preferring what he called 'pent up energy', expressed through relation of masses, to the spent energy of limb movements which are rare in both drawing and sculpture after Moore's very early work. He avoided particular facial expression, and any sense of the model using gesture or expression to address the artist or viewer. Wilkinson's description of the *Standing Nude Girl, One Arm Raised* (plate 6) as having the 'impersonality of a manikin' identifies this kind of objectivity.[12]

Impersonality through lack of facial features is a recurrent theme in Moore's notes. On a notebook page of 1925 (HMF 159 verso) he wrote advice to himself: 'Sculpture – in the round – power of projection / and yet compact composition – Effect to be gained / by contrasts of masses and planes not by features etc / do figures without features – Abstract composition / of form – Contrasts of direction – & shapes of masses.' In 1959, when Moore's pin-headed sculpted figures were drawing criticism, he said: 'My aim has not been to capture the range of expressions that can play over the features but to render the exact degree of relationship between, for example, the head and the shoulders; for the outline of the total figure, the three-dimensional character of the body, can render the spirit of the subject treated.'[13]

Form was still what mattered most to Moore, more than the mimetic or casual, meaning the aspects of a person's appearance that are temporary and subject to change. Moore's figure work through the 1920s shows that monumentality was more important than intimacy and self-discovery was different from self-expression. Drawings from life are not always easily distinguished from drawings for sculpture, and there is a category in which the figures have a lifelike naturalism but are part way to being sculptures of a primitive kind. In *Ideas*

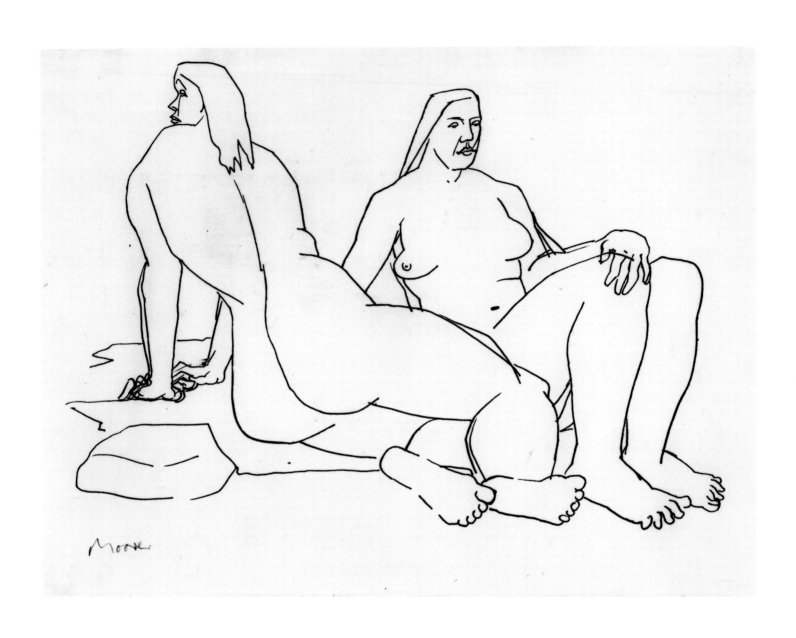

8 *Two Seated Figures*, c.1924.
HMF 263. Pencil, pen and ink,
24.2 x 32.7 cm (9½ x 12⅞ in).
Art Gallery of Ontario, Toronto,
gift of Henry Moore

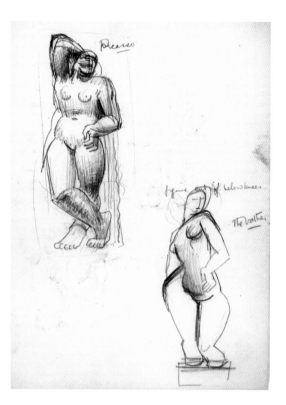

9 *Figure Studies,* 1922–4. HMF 134. Pencil, 22.5 x 17.3 cm (8⅞ x 6⅞ in). Henry Moore Foundation

10 *Ideas for Sculpture: Standing Nudes with Clasped Hands,* 1925. HMF 361. Brush and ink, 25.1 x 30.6 cm (9⅞ x 12 in). Henry Moore Foundation

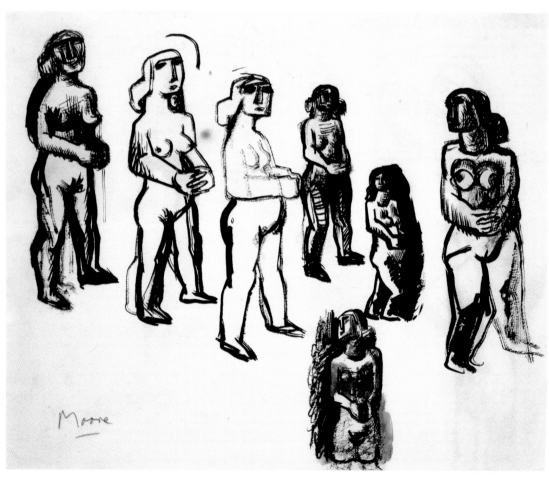

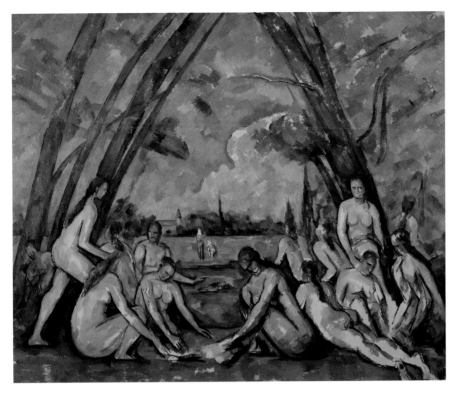

11 Paul Cézanne, *Les Grandes Baigneuses*, 1906. Oil on canvas, 208.3 x 251.5 cm (82 x 99 in). Philadelphia Museum of Art (W P Wilstach Fund)

12 *Studies of Figures from Cézanne's 'Les Grandes Baigneuses'*, c.1922. HMF 26 verso. Pencil, 24.1 x 16.1 cm (9½ x 6⅜ in). Henry Moore Foundation

for Sculpture: Standing Nudes with Clasped Hands, 1925 (plate 10), formalised heads and bodies suggest origins within non-European sculpture, but feet held apart and glances directed towards the viewer indicate real people. Ambiguity between human beings and sculpted images remained a preoccupation of Moore's, many of his drawings suggesting that existing sculpture (his own or others') was as much the starting point as the living body. The slippage between the two interested him, and fed into later concerns with the principle of metamorphosis: ambiguity between animate beings and inanimate objects, and in the 1940s the borders between life and death.

Cézanne

With an introduction from William Rothenstein, principal of the RCA from 1920 to 1935, Moore visited the Auguste Pellerin collection of Cézannes – numbering some 90 works and by far the largest Cézanne collection in existence – when he first visited Paris in the spring of 1922. 'There, in the entrance hall of ... [M. Pellerin's] house was the big triangular composition The Bathers. For me, that represents the most ambitious, the biggest effort that Cézanne made in all his life'.[14] In recalling the Pellerin visit, Moore invariably singled out this large late composition, *Les Grandes Baigneuses*, c.1906 (plate 11), a detail of which he copied, probably afterwards from a photograph (plate 12). 'Cézanne's figures had a monumentality about them I liked. ... [They] were very sculptural in the sense of being big blocks and not a lot of surface detail about them. They are indeed monumental....'[15] Moore told John Russell in 1961 that 'what had a tremendous impact on me was the big Cézanne, the triangular bathing composition with nudes in perspective, lying on the ground as if they had been sliced out

of mountain rock. For me this was like seeing Chartres Cathedral.'[16] Roger Fry, using the Pellerin collection as the basis for a book on Cézanne in 1927, also described the picture as monumental, and his comments in general are compatible with Moore's.[17] Both were interested in Cézanne in relation to the Italian primitives, and like many artists saw Cézanne as himself the primitive of a new age. At a moment when so many, varied ways were being explored to renew art from the ground up, the word primitive acquired numerous meanings and resonances related to the idea 'primal' as much as to any art, European or non-European, customarily designated as primitive.

Moore's referring to the painting as having 'not a lot of surface detail', was language Fry would have understood. Both saw art's renewal after the nineteenth century as involving elimination of anything that was not necessary for strong formal expression in the way Cézanne's painting worked here. But when Moore identified the 'sculptural' in Cézanne with 'big blocks', he was using particular language: Cézanne was a painter not a sculptor and his 'blocks' are flat areas rather than three dimensional masses. 'Sculptural' applied by Moore to Cézanne meant something different from its use applied to his own work. Related to himself 'big blocks' meant sculpture in the round, or sculpture as mass as he found it in Gaudier-Brzeska. 'In the round' and 'big blocks' are phrases found in Moore's sketchbooks at this time to define desirable qualities in sculpture. Moore saw that different lessons were to be drawn from historical painting and sculpture and he explored how Cézanne's bathers, even if flat as Cézanne painted them, could be turned into sculpture 'in the round'.

Moore's *Studies of Nudes*, 1922–24 (plate 13), comes from Notebook No.3 which he used after his return from Paris, and though the drawing is not specifically after *Les Grandes Baigneuses*, the clusters and poses of the figures are similar to Cézanne's. At the top right, Moore has drawn figures enclosed in a box. His notes explain this: 'Compose in box; here group / of bathers; recangular [sic] / square / triangular / pyramidical [sic].' The box was Moore's aid to translating the two dimensions of painting into three for sculpture. The objective was compression, and creation of masses that push outwards against the edges of the composite form but are tightly held within the box. Vitality for Moore was contained in the tautness of bodies, not expressed in movement of limbs. This is a lesson in making single, composite forms from groups of figures that Moore could have recognised in Gaudier's treatment of a group of birds as a single sculptural form in *Birds Erect*, 1914 (plate 14). Moore recalled that he found 'great help and excitement ... [in] Ezra Pound's book on Gaudier-Brzeska', where Gaudier emphasised the need to compose in mass.[18] In 1935 Geoffrey Grigson commented on

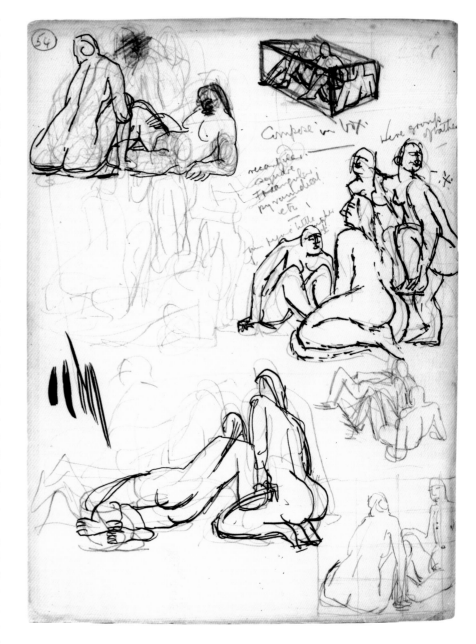

13 *Studies of Nudes*, 1922–4. HMF 106 verso. Pencil, pen and ink, 22.5 x 17.3 cm (7⅞ x 6⅞ in). Henry Moore Foundation

14 Henri Gaudier-Brzeska, *Birds Erect*, 1914. Limestone, 68.3 cm (26⅞ in) high. Museum of Modern Art, New York

Moore's art, which was then more broadly based in nature under the beneficial influence of Surrealism, that he 'belongs to the Cézanne type. His energy emerges, not volcanically, but in the slow and solid block'.[19] It is impossible to overestimate the importance for Moore of Fry's stress on the need for strong form if vitality was to be embodied in the figure rather than added as a veneer. If, after the 1920s, Moore developed new interests that did not relate to Fry, Cézanne or Gaudier, it does not mean that he no longer cared but that their lessons were embedded and he could proceed to new interests.

Through the 1920s, Moore's notebooks come back to the idea of mass. On a sheet from Notebook No.6 dated 4 May 1926 we have: 'SCULPTURE / Disposition of masses with opposition thrust; opposition of swellings ' (HMF 427). On another page of the same notebook (plate 15), Moore insists: 'Stay on the big design & play of / masses. until power of form is / achieved – That is interest. / Sculptural intensity. Have an / idea & express it powerfully. – / opposition of swellings & balance. / (not symetry [sic]).'

Moore's comments on his artistic development are mainly retrospective and focus strongly on issues of technique, rarely diverting into subject matter. He liked identifying iconic moments in his development – the first visit to Paris and Cézannes *Les Grandes Baigneuses* was one, the British Museum, the Masaccios in Florence, and later on Michelangelo, were others. It is important, though, to recognise these not just as truths, which they were, but also as part of Moore's construction of himself as heir to the masters, and to wonder, also, what early influences either proved in the long run to be unimportant, or which Moore – in the many interviews he gave later in life – did not want to become part of the canonical narrative of his development. Some 30 of Pellerin's Cézannes were early works, several of them idylls and group picnics of around 1870 which have a strong erotic overtone that is notably absent in Cézanne's later paintings of nudes.[20] Moore seems to have picked up on this in a number of drawings in Notebook No.3 – which he had with him in Paris and used subsequently – of himself and his known friends (sometimes identified on the drawing) picnicking naked (HMF 142) or otherwise composed as a nude group (HMF 143). Robert Burstow has compared these drawings convincingly with the outdoor nude canvases of *Die Brücke* artists at the Moritzburg lakes outside Dresden before the First World War. These, in their own way, are also in a line of descent from Cézanne.[21] These are early works of Moore that do not lead to later developments either in sculpture or drawing, and are important, more than for any other reason, for the way they show Moore directing the study of his own work, in this case by focusing on *Les Grandes Baigneuses*.

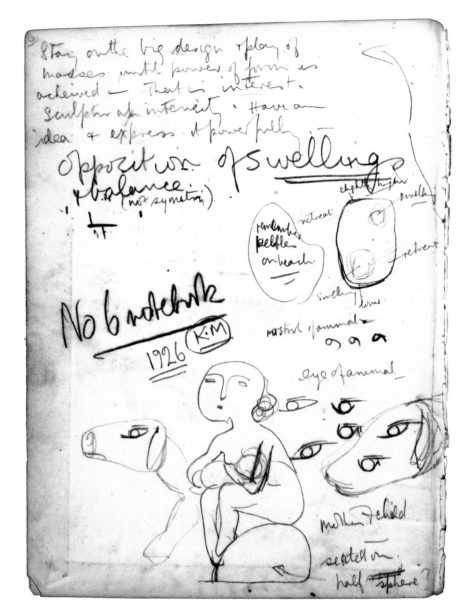

15 *Miscellaneous Sketches*, 1926. HMF 426. Pencil, 22.3 x 17 cm (8 ¾ x 6 ¾ in). Henry Moore Foundation

16 *Studies after Works in the British Museum*, 1921–2. HMF 63. Pen and ink, 22.5 x 17.5 cm (8⅞ x 6⅞ in). Henry Moore Foundation

The British Museum

In a submission to the Royal Commission on National Museums and Galleries established in 1927 the director of the British Museum, Sir Frederick Kenyon, argued (in vain, as it turned out) for a new gallery of ethnography, in an attempt to end a decades-long debate about the adequacy of the displays. The size of the displays and their popularity with the public, he felt, made this a pressing matter. He described the current display as a 'long range of galleries, packed to overflowing with objects from Asia, Africa, America and Oceania, where a visitor passes in a few steps from the pottery of ancient Peru to the canoes of the Solomon Islands, the fetishes of Benin, the carvings of the Maoris, and the influence of the Esquimaux … The effect is simply that of a large curiosity shop'.[22]

Letters to his Leeds friend Jocelyn Horner in October 1921 show that Moore worked his way methodically through the museum as soon as he joined the RCA.[23] The British Museum was Moore's dictionary. A note to himself in Notebook No.3, 1922–4, says: 'Sunday July 4.5 or 6 or 7 / got as far as Easter / Island / Sunday July 12.13 or 14 / reached N.W. Coast of America', and elsewhere on the same page 'Saturday / Figi [crossed out] Fiji Islands'. This is not a diary of focused learning but the research of someone who wanted to know everything, and was working his way through the displays section by section. The idea that there was an 'everything' waiting to be known underpins Moore's thirst for a comprehensive knowledge of non-European cultural artefacts right through the 1920s. He told James Johnson Sweeney in 1947 how his father, a Yorkshire miner, had 'educated himself: knew the whole of Shakespeare, taught himself engineering to the point where he could have become manager of the mine in which he worked'.[24] It is a touching picture of filial respect, but Moore himself wanted to go further and take a leading part in his own professional field within a social system that had kept his father at arm's length. What made Moore's project possible was the very fact that his idea of a 'world sculpture' (a phrase to be found in Moore's sketchbook notes) was basically reductive, in the sense that his convictions about form and technique (organisation of masses etc.) could be applied to the sculpture of any race or culture. Around 1930, however, Moore was to discover that learning was a dynamic process. The scope of any field of inquiry could not be defined in advance, because new areas of significance opened up as earlier ones closed. Later, Moore's attraction to primitive art was more on a basis of need – of establishing how a present direction in his art could be supported by external factors.

He agreed with Kenyon's judgement that the ethnographic galleries were, as Moore was to put it in 1941, 'overcrowded and jumbled together like junk in a marine stores, so that after

hundreds of visits I would still find carvings not discovered there before.'[25] But what the director faced as a problem, was for Moore a virtue.

That is the value of the British Museum: you have everything before you; you are free to try and find your own way and, after a while, to find what appeals to you most. And after the first excitement it was the art of ancient Mexico that spoke to me most – except perhaps Romanesque, or early Norman. And I admit clearly and frankly that early Mexican art formed my views of carving as much as anything I could do.[26]

Looking back in 1930, Moore applauded 'the removal of the Greek spectacles from the eyes of the modern sculptor', and listed a wide variety of non-European artefacts that helped a sculptor to 'realise again the intrinsic emotional significance of shapes instead of seeing a mainly representational value, and freed him to recognise again the importance of the material in which he works'.[27] By 'Greek spectacles' Moore meant images typical of later Greek sculpture. The phrase 'the Greek ideal', which Moore also used, referred to the tradition of classicism dominating sculpture from the Renaissance to the present day. Moore was saying little more in that respect than Gaudier-Brzeska and Pound had said already.

17 *Studies of Sculpture in the British Museum*, 1922–4. HMF 123 verso. Pencil, 22.5 x 17.3 cm (8⅞ x 6⅞ in). Henry Moore Foundation

18 *Studies of Sculpture in the British Museum*, 1922–4. HMF 123. Pencil, 22.5 x 17.3 cm (8⅞ x 6⅞ in). Henry Moore Foundation

19 *Woman in an Armchair*, 1930. HMF 774. Brush and ink, oil paint, 34.3 x 40.7 cm (13½ x 16 in). Henry Moore Family Collection

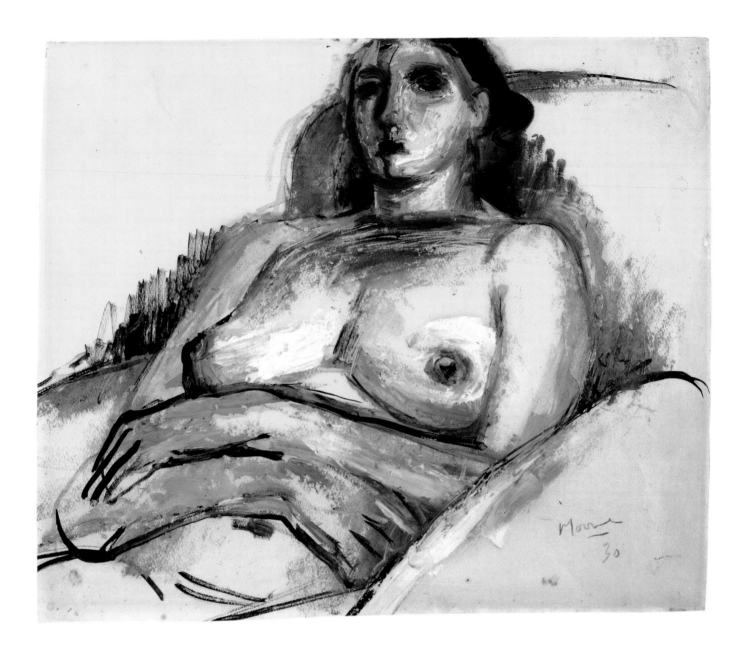

Moore's most respected mentor, however, was still Fry whose essay 'Negro Sculpture', 1920,[28] opened with the same point, namely that the rise of African art was a condition of the decline of Greek and Roman ideals and their repetitions. Fry centred his argument on the notion that the African artists 'have complete plastic freedom; that is to say ... [they] really conceive form in three dimensions'.[29] Moore has been quoted already talking of 'mass' in Fry's terms. In notes dated by Wilkinson to 1925–6, Moore follows Fry very closely, praising Africans' 'wonderfully fertile invention of abstract forms', and suggesting that their 'unique claim for admiration is their power to produce form completely in the round'.[30]

Moore's passionate involvement with the British Museum is manifested most fully in Notebook No.2, 1921–2 (plate 16), and Notebook No.3, 1922–4 (plates 17 and 18). In respect of primitive artefacts, Moore's notes on sketches made in the British Museum are mainly concerned with technical issues, with 'abstraction; directions / & poising of weights' (plate 16) and he tells himself: 'Define difference between modelling Sculpture / Keep in mind –; Sculpture is relative of masses etc etc / modelling is undulation of surfaces / ... / Keep ever prominent the big view of sculpture / The World Tradition' (HMF 427 from Notebook No.6). Moore's interest in the British Museum's collections was sculptural and formal, not ethnographical.

Italy and Classicism

Moore was awarded an RCA scholarship to travel in Italy in the first half of 1925. Initially reluctant to go, he tried unsuccessfully to have the destination changed to Paris, but in the event he was disappointed by his short stay in Paris and immensely stimulated by Italy. Writing from there to William Rothenstein, Moore listed Giotto and the post-Giottesques leading up to Masaccio as being of greatest interest.[31] He visited the Masaccio frescoes in the Brancacci chapel of Santa Maria del Carmine in Florence daily. Masaccio, working near the beginning of the fifteenth century, was to remain for Moore the pivotal figure in whom the directness and vitality of Giotto and the primitives was developed to a point of monumentality, while later Renaissance painting, he felt, tended to decorativeness that concealed strong form. Painting exemplified the monumentality Moore was searching for better than sculpture. 'Of great sculpture I've seen very little. Giotto's painting is the finest sculpture I've met in Italy.'[32] Giorgio Vasari in the sixteenth century had made the same point about Masaccio: 'All the most celebrated sculptors since Masaccio's days have become

excellent by studying their art in this [the Brancacci] chapel.'[33]

In 1928–30 Moore stepped beyond conventional drawing into designs like *Woman in an Armchair*, 1930 (plate 19), and *Reclining Figure*, 1929 (plate 20), that were painted partly in oils, applied with both brush and palette knife, alongside conventional drawing materials like charcoal and chalk. These figures are monumental and sculptural, their strength and vitality manifest not through expression or gesture but by build-up of energy in the body mass. Faces have more detail than before, but they are mask-like and relatively impenetrable. As a sculptor, Moore made nine masks in the late 1920s under pre-Columbian influence, and while the faces in the drawings are of a piece with the bodies and not directly influenced by non-European art, there is here also some of the sense of classical detachment there had been in early figure drawings.

After the Moores' marriage in 1929, Irina modelled for some of the new figure studies. But the new drawings do not express domesticity or intimacy. Moore has been quoted as lacking concern with faces and he elaborated on this further in 1949, saying that it was not by facial features but by the

20 *Reclining Figure*, 1929. HMF 719. Pen and ink, oil paint, chalk and wash, 26.7 x 44.8 cm (10½ x 17⅝ in). Henry Moore Family Collection

21 *Standing Female Figure*, 1930. HMF 760. Pen and ink, crayon, watercolour, wash, gouache and oil paint, 52.1 x 39.3 cm (20½ x 15½ in). Victoria and Albert Museum, London

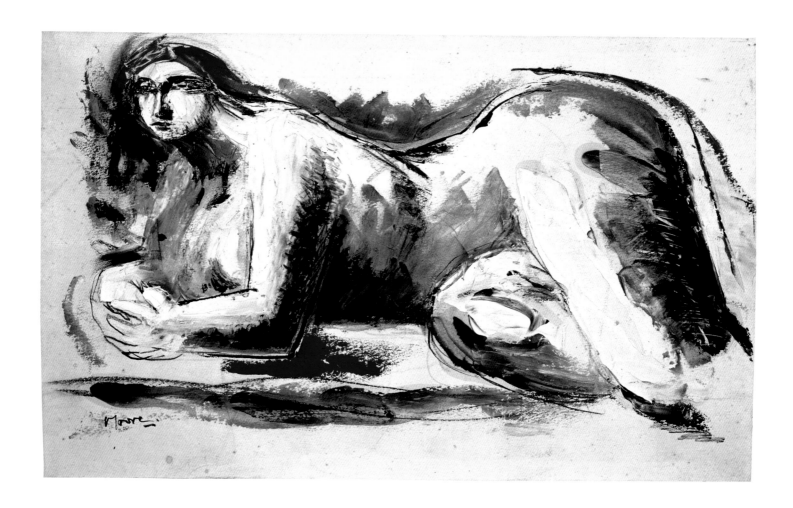

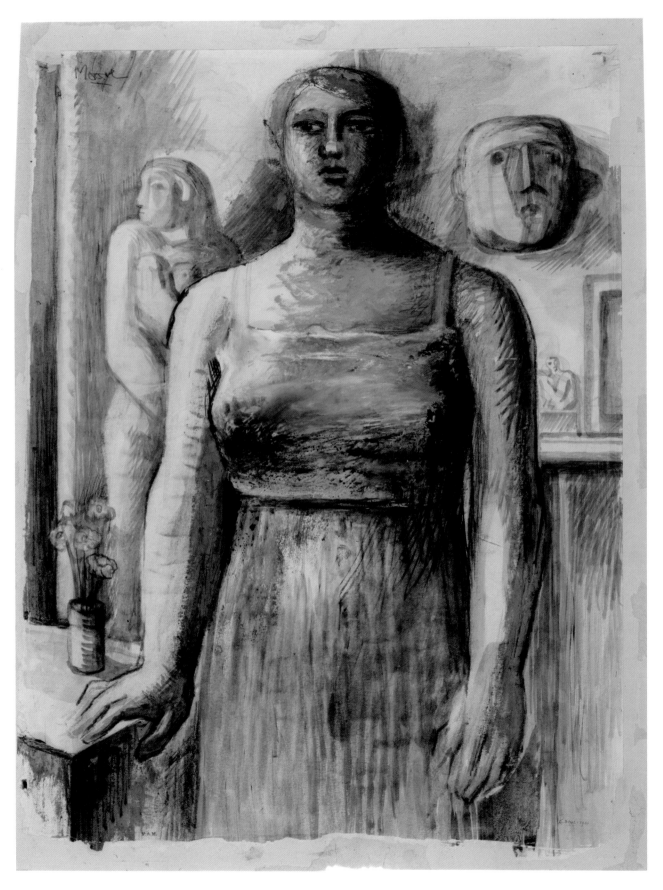

articulation of the body as a whole that one recognised a person at a distance.[34] Presence conveyed through strength of form was Moore's priority over facial expression or demeanour. But that need not exclude concern with the face altogether. In these late 1920s drawings Moore *was* interested in the face, but treats it with austerity and reserve.

By 1930 Moore was also starting to indicate a figure's environment in his drawing, constructing pictorial space, a development which suggested a step away from concern with sculpture alone. *Standing Female Figure*, 1930 (plate 21), shows three of Moore's sculptures behind the figure of Irina in the studio of the Hampstead home they moved to in 1929. As a quasi joint portrait, it is understandable as a celebration of marriage and a new home and studio. Though Irina often posed for Moore nude, here she is clothed, which is unusual for Moore at this point and was surely intended to identify Irina as a person and not simply a model. Indeed, the flowers on the table are an unusual domestic touch, further suggesting that this is an exceptional drawing. Another oddity is the standing figure's nervous expression, which seems to be answered by the sculpted mask of 1929 on the wall behind to the right – it gives her a quizzical look out of the

corner of its eye. The drawing is ambiguous and contradictory, human and sculptural at the same time.

Italy and early Italian painting increased the grandeur Moore found in the human figure and helped his drawing to become more sculptural. He was excited by Masaccio because he saw in his work a new sense of substance entering Italian painting, with figures who satisfied his sense of reality: a reality that implied human lifelikeness not in terms of the literal or mimetic but on account of the vitality the figures drew from strength of form. Notwithstanding that biblical characters were portrayed, their strength of form made them believable as people in modern terms. For Moore, the emotions of guilt and humiliation shown by Masaccio's Adam and Eve driven from Paradise are real human feelings and not conventional expressions repeated from previous art. Moore, it has been argued, wanted to recreate his own sense of being in the world into drawings without making them direct reflections of self. Masaccio helped show him the way to achieving that, by the sense that these could be real people, but, on the other hand, possessed of enough detachment to give them character of their own distinct from everyday life.

Classicism was the subject of constant debate in the

post-war period, as attempts were made to restore stability in all walks of life and culture. In an editorial in *Drawing and Design* for November 1926, 'The Classical in Modern Art', the writer condemned what in the modern movement was 'synonymous with eccentricity, extravagance and anarchy', suggesting that 'the essence of the modern age lies in the fact that it has attempted to establish order and to make the canons of art much more severe'. 'Classical', the article suggested, did not imply a revival of Greek art, 'We aim', the writer claimed, 'at being classical in a far deeper sense. The modern ideal ... is assuming the formal, the exquisite, the passionless quality, which is the true "classicism" ... An artist of the past who was classical in this definition was Raphael. The modern exemplar, we suppose, is Picasso.'[35]

Moore has already been quoted as applauding, in 1930, the removal of 'Greek spectacles', and the point made that it was only later Greek art and subsequent repetitions of the imitative, as opposed to primitive, side of classicism that he condemned. The editorial in *Drawing and Design* supported the argument for a 'true classicism' that was allied to the severity of the primitive and not the naturalism of later classicisms. While Moore's work is not passionless, as the writer defines true classicism, it is formal and reserved, and by the end of the decade has a grandeur that is within the European tradition. Moore was anxious on his return from Italy because he felt unable to reconcile his discoveries there with earlier ones in the British Museum. Certainly, the impact of primitive artefacts was for a time much reduced. But the notion of a 'primitive classicism', and the appreciation that Moore's endorsement of early Italian painting stretched chronologically not much further than Masaccio, makes it clear that 'the primitive' in its wider connotations was by no means lost to him.

Picasso

As the modern ideal of classicism, the writer in *Drawing and Design* used Picasso, obviously thinking of the post-war classical portraits and giant women. Picasso had been a guide since Moore first saw these at Paul Rosenberg's gallery in Paris in 1922. As has already been mentioned, his name is inscribed on *Figure Studies* (plate 9) and Moore later told Wilkinson: 'I was attempting to make a simplified life figure and was influenced by Picasso's big shortened figures.'[36] Some of Picasso's classical figure compositions, from 1906 and again after the war, lack any kind of background or context, something which Moore also experimented with. Moore was looking for wholeness and stability in the human figure, a healing process – in part – as a response to the terrible dismemberment bodies had suffered so recently. In this context an authentic classicism could be beneficial, by affirming tested values and re-establishing continuity across time. Moore can be seen in the terms Elizabeth Cowling has set out in respect of Picasso, describing his giant women as possessing a 'temporal vagueness [which] focuses on the inexorable *passage* of time, on the ceaseless transfer of present into past tense, and the generalised references to classicism [which] function both for the past as such and the continuum of cultural history'.[37] The notion of the 'continuum of cultural history' was of paramount importance to Moore also, and the deepest similarity between Picasso and Moore relates to their sense of the aliveness of the past, not just as it was combined with the values and modes of expression of the present, but also as the two are umbilically connected, registering the past not just as an influence on, but as something still alive in, the present.

Three Nudes on a Beach, 1929 (plate 22), shows Moore working on a composition of figures against the sea, Picasso-like in subject and colour. However, by the time Moore had achieved this kind of harmony, he was already moving on. In a more abstracted design, *Seated Woman*, 1928 (plate 24), Moore uses a brush to create a more synthesised form of a kind that was to lead him within a year or so to look closely at the loose, cursive handling of Picasso's metamorphic paintings in his *Woman in an Armchair* series and other paintings of 1927 (plate 23). Especially at this point, when Moore was feeling his way to a bolder modernism with more daring distortions, his varied reactions – in this case to Picasso – warn against expecting consistency.

Picasso above all was the artist whose work, as draughtsman, painter and sculptor, Moore, 17 years his junior, now debated and matched himself against. Moore was aware by 1930 of the range and variety of Picasso's art through visits to Paris and from reading French art journals *Cahiers d'Art* which, through its editor Christian Zervos, was virtually a mouthpiece for each stage of Picasso's new art, and the unorthodox Surrealist journal *Documents*. The two together provided a running commentary on what Picasso was doing. Many French journals of the period remain in Moore's library and testify to the close watch he kept on the Paris art scene. Picasso was sculptor as well as painter, and though he made no sculpture between 1914 and 1927, many of his paintings were highly sculptural as if, when he was not actually making sculpture, he found in painting a forum for developing sculptural ideas. For Moore, Picasso was both an example to follow and a source of anxiety. Though Moore wanted vitality more than beauty, responding to the radicalism of Picasso's estranged and tormented figures did not come easily. Thus Picasso was a debating point for Moore through the 1930s and beyond.

Moore was unlike Picasso in that his sculpture, at least, had a narrower formal morphology and range of materials than

Picasso's, it was more consistent than the products of Picasso's notoriously unbounded, mercurial imagination. In his drawing, though, Moore does at certain points – especially during the years from 1928 to the Second World War – allow his imagination a freedom to range and explore that is never altogether permitted to his sculpture. There seems to have been a distinction in Moore's mind between sculpture as his public face, the art by which he ultimately wanted to be known and judged, and drawing, which he regarded as a subsidiary practice and which for that very reason was allowed greater freedom of expression.

Recent debate around the 'recall to order' in European art after the First World War has distinguished between the demeaned classicism of nineteenth-century and later painting and sculpture and the authentic expression of vitality and feeling in Cycladic, early Greek and Etruscan sculpture or the classical sculpture of Iberian Spain that had meant much to Picasso at the threshold of Cubism. Essentially, this is what Moore was saying in his 1930 statement condemning later Greek art and subsequent classical revivals, and he was also making the same contrast between that and other areas of Greek art, like Cycladic and Etruscan. Elizabeth Cowling and Jennifer Mundy argued in *On Classic Ground* that tranches of past art were both classical and primitive, that since the Romantic movement the primitive had been associated with the avant-garde, and the myth of the purity of primitivism had become the great myth of modern times.[38] Escape from the decadence and over-sophistication of the present could involve a review of the classical past, a return to origins. Mundy quotes Moore's Italian contemporary Carlo Carrà saying, 'I am going back to primitive, concrete forms. I feel myself to be the Giotto of my times.'[39] Cowling says of Picasso's paintings of his wife Olga and their son in 1921 that 'he employed the language of classicism to objectify the private subject and confer on it an austere, iconic dignity'.[40] Moore's interest in Italian art from Giotto to Masaccio was a twentieth-century expression of a shared identity between true classicism and the primitive.

Moore's authoritative statement on the meaning of the primitive for him came only in 1941, but what he wrote then confirms the concepts building up in his mind earlier on. The primitive was normally applied, he said, to all cultures except those of Europe and the Orient. Moore said nothing more of the Orient but his principle was that cultures worked cyclically, that all great cultures – Greece, the Italian Renaissance or whatever – start with the primitive and gradually decay. The quality that defines the primitive for Moore was 'intense vitality' and its route to this was via the 'elemental' which involved simplicity of form – not the simplicity that was the product of emptiness but the simplicity that comes from 'direct and strong feelings'.[41] His appreciation of Masaccio had been

formed around this: 'The tradition of early Italian art was sufficiently in the blood of Masaccio for him to strive for realism and yet retain a primitive grandeur and simplicity.'[42] Allowing that the oriental arts were never a significant interest of Moore's, he adhered to the concept of a world art based on strong formal values reflecting 'direct and strong feelings'.

Around 1930 this sense of common principle underpinning sculpture in most of the world is extended from geography to history, with the added notion of a total historical span, the beginnings of which are seen in a series of drawings after one of the best known Palaeolithic votives, the *Venus of Grimaldi*,

23 Pablo Picasso, *Woman in an Armchair*, 1927. Oil on canvas, 130.5 x 97.2 cm (51⅜ x 38¼ in). The Solinger Collection

24 *Seated Woman*, 1928. HMF 673 verso. Pencil, brush and ink, 22.7 x 14.9 cm (9 x 5⅞ in). Henry Moore Foundation

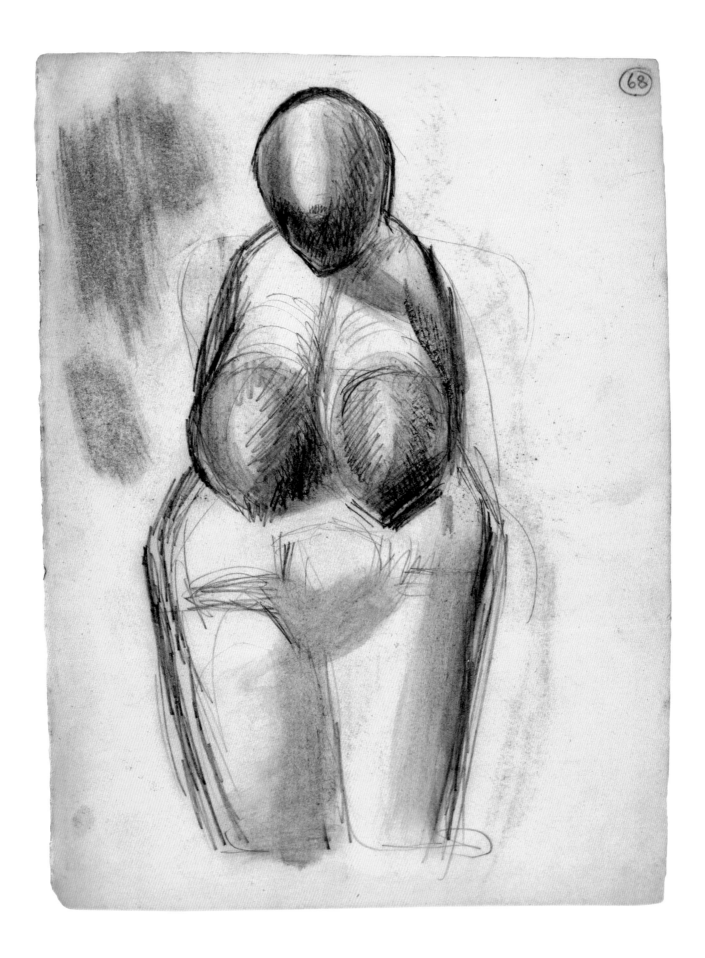

68

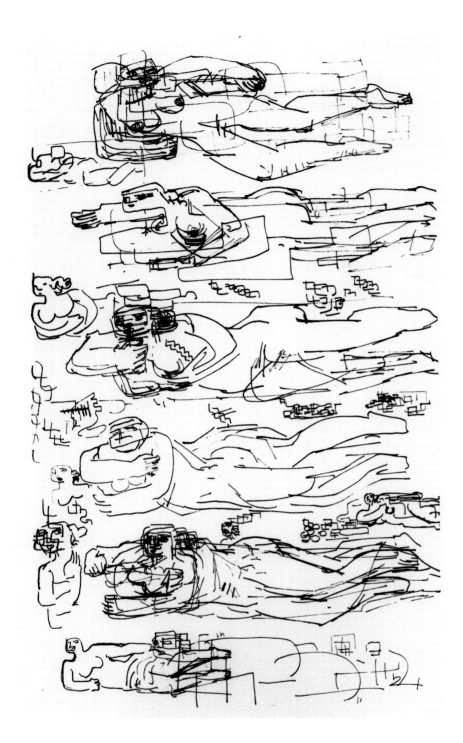

25 *Study after the 'Venus of Grimaldi'*,
1926. HMF 460. Pencil, wash,
22.3 x 17 cm (8⅞ x 6⅞ in).
Henry Moore Foundation

26 *Ideas for the 'West Wind'
Sculpture*, 1928. HMF 647 verso.
Pen and ink, 22.8 x 18 cm (9 x 7⅛ in).
Art Gallery of Ontario, Toronto,
gift of Henry Moore

1926 (see plate 25), copied from Herbert Kühn's *Die Kunst der Primitiven* (1923). The point is less that Moore was interested in the past for its own sake than for its life in the present. In a review in 1935 of Christian Zervos' *L'Art de la Mésopotamie*, he wrote: 'It is not necessary to know their [the Sumerians'] history in order to appreciate and respond to these works of art. We need to look at them as sculpture, for once a good piece of sculpture has been produced, even if it was made like the Palaeolithic 'Venuses' of twenty thousand years ago, it is real and part of life, here and now, to those sensitive and open enough to feel and perceive it.'[43] Moore saw the bridge between prehistory and the present more as a service of the past to the present, a lesson in how to reinvigorate a defunct western tradition than a feeling for earlier worlds for their own sake.

The West Wind

At the end of the 1920s Moore's drawings were monumental and detached. In terms in which the word was then used, they were classical. His 1930s drawings were different, and evidence of change is clear in the numerous sketches for the *West Wind* sculpture commission, 1928 (LH 58), for the new London Transport building. The theme led Moore to produce many sparkling images of wind goddesses blowing across the pages. The drawings are summary and swiftly realised, but complete in that each is a sketch of a notionally completed sculpture, not a study for parts of it. Moore almost never made studies, in the sense of working out aspects or faces of sculpture in different drawings: there is rarely a progression in his drawings showing him first making one side of a sculpture and then another. His sketches are of numerous possible end results and reveal little or nothing about sculptural process. But there is also something new about these drawings, a sense that they are independent flights of the imagination, related of course to the proposed sculpture but with lives of their own.

One page (plate 26) with six large images and several smaller ones in the interstices, also has abstract patterns filling blank corners of the page (especially at the bottom right). The patterns can be read as shorthand for the stone blocks of the building façade, but Moore also used the words 'scribbles' and 'doodles' for marks of this kind when they were purely graphic and unrelated to sculpture. There is a compulsive filling of space, a *horror vacui*, which becomes a leitmotif of Moore's drawings in the next decade. The *West Wind* notebook looks forward to all those sheets of sketches in the 1930s where Moore created streams of related images clustered on the same page – the density of images created a sense he liked of his sculptures grouped in families. Speed of drawing was also a way of avoiding too much conscious intervention in the flow of ideas and was to take Moore in the direction of Surrealist automatism.

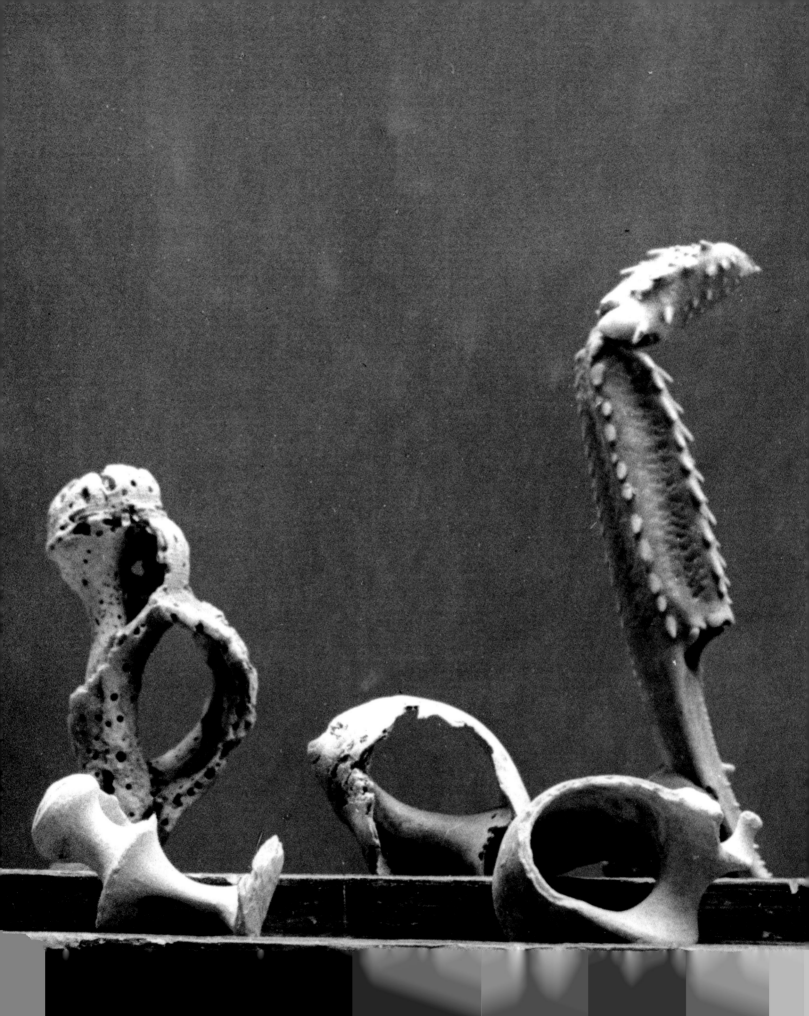

2 | Transformations

27 Henry and Irina Moore at 11a Parkhill Road, London, 1930.

Opposite: Detail from Plate 32

Moore in 1930

When the Moores married in 1929 they moved, on the initiative of Barbara Hepworth and her first husband, the sculptor John Skeaping, to a new home and studio on the edge of Hampstead (plate 27). They were to be joined, nearby, over the winter of 1931–2 by Ben Nicholson and in the summer of 1933 by Herbert Read. Moore had visited Paris regularly since 1922, but these trips changed in character in 1930–31 when he met for the first time members of the Surrealist circle, Jean Arp, Joan Miró and Alberto Giacometti, followed soon afterwards by Max Ernst and, in 1937, Picasso. When talking of his artistic development he traditionally emphasised the role of the old masters and primitive arts, and it was only late in life that he admitted that Picasso, Miró, Giacometti, André Masson and Arp were all influences on his art at this point.

Moore was affected, as others were, by the adverse economic and political conditions of the time. The art historian Meyer Schapiro argued in 1937 that during 'the present crisis' (he meant both the economic depression and the rise of fascism) the 'mechanical abstract styles', which he linked to the optimistic rationalism of the post-war period, had given way to 'biomorphic abstraction', which he associated with 'a violent or nervous calligraphy, or with amoeboid forms, a soft, low grade matter pulsing in an empty space. An anti-rationalist style, Surrealism ... becomes predominant and beside it arise new romantic styles, with pessimistic images of empty spaces, bones, grotesque beings, abandoned buildings and catastrophic earth formations'.[1]

If, at the beginning of the 1930s, not all the features Schapiro associates with Surrealism were evident in Moore's art, most of them certainly were by the time the article was published. Surrealism in England has been viewed institutionally, through exhibitions, especially the International Surrealist Exhibition in 1936, through membership of the Surrealist group in England, which was formed at the same time, and through supporting publications, in all of which Moore was involved. Because of this, Surrealism has often been regarded as having had only a late manifestation in England, while actually its influence seeped in gradually from around 1928–9 through artists' travel to Paris and familiarity with Surrealist-orientated journals. Several British artists (including Moore, Paul Nash and Edward Burra) incorporated early 1930s work alongside new art in the 1936 Surrealist exhibition, while the principle of metamorphosis that underpins Moore's sculpture and drawings in the early 1930s was central to Surrealism as a whole.[2]

It is possible, though, to distinguish earlier and later stages in Moore's Surrealist drawings. The metamorphic drawings of the early 1930s, though near abstract, nonetheless look outward onto the world in a positive way by associating the human figure with the rest of animate and inanimate nature. In contrast, the later phase starting in 1936 reflects Schapiro's world of 'empty spaces' and 'grotesque beings'. Towards the end of the decade, in the shadow of war, Moore created distorted skeletal figures, wrecked human beings barely distinguishable from defunct machines and closer to still life objects than real people. In contrast to the earlier drawings' pulling together elements of the natural world, these later ones look inward to the human psyche, offering up images of anxiety and insecurity.

From 1930 Moore drew less from the figure, and explored the wider natural world. Pebbles and flints, bones and shells move to centre stage: natural but inanimate forms which Moore manipulated on the page to create figures, personages, birds, and animals, as the boundary between animate and

inanimate was dismantled. Technical changes to drawing style were a consequence (the drawings were now mainly in pencil) with new cursive lines making asymmetrical, rounded and enclosed forms. These are the formal principles associated with 'biomorphism' by Geoffrey Grigson and they were adopted by Schapiro in the remarks quoted above.[3]

Stones, Bones, Shells

In Moore's Notebook No.3, 1922–4, there is a page, *Studies of Sculpture in the British Museum* (plate 28), with – towards the bottom – the inscription 'fish / tail' and 'Bone / hole / bone / hole' attached to drawings that appear to have started as bones and then become animals or fetish objects through the addition of eyes and mouths. This seems to be where the principle of metamorphosis begins in Moore's drawings – notably in the penultimate row of sketches from the bottom, where eyes, a nose or a mouth have been added to bone forms to create the effect of a person or a dog – but it was only around 1930 that transformation itself became a focus of interest. For Moore a bone was always a pared down, skeletal object, the equivalent of a piece of carved stone except that the 'carving' was done by nature (plate 29). Similarly, an interest in stones can be traced back to a page from Notebook No.6 of 1926 (plate 15), which includes a sketch of two pebbles, one with holes through it and the inscriptions 'swelling' and 'retreat', and the other marked with 'remember pebbles on beach'. Other notes, like the previously quoted 'opposition of swellings and balance' and 'not symetry [sic]', show Moore's attraction to asymmetry in natural forms, both organic and inanimate, as well as the contrast of substance and void he liked in sculpture. Again it was only in 1930 that these ideas became focal points of interest.

Moore's parents left the family home town of Castleford in Yorkshire for Norfolk in 1922, and though Henry by then lived in London, he visited Norfolk regularly and, a few years later, the Suffolk coast around Sizewell. Talking to Arnold Haskell in 1932, Moore recalled that 'during visits to the Norfolk coast I began collecting flint pebbles',[4] and in 1968 he told David Sylvester that the date he started collecting pebbles, shells and bones was about 1928–9.[5] In the summer of 1930, on holiday at Happisburgh with friends including Ben Nicholson, Barbara Hepworth and Ivon Hitchens, Moore started carving directly out of ironstone pebbles he picked up on the beach.

For the next three years Moore explored in drawings of flints (plate 30), bones (plate 31), and crustaceans' shells (plate 32) – found objects from the natural world, objects he kept permanently in his studios. He was interested in change, in the way a bone form, for example, could be manipulated with a few simple pencil lines to make it into, say, a reclining

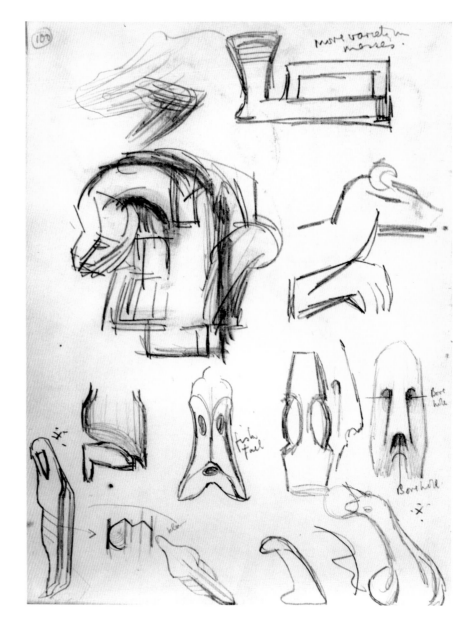

28 *Studies of Sculpture in the British Museum*, 1922–4. HMF 120 verso. Pencil, 22.5 x 17.3 cm (8⅞ x 6⅞ in). Henry Moore Foundation

29 *Study of Bones*, 1932. HMF 936. Pen and ink, 27.3 x 18.1 cm (10¾ x 7⅛ in). Private Collection

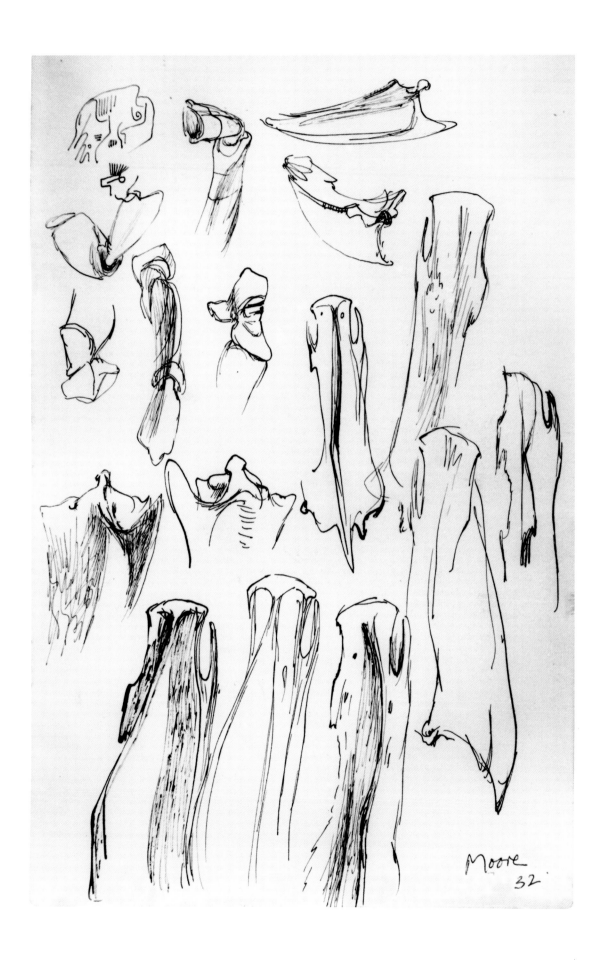

31 Bones in Henry Moore's Studio.
Date unknown.

32 Crustacean shells in Henry Moore's
Studio. Date unknown.

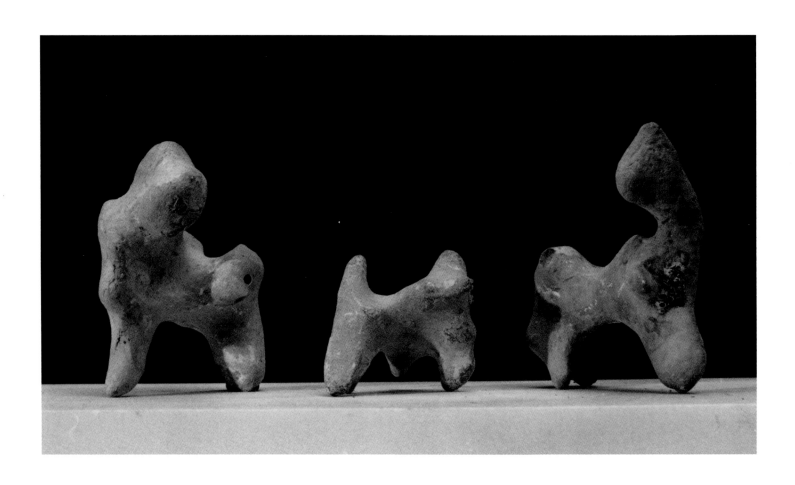

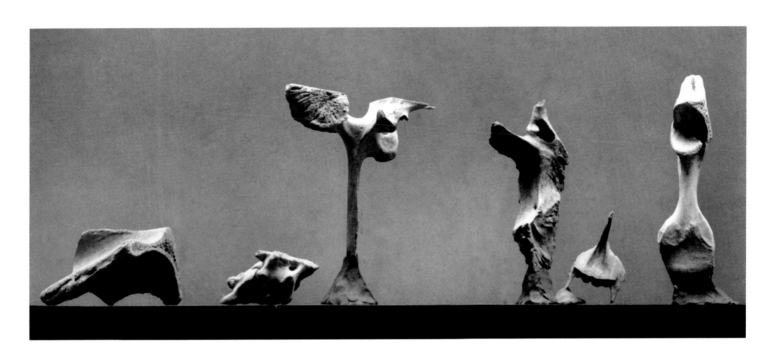

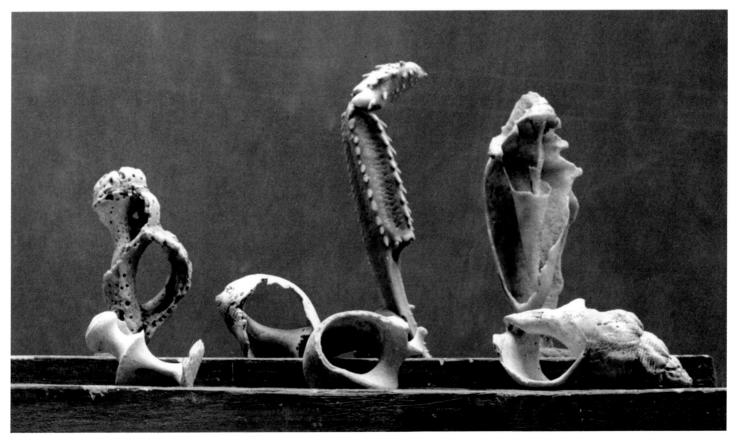

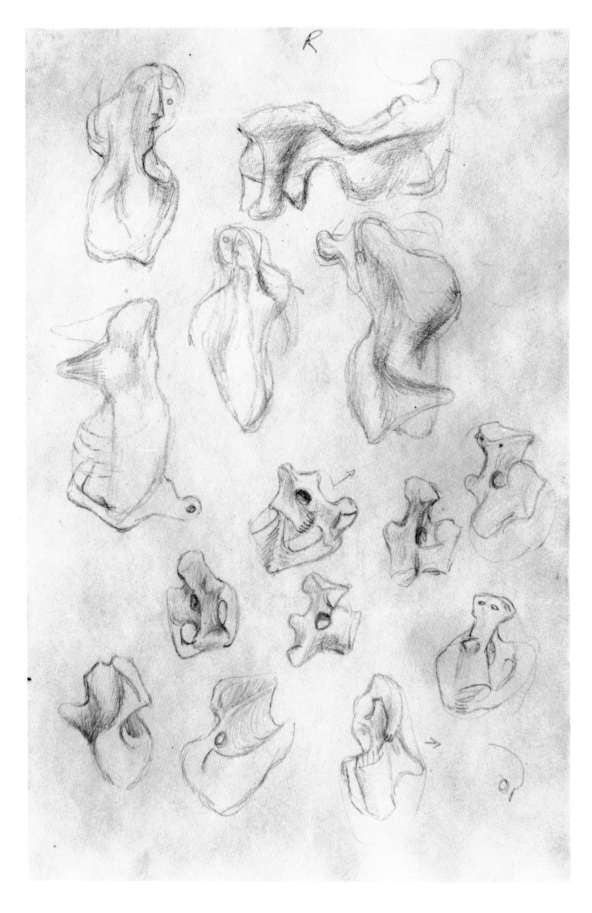

33 *Bone Forms: Reclining Figures,*
*c.*1930. HMF 793 verso.
Pencil, 27.3 x 18 cm (10 ¾ x 7 ⅛ in).
Henry Moore Foundation

34 *Ideas for Sculpture*, 1930.
HMF 808. Pencil, brush and ink,
20 x 23.8 cm (7 ⅞ x 8 ⅜ in).
Art Gallery of Ontario, Toronto

35 *Composition*, 1932. LH 128.
Dark African wood,
36.6 cm (14 ⅜ in) high.
Private Collection, formerly Jacob
Epstein, Kenneth Clark

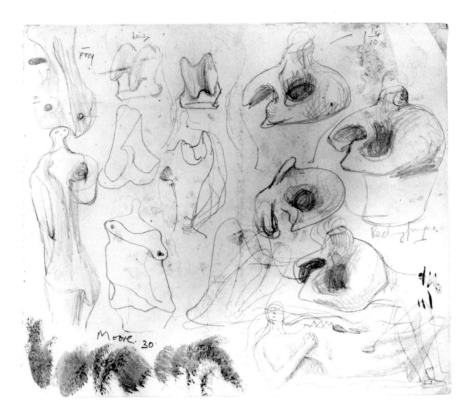

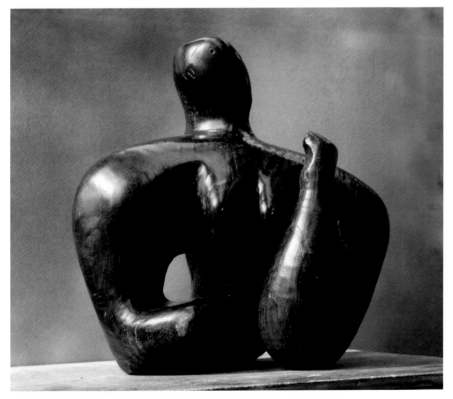

figure. He was curious about visual likeness between different natural things, whether animate or inanimate. *Bone Forms: Reclining Figures*, c.1930 (plate 33), shows Moore's starting point, with bone shapes that become human forms with the addition of heads and eyes, or just eyes alone. Different parts of a bone are extended, so that a flint form – in the middle left – can end up as a reclining figure if turned through 90 degrees, while in other sketches flint and figure share the same orientation. A flint can also become a head and shoulders, or, at the top, a nude seen from the back with the head facing in two directions. The purpose was not to find natural objects that were figures already but to develop shapes that were suggestive of life. 'Of course one does not just copy the form of a bone, say, into stone, but applies the principles of construction, variety, transition of one form into another, to some other subject – with me nearly always the human form, for that is what interests me, so giving, as the image and metaphor do in poetry, a new significance to each.'[6] *Ideas for Sculpture*, 1930 (plate 34), shows a standing figure on the left apparently formed with the addition of a head from the sternum bone of a bird or small animal. To the immediate right is a flint with one face of the stone as a woman's chest with breasts at the extremities and a head added, while on the far right are studies from a pebble with a hole that leads to the head and chest of the figure in *Composition*, 1932 (plate 35). A sketch towards the bottom right shows Moore adding lines to its right side suggesting it could equally have led to a reclining figure facing downwards. Though small, these sketches are worked out in detail and conceived in three dimensions. Preference for sculpture in the round over relief sculpture was a reason for Moore's preoccupation with holes and cavities in stone or bone which, as in four of the sketches here, could be translated into shapes between and under the arms.

In *Ideas for Sculpture: Transformation of Bones*, 1932 (plate 36), a jawbone became the starting point for reclining figures and other apparently cloaked figures at the bottom of the page which appear to be holding something, possibly a child. Seeing the way these drawings relate to sculptures confirms Moore's fundamental interest in the human figure, or, at least, animate life in the form of birds and animals. *Torso Figures* (plate 37), shows how what seems to have started as a molar tooth becomes, at the left, a three-legged personage with breasts and, on the right, a three-legged bird or animal with buttocks and a mouth that doubles as breasts. Moore tried a number of ideas from the original tooth shape, which, after simplification and turning on its side, came to resemble the tiny alabaster sculpture *Suckling Child*, 1930 (plate 38). There is not always a straight line of development from drawing to sculpture. *Suckling Child* relates to *Ideas for Composition in Green Hornton Stone*, c.1930–31 (plate 39), and in both drawing

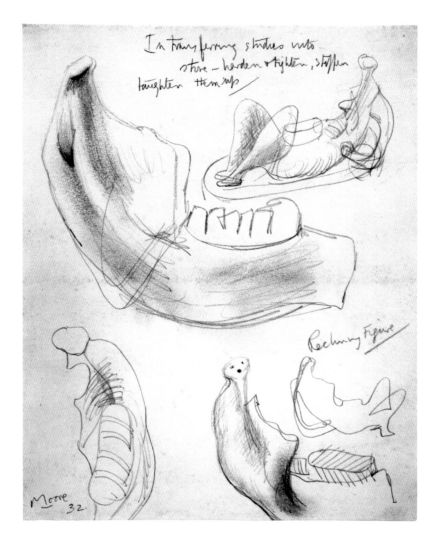

In transferring studies into
stone – harden & tighten, stiffen
taughten them up

Reclining Figure

Moore 32.

36 *Ideas for Sculpture, Transformation of Bones*, 1932. HMF 941. Pencil, part rubbed and wetted, 23.6 x 19.5 cm (9¼ x 7⅝ in). Henry Moore Foundation

37 *Torso Figures*, c.1930–31. HMF 829. Pencil, 16.2 x 20.1 cm (6⅜ x 7⅞ in). Henry Moore Foundation

38 *Suckling Child*, 1930. LH 96.
Alabaster, 18.6 cm (7⅜ in) high.
Pallant House Gallery, Chichester

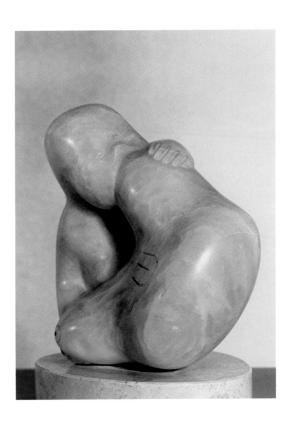

and sculpture what the child is suckling appears now to be a stone rather than a breast form derived from a tooth.

It is possible that Moore was looking back to a much earlier drawing from Notebook No.2 of 1921–2, titled on the page *Crocodile or lizard climbing over / rock* (plate 40) and presumably drawn in the British Museum or from a book: a further example of Moore reviewing earlier drawings with a clearer sense now of how they could be developed. The image on the right of plate 39 seems to show the child, now beaked and predatory, transformed into what may be a bird seated on a nest, the nest being the form that started as a tooth, but that had been amplified in the intervening time with breasts. There is also a hint that Moore intended the ensemble on the right of plate 39 to be a standing form with two legs. This sketch has next to it Moore's mark ※, an early manifestation of the sign he used to indicate a drawing he wanted to convert to sculpture. The sculpture is *Composition*, 1931 (plate 41), which retains evidence of the bird / baby form at the top, the tooth / nest / breasts form in the middle, and vestiges of the legs below. As sculpture in three dimensions, *Composition* has a character of its own – separate from any of the drawings and given emphasis by the smoothness of the stone

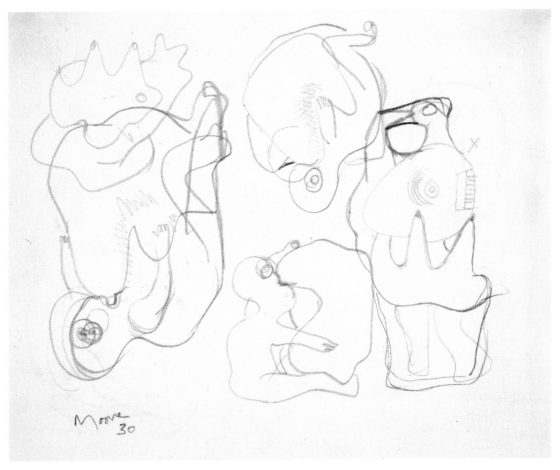

39 *Ideas for Composition in Green Hornton Stone*, c.1930–31. HMF 832.
Pencil, 16.2 x 20.1 cm 9⅜ x 7⅞ in).
Henry Moore Foundation

40 *Studies for Sculpture* (detail),
1921–2. HMF 66. Pencil, 22.5 x 17.5 cm
(8⅞ x 6⅞ in) (full page).
Henry Moore Foundation

41 *Composition*, 1931. LH 99. Green
Hornton stone, 475 mm (18¾ in) high.
Henry Moore Family Collection

surface and the comfortable fit of the various elements – which conveys unity and a feeling of resolution that the drawings do not have.

These comments on Moore's drawings at the beginning of the 1930s are different in kind from previous discussions, because it has become necessary to look at the sketches as sequences and not, like the single human figures of 1929–30, as complete in themselves. The earlier figures can be called classical or humanist because the human being is central. The new drawings are uncentred in the sense that one thing is in constant process of becoming another, there are no ideal forms as ultimate objectives; change is not incidental but a principle.

A Fantasia of Forms

Writing in 1948, David Sylvester distinguished between the 1920s drawings, in which Moore used distortion to give a figure 'fuller plastic realisation', and the new drawings of the 1930s, which he described as Surrealist because what they demonstrated was not distortion but invention:

Moore *improvises* to create a fantasia of forms whose themes are fragments of nature, his hand dances on the page under the inspiration and control of a remembered knowledge of natural forms. Since those forms include not only those of the human figure, but also bones, pebbles and shells ... and since different parts of the body resemble one another while bones, pebbles and shells also can look like human organs, a shape on the page often telescopes into a single image a number of more or less similar objects of which it is a common factor. Such metamorphic images evoke in quick succession, or even concurrently, a series of things which in nature are unconnected but vaguely alike. Thus an orifice suggests a mouth, a navel, a hollow or a hole in a pebble; a pair of rings suggests eyes and nipples; a bulge suggests a breast, a bent elbow a mountain. The figure as a whole is *personnage*, monster of the moon and lone boulder or bone.'[7]

Sylvester identified the shift in Moore's work from distortion to invention, his starting not from 'the realisation of an observed object or preconceived invention but an exploration of the unconscious which arrived at the image'.[8] Sylvester may have underestimated the empirical nature of Moore's drawing, which remains despite his play with transformation, but rightly identified the poetry of Moore's associations across the natural world, and the element in it of automatism involved in the 'exploration of the unconscious'.[9]

Looking back on this period in a later interview, Sylvester asked Moore: 'May I get this idea straight about drawing as a means of generating ideas? How much automatism was there?

Was it when the pencil was on the paper that things began to happen? Or were you actually carrying out things you visualised in your head before you drew them?' Moore replied that it was both. Moore, starting from the actual things in front of him, but discovering Surrealism, then started letting the pencil take its course. 'Sometimes', he told Sylvester, 'you would sit down with no idea at all and at some point you'd see something in the doodling, scribbling.'[10] This basically confirms what Moore had told James Johnson Sweeney at the time of his New York retrospective in 1946: 'I sometimes begin a drawing with no preconceived problem to solve, with only the desire to use pencil on paper, and make lines, tones and shapes with no conscious aim; but as my mind takes in what is so produced, a point arrives where some idea becomes conscious and crystallises, and then a control and ordering begins to take place.'[11] Moore's preference for drawing quickly gave him a natural entrée to automatism, though he exercised this cautiously even now. His figure drawings at the end of the 1920s had been monumental and detached and though these new drawings are clearly very different, automatism – in the terms in which the Surrealists practised it – was intended to bypass the intervention of consciousness, as a way of avoiding subjectivity. Automatism, for Moore, was spontaneous rather than unconscious.

Sylvester took the argument a stage further in 1949. Returning to metamorphosis he argued that 'it is not in spite of but *because* of the ambiguity of his forms that he communicates ... definite feelings: *the ambiguity is itself the means of communication*'.[12] Change, he was saying, was the principle as well as the process or means of connection between one thing and another. He also argued that change did not point in only one direction.

Moore tells us that in stones on some forgotten shore is the seed of the form of man; that the human and the monstrous and the inanimate are all manifestations of the same life-principle; that if no woman had ever lived, the curve of a woman's breast would have been moulded in pebbles by the sea; that man will petrify and stones arise in a slow process of awakening; that man is both offspring and ancestor of the earth

...

It is a conception of existence as a perpetual slow transmutation of animate into inanimate and back again. From stone or bone man emerges and to stone or bone he returns.[13]

Sylvester assembles a range of ideas underpinning Moore's art at this point: the present and remote past, the origins of life, death and a return to beginnings.

Psychological Drives

In *Unit One*, the book edited by Herbert Read for the exhibition of avant-garde British art at the Mayor Gallery in April 1934, Moore wrote: 'The human figure is what interests me most deeply, but I have found principles of form and rhythm from the study of natural objects, such as pebbles, rocks, bones, trees, plants etc.' Moore's concern was formal: 'The observation of nature is part of an artist's life, it enlarges his form knowledge, keeps him fresh and from working only by formula and feeds inspiration.' But that was not all: 'To me of equal importance is the psychological, human element.'[14]

'Psychological' was not a word commonly used by Moore, and was probably an outcome of his closeness to Read. While editing *Unit One*, Read was also writing a monograph on Moore, in which he discussed the psychological drives behind the creation of art through the ideas of the German aesthetician Wilhelm Worringer, and particularly at this point how art would respond to 'our outer world, in its state of political, economic and spiritual chaos', as he had put it in his book *Art Now* in the summer of 1933.[15] Worringer argued that there were essential psychological differences between southern and northern Europe in their approaches to the outside world, with southern European art tending towards naturalism and northern Europe resisting sensuousness and espousing an approach to nature in which vitality was sublimated in more abstract form.[16] Writing in *Unit One*, Moore repeated his 1930 statement dismissing the naturalism of the classical tradition, saying that, 'for me a work must first have a vitality of its own. I do not mean a reflection of the vitality of life ... but that a work can have in it a pent-up energy, an intense life of its own, independent of the object it may represent'.[17] When Moore added the phrase 'psychological, human element' to his way of treating natural forms, he was saying that art consists of two things: the natural world out there and the way an artist, working within a specific regional tradition, would be likely to approach it.

Read had been pressing for a decade or more the north-south distinction Worringer proposed. It was particularly relevant now because Worringer's sense that in northern Europe, where climate was less amenable than in the south, the vitality of nature was sublimated in art in more abstract forms. Moore was not at any time a non-figurative artist, but he did stress the need for both abstract and Surrealist elements in current work (both his own and others') and his concern for a balance between the two conformed to Worringer's and Read's notion of the north European. Moore also stressed the need for 'vitality'. Vitality was a reason he gave for his admiration for primitive art. It was not the vitality of the subject that mattered – a figure in movement, for example – but the way it was expressed which 'must first

have a vitality of its own'. Moore had felt this of his figure compositions in the 1920s when he advocated formal organisation as the source of a drawing's strength rather than a simple copying of the model. But now that humanity represented just one element of the natural world in his work, he needed a fresh approach to it that sought to define energies rather than appearances.

Biomorphism

When the term 'biomorphism' was introduced to the language of art by Grigson in 1935, it was intended as a description of techniques and subjects.[18] Applied to drawing, it implied cursive lines creating enclosed or semi-enclosed forms. In terms of subject, it suggested natural origins in the broadest sense, to include plant forms, primitive biological organisms, and shapes found under the microscope. The word 'biomorphism' relates to concepts of change within life forms; its early application to art, especially in Grigson's writings, relates it to origins, pre-history and the primitive.

In a contribution to the art journal *Axis* in January 1935, Grigson singled out Moore (alongside Wyndham Lewis) as able to steer a way between the 'unconscious nihilists of extreme objective abstraction' and the new Pre-Raphaelites of *Minotaure* (referring to Salvador Dali and others reproduced in the new Surrealist-leaning periodical in Paris).[19] Grigson's approach was shaped by the anthropologist Wilhelm Wundt's study of a central Brazilian tribe, the Bakairi, who made simple abstract designs on wood affective through symmetry and rhythm and then incorporated into these designs the memory images of objects like snakes and swarms of bees. In these patterns, in which abstraction was animated by residual natural forms, Wundt found the origins of art. Grigson agreed, claiming that 'abstract art at this time needs ... to be bodied out in such a way; to be penetrated and possessed by a more varied, affective and intellective content. Only so can it answer to the ideological and emotional complexity of the needs of human beings with their enlarged knowledge of the widened country of self'.[20]

The 'widened country of self' was seen as a partnership between man and environment: 'In art we are in a sense playing at being what we designate as matter. We are entering the forms of the mighty phenomena around us and seeing how near we can get to being a river or a star without actually becoming that ... Or we are placing ourselves somewhere behind the contradiction of matter and mind, where an identity ... may more primitively exist.'[21] Grigson regarded Moore as 'the one English sculptor of large imaginative power'[22] because he saw in him this new kind of artist looking both inwards into the self and outwards onto the cosmos, and finding links between the two. The stone or the bone

which is also a woman or mother and child forms linkages not just between the human world and another world normally regarded as inanimate, but has temporal meaning also: Moore's work at this point is about self and origins. Jennifer Mundy has spoken of the 'attribution to biomorphist art of the connotation of a primitivist return to origins reflecting the impact on avant-garde art of a modern interest in prehistoric and primitive art. Man's relationship to states of beginning, to nature, to his own psyche – all came to help define biomorphic art'.[23] In the 1920s 'primitive' for Moore had meant non-European – African, Oceanic, pre-Columbian – and though this had not changed, the word was gaining a wider reach in his mind: it increasingly meant prehistoric – European or non-European – and it had implications of the primal or of beginnings, including the early stages of an artistic cycle, the clearest example being Italian art from Giotto to Masaccio. Moore is concerned with different kinds of beginnings and their links with the present which, like many Surrealists, he saw as a time of fragmentation and dispersal that needed to be subjected to a process of healing and reintegration.

Instead of the monumental figures of the late 1920s, Moore's drawings now are, in one sense, fragile because life is seen in a process of emerging tentatively from the inanimate. But, in a different sense, they are strong, because the stones and bones from which life emerges anchor it to the durability and longevity of the natural world.

Revising his comments for an essay in *The Arts Today* published the same year, Grigson associated Moore with Miró. 'Like Miró, but more thickly and strongly, without a witty, gay, almost entertaining graciousness, he is exploring and opening up a world so unfamiliar that one is almost deceived into calling it a new world, of new "real" ideality; certainly it is a world into which many others will trek.'[24] Grigson chose his words carefully, recognising that the surface ease of Miró's paintings and drawings was different from Moore's obvious gravity in the face of nature; but in the association of 'real' and 'ideality' he saw how Moore could manoeuvre himself between the concrete world of nature's particulars and a transcendent nature linking man and the stars in a concept of universality. As a critic and anthologist of English poetry, Grigson valued modest reputations – like John Clare's – where he perceived authentic vision and diction as well as manifestly larger ones. In valuing Moore's 'big sense of the wonder and mystery of universal life', he nevertheless drew back from allowing that 'Moore's pantheism is a motive as exalted as the vision of life in Raphael's *School of Athens* or Michelangelo's ... sonnets. Moore's pantheism is not Goethe's or Wordsworth's'.[25] It is a judgement to take notice of, because it defines Moore's imagination without moulding him into a major representative of late Romanticism.

From the beginning Moore had expressed interest in the wellsprings of life through the subjects of the mother and child and the earth mothers of his reclining figures. These interests never diminished, but in the early 1930s Moore had additional priorities stemming partly from discoveries in the study of life forms. The position of sculpture in relation to biology was noted by John Grierson in an article of November 1930 on new British sculpture, in which he noted of Moore and others a

quickened consciousness of organic life which I am apt to think is a special stock-in-trade of a new generation. It may be that the cinema has done something to open our eyes in this respect, with its power of revealing the constructions of plant life, animal life, and all life together in motion. It would be still more accurate to say that biology is getting into our blood. Certainly we become more conscious of the sculptural relations between the different worlds.[26]

In his contribution to *Unit One* in 1934, Moore noted the importance of the microscope and telescope in informing us about the world and later, in 1943, it was Grigson who wrote retrospectively of Moore at this period that 'our age of discovery and study of single-celled organisms has been followed by a search after the units, the source, the primitive form of expression'.[27]

The change in perceptions of biology which underpinned Grierson's observations was a shift from a mechanistic to an energy-based concept of life. J. B. S. Haldane's attempt in *The Philosophical Basis of Biology*, 1931, to explain modern biology in terms that could be popularly understood underpinned the kind of argument Grierson was making. Haldane argued that living matter had no meaning apart from its environment. The terms 'environment' and 'interdependence' are keywords for Haldane: living matter could not be explained in terms of physics and chemistry alone because of its dependence on what each element of an organism absorbed from its surroundings. Nor did Haldane credit the traditional notion of vitalism, which attributed an inherent energy or life force to an organism – because that attributed singularity, as opposed to interdependence – to each organism. 'Life' for Haldane was defined through the relations of parts of an organism to one and another and of the whole to the environment. He argued, further, 'specific identities in relationships of parts are fundamentally the same in many different species of organisms, so that the latter form naturally related genera or families'.[28]

Moore may or may not have been aware of Haldane's book, which in any case was only one – albeit the leading – example of the new interconnective biology. The new biology, in relation to more traditional concepts of life, like mecha-

nism and vitalism, was much discussed, including in the BBC's journal the *Listener*, which was widely read and to which Moore's friends Herbert Read and Paul Nash were both at this point contributors. The reason the new biology is important for Moore is that it mirrors his own shift in 1930 away from preoccupation with the human figure apart from its environment to a new interest in commonality behind different manifestations of life, and the idea of a stone or a bone form taking on human identity. The relationship between biology and sculpture is strictly a parallel one and there is no need to think of Moore working within narrowly scientific terms, or underwriting his work with a resolved concept of universality in nature. Grigson rightly recognised that Moore was no Goethe. Moore's observations were empirical in origin but his drawings at this point also follow the example of Haldane and other scientists who stressed relatedness between all life forms.

There is another significant line of thought stemming from Haldane that seems important here. Because the new biology stressed that change was the result of interaction between organisms and environment over time, heredity and evolution were important, gradualism was stressed and Haldane was reluctant to define a specific point at which life emerged from pre-life. Implied, at least, is the notion that animate and inanimate are hard, or even impossible, to distinguish and, at the very least, the distinction cannot be pinpointed in time. As soon as the sequence of organisms' development in time is the subject of study, the evidence of palaeontology (briefly mentioned by Haldane) – the world Moore had been studying through visits to the Natural History Museum – becomes important. In the 1920s, Moore's concept of the primitive related largely to African artefacts in the British Museum. In the 1930s it was attached as much, or more so, to the visual relics of pre-history and the origins of life.

The principles of inter-relatedness and change typical of the new biology also had social references which, in the context of the economic depression and the growth of socialist ideologies, elevated ideas of community against individualism. An art representing the heroic, reflected in the single human figure, was increasingly untenable, and if the figure was to remain central to art – as Moore fervently believed it should – it could no longer be seen in classical humanist form. Its expression should be, firstly, as Moore presented it in the early 1930s, in terms of other aspects of life, and secondly, as inward-looking and stripped to the core in the process of self-examination, as Moore's figures in the later 1930s were to be.

The Origins of Art

Geoffrey Grigson's reading of Wilhelm Wundt, leading to his conviction that the renewal of art involved reconsideration of origins, was important in helping reframe Moore's art. Pre-

historic cave paintings were relatively recent discoveries, which entered the literature of British art through the 'Gaudier-Brzeska Vortex', the sculptor's manifesto in the first issue of *Blast*, June 1914.[29] Gaudier had identified peak moments in the history of sculpture according to his own values: the Palaeolithic Vortex was one. Moore knew Gaudier's manifesto and already admired it for its emphasis on sculpture as mass and the vortex as symbol of energy. Like Gaudier, Moore did not mind whether he found these values in sculpture or painting. Cave painting represented the direct experience of life he admired in the primitive in general.

When Moore's drawing teacher Leon Underwood visited the cave of Altamira in Spain in 1925, he had met Professor Hugo Obermaier of Madrid University, a leading expert on Spanish pre-history, and had relayed his excitement to Moore and his college friend Raymond Coxon. In 1934 Moore, with Coxon and their wives, visited Altamira as well as the caves of Les Eyzies and Font-de-Gaume in southwest France. It was not unusual then to think, as Moore did, of the primitive as broadly inclusive, so that it incorporated what was primal in the sense of early in time – like prehistoric art – alongside works made early in artistic cycles, like Giotto's, as well as those remaining in a supposedly early state compared with European art, like African artefacts.

Moore's involvement with primitive art in the 1920s had been through sketching in the British Museum and copying plates in books. The earliest evidence of his interest in the palaeolithic are copies of the *Venus of Grimaldi*, 1926 (see plate 25), one of the best known figurative fertility images of pre-history. But around 1930 Moore's drawings reflect a new kind of interest in prehistoric artefacts: he appears to have looked at books on prehistoric art with plates showing such items as flint tools, necklace beads made from bone (plate 42) or teeth presented as human statuettes (plate 43). These plates are taken from *The Art and Religion of Fossil Man* by the French psychologist and pre-historian, G. H. Luquet, published in English in 1930. Luquet's particular interest was to distinguish early man's fashioning of tools for practical needs from an interest in art made for its own sake and adopted principally as a form of adornment. Luquet showed that in early times men drilled holes in pebbles, antlers and mammoths' teeth. If the objective was functional, it could have been, he suggested, to attach stones to fishing nets to weigh them down, and if for non-functional, decorative purposes, it could have been for necklaces.

Among Moore's transformation drawings, it is common to find sketches like *Ideas for Sculpture*, 1932 (plate 44), in which circles or points are added to the upper sections of forms – the area where early man made holes in teeth – to allude to eyes or breasts. *Ideas for Sculpture* is suggestive, not of Moore

42 Prehistoric Carved Teeth and Bone, from G. H. Luquet, *Art and Religion of Fossil Man*, 1930.

43 Prehistoric Human Statuettes Carved from Mammoths' Teeth, from G. H. Luquet, *Art and Religion of Fossil Man*, 1930.

44 *Ideas for Sculpture*, 1932. HMF 980. Pen and ink, 37.5 x 27.3 cm (14¾ x 10¾ in). Private Collection

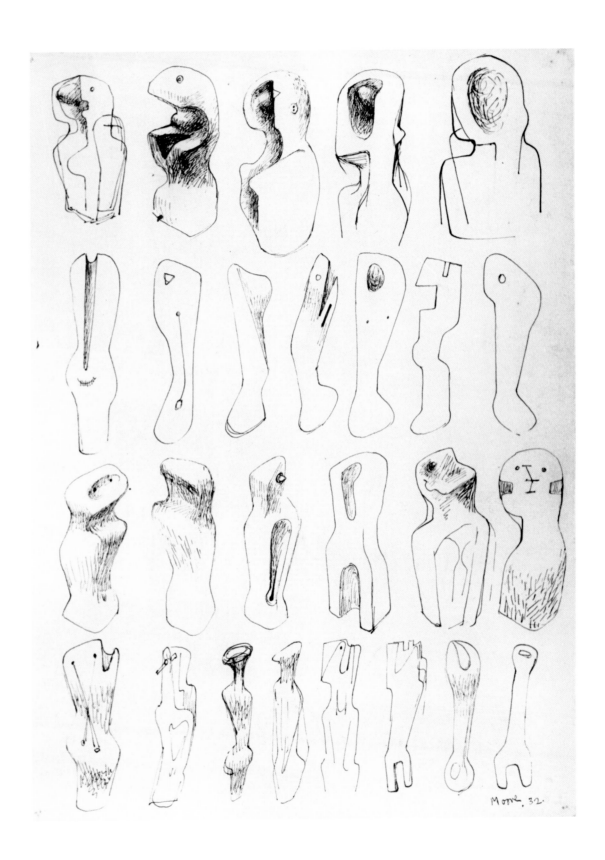

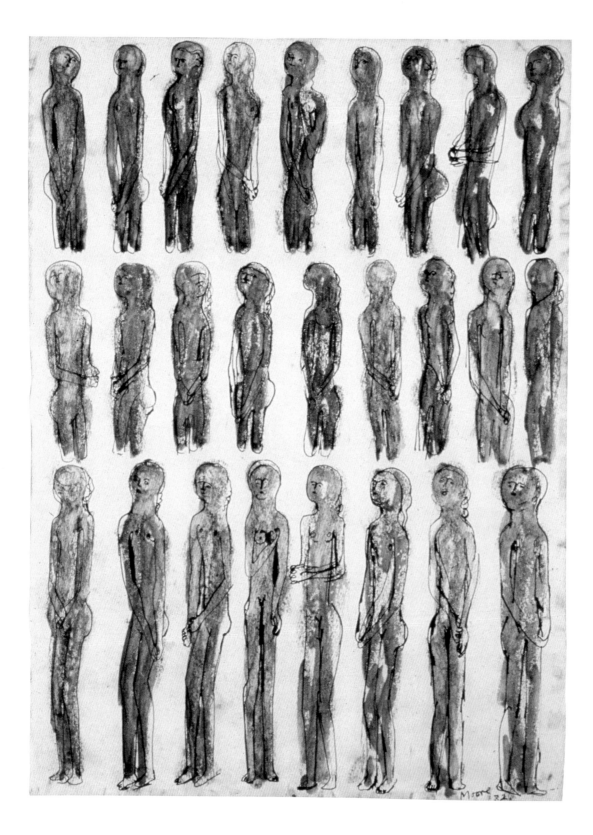

45 *Ideas for Boxwood Carving*, 1932.
HMF 922c. Pen and ink, wash,
38.7 x 29.2 cm (15¼ x 11½ in).
Hunt Museum, Limerick

46 *Girl*, 1932. LH 112. Boxwood,
348 mm (13¾ in) high.
Dallas Museum of Art, Foundation
for the Arts Collection, gift of Cecile
and I. A. Victor

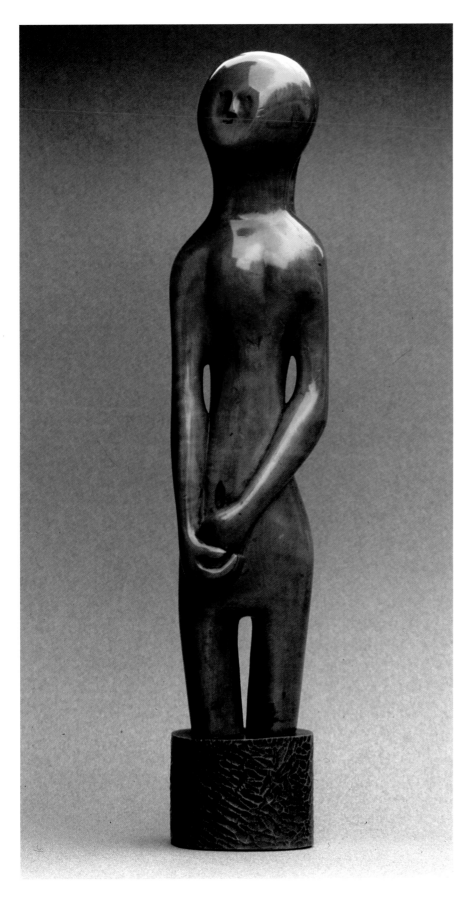

copying plates from books, but of using similar forms and organising them in orderly fashion across the page as they would appear in an anthropological book. There is a particular kind of shading, rare in Moore's work before this, but seen here in the right end figure in row three, that is characteristic of anthropological illustration. In drawings like this, Moore was preoccupied with converting shapes, some of which could have started as primitive tools, into human likenesses. In his chapter 'The Origins of Art', Luquet suggested that early man recognised resemblances to human form in mammoths' teeth (plate 43) without their being worked on at all,[30] while he suggested that early man may have done exactly what Moore himself did, trawl the beach for bits and pieces he fancied.[31] Luquet contributed to a current debate on what he called the 'game of nature', which was again remarkably like a new practice of Moore, describing early man's observation that certain pebbles, notably flints, could be read as 'figure stones', because they bore 'an approximate resemblance to actual beings and this natural likeness would be accentuated by retouches which seem ... [to most pre-historians] intentional'.[32] Even if he never used the term, 'figure stones' are plainly part of Moore's thinking and, if he arrived at his own discoveries in part via pre-history, the work of Luquet and other pre-historians would indicate an additional point of origin for the principle of metamorphosis in his work.

By the early 1930s arrangement of sketches on the page was often more formalised than before. *Ideas for Boxwood Carving*, 1932 (plate 45), is one of five sheets of studies connected with the same sculpture, *Girl*, 1932 (plate 46). Though there are similar upright figure sculptures, *Half Figure*, 1931 (LH 108), and *Girl*, 1932 (LH 109), which some of the drawings could have fed into, it is difficult to see why Moore would have needed so many sketches to reach his objective. Moore's 'ideas for sculpture' were not necessarily *only* for sculpture. They could be for his own delight in drawing or, as here, a comment on the Enlightenment preoccupation with taxonomies. Eighteenth-century rationalism stands at the head of the kind of typological organisation seen in books like Luquet's and museum displays as well. But in art at this point the practice was not always treated rationally. Picasso's *An Anatomy*, 1932 (see plate 47), published in the first issue of *Minotaure* in 1933, is the best known example of an artist with a strong feeling for the irrational subverting the Enlightenment's delight in organisational correctness with eccentric bodies that prefigure Moore's most radically dehumanised forms of the late 1930s. Moore enjoyed developing images from books, but here took as a starting point less the actual images than the graphic design conventions through which they are presented and which came to influence the organisation of his own drawings on the page.

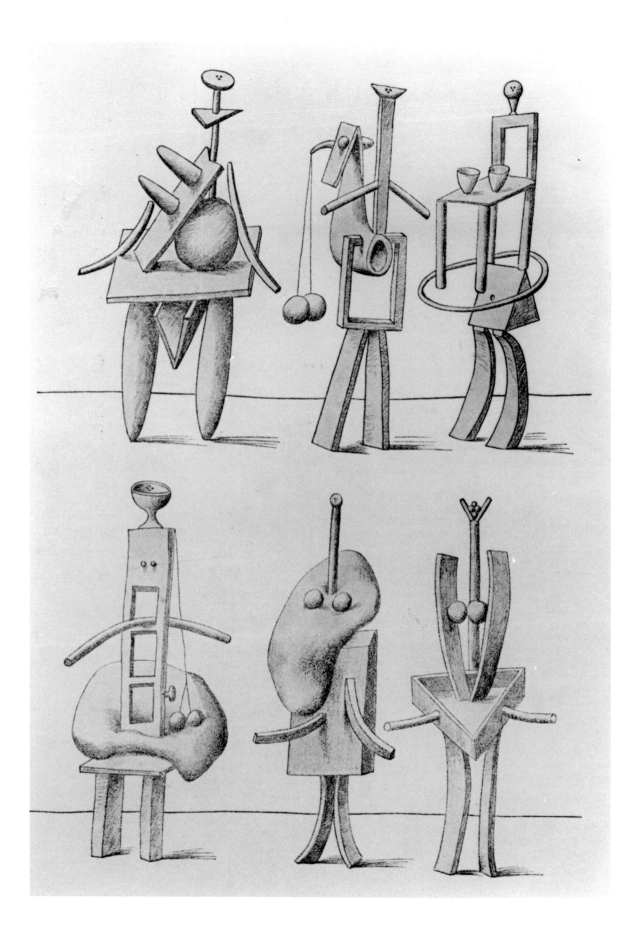

Metamorphosis: Precedents

It is clear that developments in Moore's art around 1930 were drawing him in the direction of the metamorphic principles that had been interesting Picasso and Surrealists for some years. The classic study of transformations of men and women to animals and inanimate objects is Ovid's *Metamorphoses*. Book One of the *Metamorphoses* parallels *Genesis*, with the story of the Flood followed by the renewal of life on earth, entrusted to Deucalion and Pyrrha, who are instructed by the goddess Themis to 'replant' the earth by picking up the bones of Mother Earth – in the form of stones – and throwing them over their shoulders, where they would become people.

> Those stones
> ... gave up their hardness;
> Their rigidness grew slowly soft and softened,
> Assumed a shape, and as they grew and felt
> A gentler nature's touch, a semblance seemed
> To appear, still indistinct, of human form.[33]

The *Metamorphoses* have been influential on the arts at different times from the Renaissance onwards, but they gained prominence in 1931 with the publication of a set of prints commissioned by Skira from Picasso. Though Picasso's draughtsmanship in that instance was unlike Moore's, and Picasso, indeed, did not illustrate the story of Deucalion and Pyrrha or the idea of stones becoming people, which is so essentially Moore's concern, Picasso's project points up the centrality at that moment of the principle of metamorphosis and the gods'

magical powers to transform men and beasts. The whole character of Moore's art depended on the broad sweep of his knowledge of contemporary and earlier arts. In this case, his five months in Italy in 1925 would have offered ample opportunity to become aware of earlier treatment of themes of metamorphosis: he could, for example, have seen Baldassare Peruzzi's fresco of *Deucalion and Pyrrha*, c.1516 (plate 48), in the Villa Farnesina in Rome, a direct representation of the transformation from stone to human. Among the Surrealist circle, the preoccupation with metamorphosis was widely shared among artists as different as Masson, Miró and Picasso. Christopher Green has pointed out that 'Miró was to base much on the realisation that a single shape inflected in slightly different ways could denote many different things',[34] and 'Just as Picasso could make the sign for a head or a harlequin become the sign for a guitar or a bottle with the slightest change of accent, so Miró could make the sign for an apple or a pear become the sign of a breast, a sun become a spider or the female sex.'[35]

As a general point relating to the Surrealists' attempt to reveal the marvellous by startling juxtapositions, this applies to Moore too: a stone or a bone can become a human figure. On a formal level too, Miró, like Picasso, was an actual influence on Moore's drawing style (see plate 49). But there are crucial differences. Green stresses that not only did Surrealism

bring together 'distant realities' in disorienting ways, but it brought together 'realities' that could not be called emotionally neutral: Masson's knives and pomegranates

and wounds, Miró's roots and genitalia or fruit and erogenous zones. As Masson said of the Cubists later: 'They rejected the representation not only of the dream, but of the instincts which are the roots of being: hunger, love and violence'.[36]

In this sense Moore was closer to Arp than either Masson or Miró, because he drew his analogies primarily from the natural world, as Arp did also from stones, bone forms and the human figure. Certainly at this point, in the early 1930s, Moore was not concerned with wounds, violence or erogenous zones. In that sense the Surrealist 'marvellous' was something he approached with caution. He had several reasons for this. Britain had had no Dada movement, and precedents for shock encounters did not exist. At the same time Britain had a unique tradition of artists' involvement with landscape and even the found object. Gainsborough had kept natural objects in his studio. Moore's collections of found objects (plates 30–32) focused on forms, like flints, that are found in landscape or relate to it in some other way. In so far as a distinction is possible at all between an empirical artist working from what is front of him and an imaginative one working out of his head, Moore at this point leans to the former. There is still here a Ruskinian side to Moore, a sense of deep respect in the face of the natural world even if it was no longer possible to regard it, in the way Ruskin did, as a God-given wonder.

Found Objects in Surrealism

Moore was not alone in collecting natural objects. He told the art historian Albert Elsen in 1967 that his interest in bones was stimulated by Picasso, possibly by the ink drawings Picasso had made at Dinard in 1928 (see plate 50).[37] As Elizabeth Cowling has pointed out, 'the works of art [Picasso collected] ... were far outnumbered by the quantities of pebbles, bones, skulls and skeletons he happened upon during rambles by the seashore, the industrial scrap he filched from dumps and back-streets, and all the bric-a-brac acquired by chance or choice or gift'.[38] Picasso told Brassaï in 1943 how strange it seemed to him that:

we ever arrived at the idea of making sculpture from marble ... It stands there as a block suggesting no form or image. It doesn't inspire ... If it occurred to man to create his own images, it's because he discovered them all around him, almost formed, already within his grasp. He saw them in a bone, in the irregular surfaces of cavern walls, in a piece of wood. One form might suggest a woman, another a bison, and still another the head of a demon.[39]

49 Joan Miró, *Painting*, 1925. Oil and gouache on canvas, 138 x 107.7 cm (54⅜ x 42⅜ in). National Galleries of Scotland, Edinburgh

50 Pablo Picasso, *Figure*, 28 July 1928. Ink, 38 x 31 cm (15 x 12¼ in). Marina Picasso Collection

51 *Reclining Figure*, 1933. HMF 984. Charcoal (washed), chalk, brush and ink, 27.7 x 37.8 cm (10⅞ x 14⅞ in). Henry Moore Family Collection

Picasso liked the same natural objects as Moore but used them differently. Moore's interest in bones was as material substances that were strong in tension even in their most pared down form (plate 29), while Picasso was less concerned with the difference between the skeletal bone and the fleshy outsides of things. John Golding has pointed to Picasso's *Metamorphosis* sculptures of 1928 as 'pulpy and tumescent' in appearance and having a 'spongy bulkiness' that 'looks forward, in particular, to developments in the work of Henry Moore'.[40] Golding is referring to Moore sculptures rather than drawings, and there is a small number of these that are near abstract 'soft' growth forms even if realised in hard stone (examples are two versions of *Composition*, 1932 and 1933,

LH 119 and 133). But they are exceptional for suggesting softness in hard material, an idea which runs contrary to Moore's general sense of the correct use of stone. This involved the idea of excavation, of removing soft material and getting to the bone. Moore liked hardness and this is often reflected in his drawings as well as sculptures (plate 29 is the clearest example). This may have had something to do with a puritanical resistance to sensuousness, but it was more likely a concern with the connection between hardness and primacy – getting back to what is originary and least destructible. Cowling points to Picasso's likely inspiration from Brittany's standing stones as his bone form drawings at Dinard were presented as designs for a monument,[41] as well as the interest

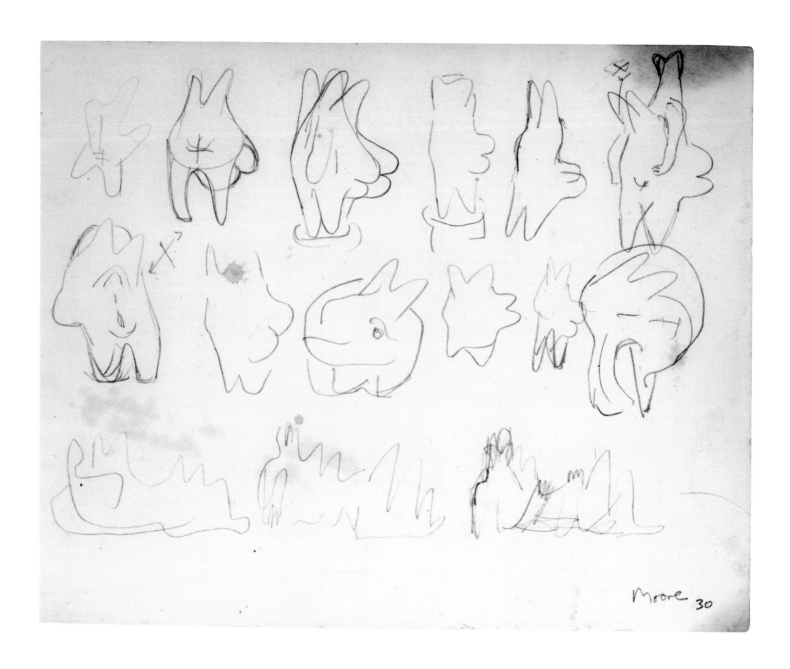

Moore 30

in skeletons which also reflect a fascination with the age old and the hard. Golding mentions how visitors to Picasso's chateau at Boisgeloup were welcomed by a rhinoceros skull and one is reminded of the treasure of Moore's late life: an elephant skull given by Julian Huxley and his wife (plate 129).[42]

Cowling has described Picasso's 1928 drawings at Dinard (plate 50) as 'standing figures assembled from propped together objects that recall flat and round pebbles, driftwood and scoured bones'.[43] They are edgy and unstable, while with Moore, however strange the shapes he draws, the work

(often, like *Reclining Figure*, 1933 (plate 51), turned through 90 degrees compared with Picasso's) does not have the same sense of likely collapse.

But the similarities are also clear. Moore drawings, as already discussed, displace parts of the body and change it virtually out of recognition. *Ideas for Sculpture: Reclining Figures*, 1930 (plate 52), resemble Easter Island hieroglyphs (plate 53) which, as John Golding has suggested, influenced Picasso's late 1920s paintings of cruelly distorted figures. Golding describes the hieroglyphs, which are signs for men,

52 *Ideas for Sculpture, Reclining Figures*, 1930. HMF 811.
Pencil, 23.7 x 29.7 cm (9 ⅜ x 11 ¾ in).
Henry Moore Foundation

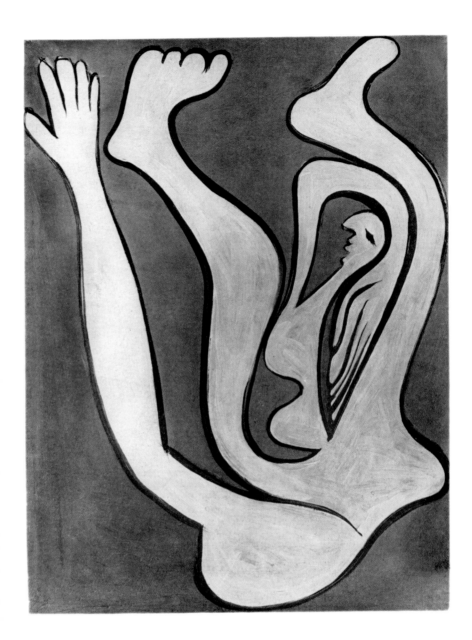

53 Easter Island Hieroglyphs Representing Men, from John Golding, 'Picasso and Surrealism', Paul Elek, London, 1973.

54 Pablo Picasso, *Acrobat*, 1930, oil on canvas, 16.2 x 13 cm (6 ⅜ x 5 ⅛ in). Musée Picasso, Paris

as having 'limbs [that] are stylised and distorted and virtually interchangeable'.[44] There is no doubt that Moore followed Picasso's progress stage by stage, and *Acrobat*, 1930 (plate 54), is reproduced here from Moore's own copy of the 1930 Picasso issue of *Documents* which still exist in Moore's library.[45] From 1930 Moore was discovering, as Miró and Masson had, that a shape could be a sign of anything, from a bone or a tooth to the head and shoulders of a person. Sylvester has already been quoted expressing this idea of metamorphosis in relation to Moore, while Grigson, interested in microscopy and the new biology, wrote that 'rounded shapes by Moore may be related to a breast or a pear, a bone, or a hill, or a pebble shaped among other pebbles on a shingle bar. But they might also relate to the curves of a human embryo, to an ovary, a sac, or to a single-celled human organism. Revealed by anatomy or seen with a microscope, such things are included now in our visual knowledge'.[46] These were two writers close to Moore who we can trust to be speaking for him as they make these analogies that indicate a new loosening up in his use of signs.

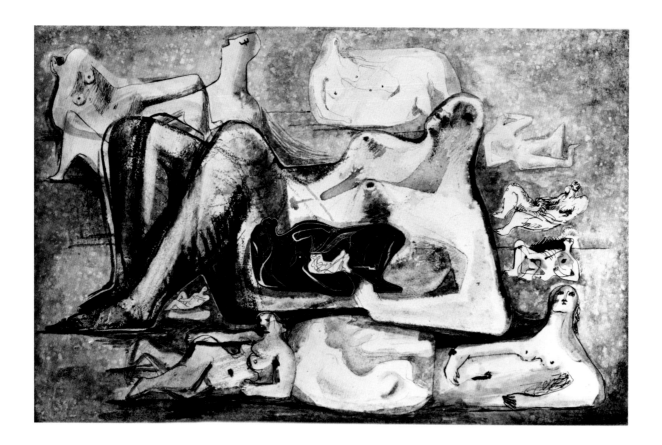

Around 1930 there was close agreement among a number of artists, including Moore, about the use of this kind of biomorphic image to allude to a range of natural features, including parts of the human body. John Russell said in 1968 that 'what we are talking about is not the deliberate appropriation by one artist of another's formal vocabulary: it is the universal presence of forms which belong to a particular moment in the history of art and force themselves upon artists whose conscious intentions have nothing in common'.[47] Others have spoken in the same vein: the French artist-critic Robert Lebel, writing in 1982 of Arp, Tanguy, Miró and Dalí, spoke of a common 'morphological current' as a phenomenon 'more to do with convergence than copying' which 'confirms the unconscious, automatic and collective character of this morphological range'.[48] This may be true, and convergence is a useful concept where ideas from widespread areas – from pre-history, found objects, and revised concepts of reality – bear upon artists in different countries. But there is a problem with adopting such a generalised concept as 'convergence' if, as a result, traditional 'influence' is downgraded. This is especially true of Moore as an English artist whose empirical nature had only started to shift under the influence of Surrealist poetics.

Collage

In 1933 Moore returned to the collage medium he had tried out briefly in 1928–9. Moore's collages are unusual in being re-arrangements of his own drawings, which have been cut out and juxtaposed, or partially superimposed on one another. In a single case he used his first print, a woodcut, as one element (plate 55). Most of the collages are of reclining figures, and not only did Moore never use material not made by him, but he used in collages almost exclusively a single motif – the reclining figure. Unlike most contemporary collages – Miró's, for instance – the medium is not used for contrast, indeed Moore's collages are not easily distinguished at first sight from other drawings that are not collages. It is difficult, therefore, to know exactly what he wanted from the medium. The surprise element he did share with other collage artists was change of scale, achieved in Moore's case through like images of varying size on the same sheet. By repeating on the same sheet forms that were individual but with clear mutual resemblance, he created what Robert Melville, in 1953, called a 'community of statuary'.[49] The collage of reclining figures known as *Montage of Reclining Figures*, 1928 (plate 56), contains at least seven figures (eight if one imagines the shape

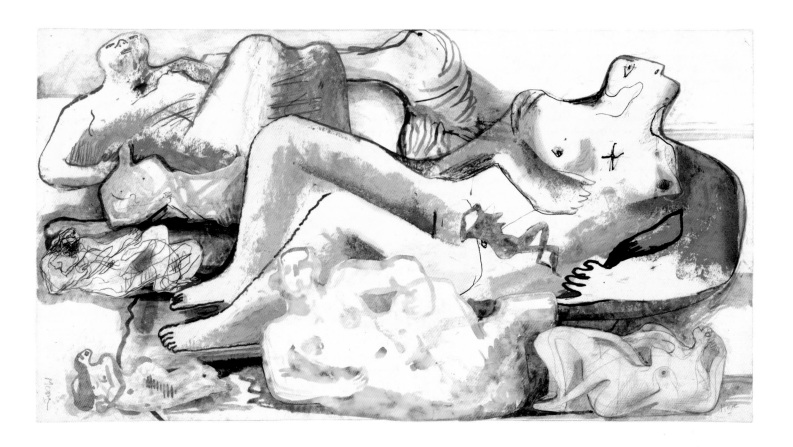

55 *Collage of Reclining Figures*, 1933.
HMF 999. Pen and ink, chalk, wash,
woodcut, collage, 36.5 x 59 cm
(14 ⅜ x 23 ¼ in). National Gallery of
Victoria, Melbourne

56 *Montage of Reclining Figures*, 1928.
HMF 689. Pencil, oil paint, watercolour,
brush and ink, chalk, 30.3 x 56.7 cm
(11 ⅞ x 22 ⅜ in).
Henry Moore Foundation

in the middle at the top as another), situated in diaphanous space and realised in delicate shades of pink and green. John Read has described it in tactile terms as feeling one's way across the spaces of the picture, thus drawing attention to an alternative reading as a hilly landscape.[50]

Moore had been making sculptures of the reclining figure from 1926, and a viewer's expectation of a sculpture by Moore in the late 1920s is of a single freestanding object: so the reasonable assumption would be that any drawn image seen on its own could be a drawing for sculpture. More than that, one would assume that sheets of related sketches, such as plate 26, would be for sculpture – as they were in that case, where the sketches were individual experiments, alternatives to one another. But the *Collage of Reclining Figures* (plate 56) is different, because the nudes there possess their own surrounding space and are in effect pictures *of* sculptures not drawings *for* sculptures.

Moore was constantly rethinking the potential of both sculpture and picture making, and the differences between them. The issue of the moment at the end of the 1920s was Surrealism. In general, traditional single-object sculpture did not offer itself easily to Surrealism, because such sculpture

occupied the same everyday space that people occupy, a fact which made it infertile ground for expression of the strange or marvellous. Surrealist-related sculpture tended to follow either the course taken by Giacometti from 1929 of creating multi-part sculptures which have an internal world of what is really pictorial space as well as an overall presence as an object. Alternatively, there was the direction followed by Picasso, which was to create rapid and continuous interchange between painting and drawing on the one hand and sculpture on the other. Moore did both. Briefly, in 1933–4, he turned, like Giacometti, to making multi-part sculptures, but he also, like Picasso around 1930, used painting to depict what are in effect sculptures that are made strange because they are presented as objects in pictorial space.

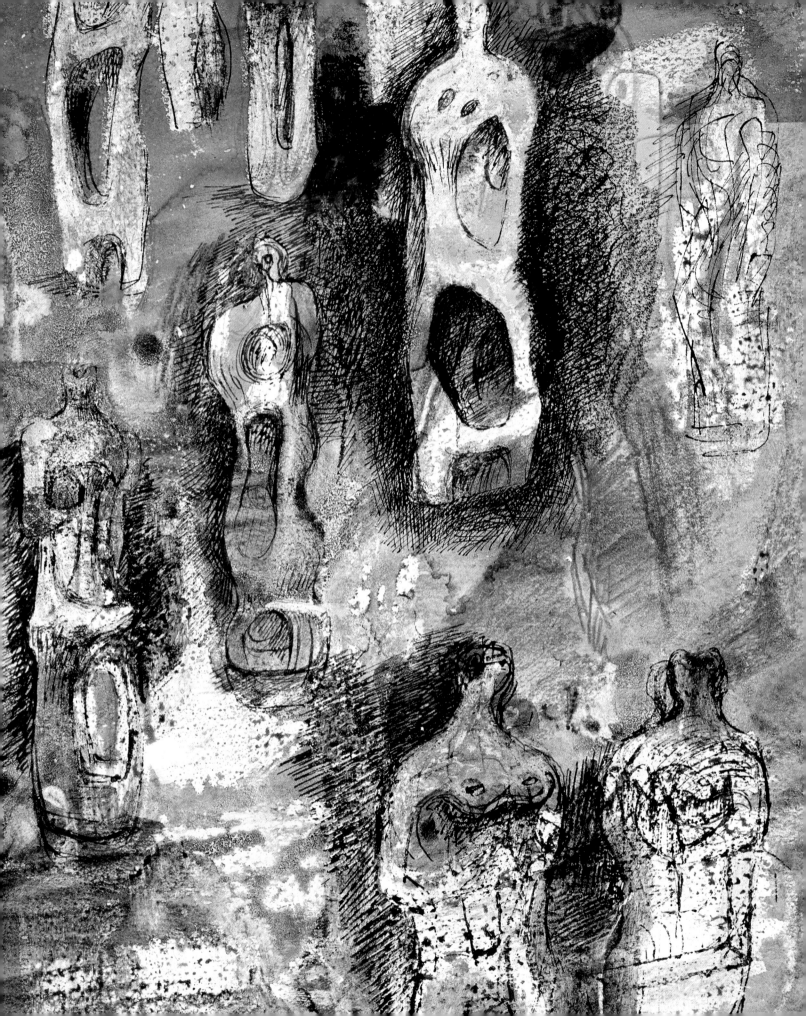

3 | Surreal Personages

57 Henry Moore in the garden at Burcroft, 1939, with *Reclining Figure*, 1939, LH 210 behind.

Opposite: Detail from Plate 75

Stonehenge

Standing stones always appealed to Moore – from his first visit to Stonehenge in 1921 to the portfolio of Stonehenge lithographs of 1972–3. This interest in the Neolithic was widely shared by artist friends as well. Paul Nash was preoccupied with Avebury, which he discovered in the summer of 1933, at the time he was collaborating with Moore on the formation of Unit One. Barbara Hepworth collected visual material connected with the Neolithic and her work was associated with standing stones by J. D. Bernal in the catalogue introduction to her 1937 exhibition. Photographs of Stonehenge appeared in *Circle* (1937), the manifesto of the London-based abstract group. Settling in England in the autumn of 1933, the former Bauhaus director Walter Gropius asked his host, Jack Pritchard,

to take him to Stonehenge on the first weekend after his arrival.[1] Nor was the Neolithic an interest in England alone. Giacometti worked with Max Ernst in the summer of 1933, hiring a team of horses to haul granite stones from the moraine of the Forno glacier near the Giacometti family home at Stampa in Switzerland for Ernst to sculpt. In a letter to the critic and historian Carola Giedion-Welcker, Ernst asked: 'Why not leave the spadework to the elements and confine ourselves to scratching on them the runes of our own mystery?'[2]

As international relations worsened in the mid 1930s, the growing awareness of national identities led to European countries portraying themselves partly through their long histories, a fact that proved a major boost to archaeology and which gave rise to the paradox – not lost on Moore – that as London became increasingly an international centre for the visual arts, the nature of 'Englishness' grew, in parallel, to be a theme of artistic debate.

Moore's first visit to Stonehenge, in autumn 1921, happened three years after the monument had been acquired for the nation: he had just come south from Leeds and it was the beginning of his first term at the Royal College of Art. For Moore, as for Gropius in 1933, Stonehenge was top priority, and for both it was the visual impact of the monument in its landscape setting as much as purely archaeological aspects of the site that mattered: 'As it was a clear evening I got to Stonehenge and saw it by moonlight. I was alone and tremendously impressed. (Moonlight, as you know, enlarges everything, and the mysterious depths and distances made it seem enormous.) I went again the next morning, it was still very impressive, but that first moonlight visit remained for years my idea of Stonehenge.'[3] Moore used to revisit the site when his daughter, Mary, was at school nearby in the 1950s. In 1971 he told his London dealer Wolfgang Fischer that:

an example of a perfect setting for sculpture is Stonehenge (which I consider is sculpture not architecture). As you approach Stonehenge, you see it on the bare brow of a rise of ground, outlined against the sky, powerful, monumental and grand.

If Stonehenge were in a hollow depression of ground and looked down upon from above, it would not have had the continuous attention and admiration it receives.

If you reduced Stonehenge by half, – if all the stones, instead of being twenty feet were only ten feet high, to the smallest only four feet, then Stonehenge would not hold the dominating place in people's minds that it does ... and one will see that the human figure is a very tiny thing, that you could get about twenty life – size figures out of such a stone. So the size of Stonehenge does matter.[4]

Wilkinson recalled Moore saying that 'ever since [his first visit to Stonehenge] he has dreamt of making sculpture of such a size that "you could walk in between, which you could inhabit almost"'.[5] It was a dream that Eric Gill and Jacob Epstein had shared in 1910 when they had planned to acquire a six-acre piece of land on the South Downs and construct what Gill described as 'a great scheme of doing some colossal figures together (as a contribution to the world), a sort of twentieth-century Stonehenge'.[6] It will shortly be seen that some of Moore's drawings of standing stones pick up on and develop this idea of stones as people. Ann Garrould has confirmed that long before buying (in 1935) Burcroft, the small house at Marley in Kent, where, for the first time, Moore had generous outdoor space, he had visualised his sculpture set against nature.[7] For Moore, as for Epstein and Gill, the 'colossal' outdoor project remained a pipe dream.

Replying to Paul Nash who had been telling him about his own first encounter with Avebury, Moore wrote:

> I've read somewhere that certain primitive people
> coming across a large block of stone in their wanderings
> would worship it as a god – which is easy to understand,
> for there's a sense of immense power about a large
> rough shaped lump of rock or stone … A great wish
> I have is to build (and design) my own place to work
> in and to have it big enough to set up in the middle of
> it a large rough-axed monolith much as one of the
> Stonehenge pieces, and near it, & of about the same
> size a part of the trunk of a big tree (such as some there
> are near here in Waldershare Park). Working with them
> in sight there'd be less risk of being sidetracked so
> often from real sculpture.[8]

Stone Personages

A drawing (plate 58) in a notebook Moore started in Italy in 1925 shows six pieces of stone that were stored in the garden of the school house at Wighton in Norfolk where his sister Mary was head teacher; she moved away in 1925 and the stones were left behind. Moore then lived in Hammersmith (his address is on the drawing), where he had a studio but no outdoor space. The blocks appear to be specimens and their types – or possibly their uses, it is not clear – are inscribed (Caen, Alabaster, Roman, Church). But they are arranged on the page as if they constituted a stone circle. This sketch is the only evidence of its kind from the 1920s.

Moore recalled later of Burcroft: 'The cottage had five acres of wild meadow. Here for the first time I worked with a three to four mile view of the countryside to which I could relate my sculptures. The space, the distance and the landscape became very important to me as a background and as an environment

58 *Stone Blocks: Opposition of Masses*, 1925–6. HMF 364. Pencil, 22.5 x 17.5 cm (8⅞ x 6⅞ in). Henry Moore Foundation

for my sculpture.'[9] Before he employed assistants, and because at that point he lacked heavy lifting tools, Moore was restricted in the size of stone sculptures he could make. But as he pointed out later, 'any bit of stone stuck down in that field looked marvellous, like a bit of Stonehenge'.[10] Between 1936 and 1939 Moore employed Bernard Meadows, later to become a sculptor of distinction himself, as assistant. Meadows has related how Moore went to Derbyshire and ordered two tons of Hoptonwood stone which had already been quarried, and the two of them spent a fortnight casting concrete bases in the field in front of Burcroft and erecting them. Meadows described them as 'like a Stonehenge or, rather, an Avebury. They were single stones in a setting.'[11] Moore thus had substantial stone monoliths erected in the garden, which he described as looking 'a little like a miniature Stonehenge, [it] still does, & will do for a year or two until they are all carved'.[12] Moore used the stones as elevated bases for small works (plate 59). Somewhat akin to Constantin Brâncuşi's practice in using bases, for Moore the base could be both part of the work and a mediating force between sculpture and nature. Some, at least, were considerably larger than any vertical stone sculptures Moore made at that time (up to seven feet long, he told Hedgecoe[13]), and, despite Moore's comment that he intended ultimately to carve all of them, he probably acquired them as much to enjoy the rough stone monoliths in their existing form as to carve them.

In his exchange with Nash in 1933, Moore took the widely held animistic view that the stones were inhabited by ancestor spirits. When he first visited Stonehenge in 1921, the official guidebook was by Frank Stevens of Salisbury Museum, *Stonehenge Today and Yesterday*, published in 1919 and in print throughout the interwar period. Stevens wrote: 'It is a recognised fact that the worship of stones is more widely distributed than any other primitive cult. Its almost universal distribution can be referred to the tendency of the half savage mind to confuse persons and things, and from seeming likeness of the inanimate to the animate, to endue the lifeless object with the virtue and power of the living object.'[14] Stevens referred to trees rather than stones as the typical habitat of ancestor spirits, but implied that, in general, spirits of the dead were ubiquitous in natural objects and communication with them was possible.

Stonehenge was widely discussed, with monolith-as-figure a regular point of reference. F. Adama van Scheltema published 'Le Centre Feminin Sacré' in 1930 in *Documents*, the unorthodox Surrealist journal that Moore regularly looked at,[15] suggesting that the circles were groups of petrified figures, as were the avenues bordered with standing stones to be found in Brittany which he described as corteges or processions. According to popular tradition, he added, the inner

59 Stones in Henry Moore's garden at Burcroft, with *Sculpture*, 1937, length 21.6 cm (8½ in).

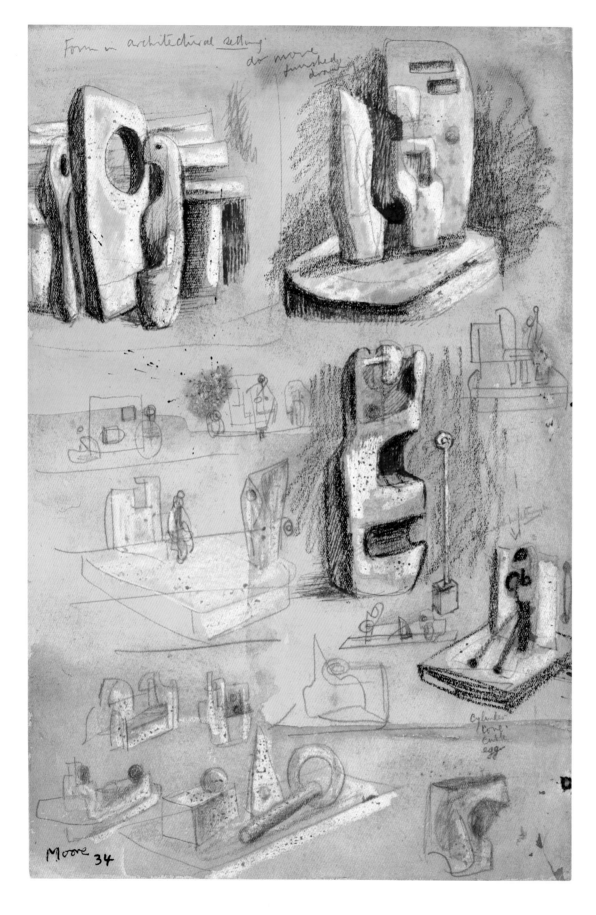

Form in architectural setting

do more furnished draw

Moore 34

60 *Monoliths*, 1934. HMF 1127. Pencil, crayon, pen and ink, watercolour, wash, 27.8 x 18.3 cm (11 x 7¼ in). Henry Moore Foundation

61 *Stone Figures in a Landscape Setting*, 1935. HMF 1163. Pencil, wax crayon, charcoal, pastel (rubbed and washed), pen and ink, 29.2 x 46.6 cm (11½ x 18⅜ in). Henry Moore Foundation

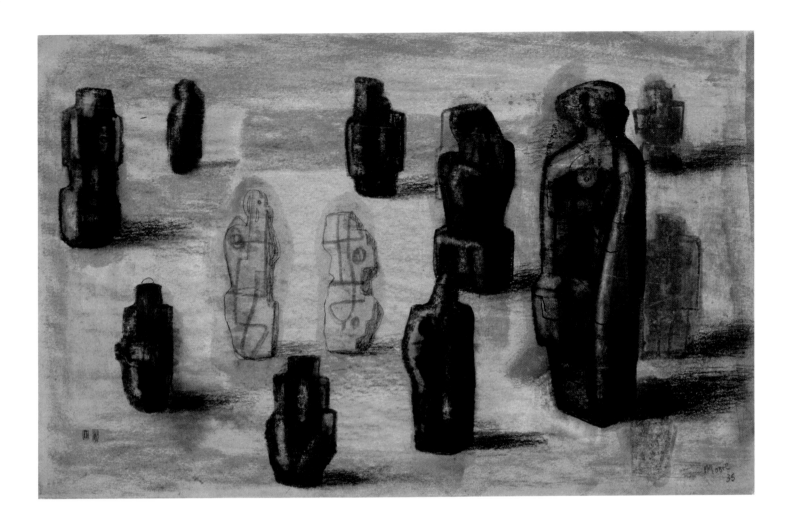

circle at Stonehenge was a group of dancers who had been invited to a wedding and who were punished for their contempt for the rite of marriage by being turned to stone. Van Scheltema reproduced an early Greek sculpture of a circle of dancers in stone to back up his argument. Be that as it may, it is clear that animistic and primitivising interpretations of Stonehenge were current, and it is unnecessary to suggest that Moore believed them, only that he allowed the romance of the distant past to loosen the ties of reason. Like the Surrealists, Moore's objective was the re-enchantment of the physical world.

The human figure in Moore's work as equivalent to the standing stone quickly takes on a subhuman kind of life. At the top left of *Monoliths*, 1934 (plate 60), two personages – confusions of people, birds and animals – look at one another through a stone or sculpture with an open centre, apparently referring to the Men-an-Tol in Cornwall, with its two upright stones on either side of a stone with a hole in its middle. Lower down are suggestions of human figures on a podium, giving scale to what, if made, would have been very large sculptures,

possibly as high as the uprights at Stonehenge, certainly much bigger than anything Moore was actually working on. Space surrounding objects in Moore's drawings at this point tends to be anonymous, more like an urban plaza than landscape, and in this lies the crucial influence of Giacometti, whose game board and city square sculptures at the beginning of the 1930s were unique in their horizontal format. By 1934 Moore was also experimenting with horizontal formats in both drawing and sculpture, but the praise he lavished in retrospect on the landscape surroundings of Stonehenge and the pleasure he drew from his own five-acre meadow are not reflected in drawing: Moore's monoliths stand in desert-like emptiness. Moore's sense of the prehistoric, like that of Yves Tanguy, was defined by extensive open space peopled, in Moore's case, by stones but with little individual character to the space itself. He was careful to avoid indications of the picturesque at a time when a trend was beginning in English art towards nostalgia and pastoralism.

The earlier metamorphic principle still underpins the *Stone Figures in a Landscape Setting*, 1935 (plate 61), in which the

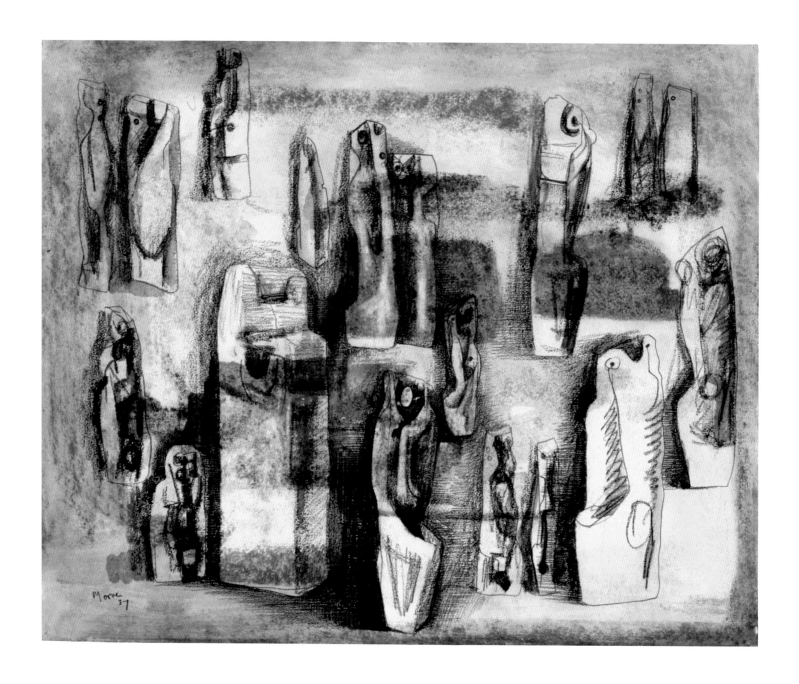

half-animate stones occupy a limitless landscape, with extensive use of rubbed crayon to blacken the stones and an equivalent psychological darkness caused by the unexpected changes of scale between the mainly smaller stones and the fearsome giant on the right. *Drawing for Stone Sculpture*, 1937 (plate 62), treats the monolith-as-figure theme through the addition of drawn circles on the tops of stones, which semi-humanise them with the attribution of eyes and other facial features. The blocks of stone delivered to Moore had machine-made circular depressions on them, probably to attach them to the quarry's lifting gear.[16] Meadows also

recorded that at the time the stones were erected in the field Moore 'had all his recent drawings around him and gradually they fitted in his mind into the pieces of stone'.[17] The meaning of this is not completely clear, especially as we do not know exactly which drawings Moore was looking at. It seems likely, though, that plate 62 drew its final form from the stones, and that the quarry's lifting gear's markings on the stones became the eyes that give strong human expressiveness to the stone figures. Several of the stones in the 1937 drawing are paired, and there is a disconcerting sense of quiet conversations taking place between them, touches of domesticity

62 *Drawing for Stone Sculpture*, 1937. HMF 1320. Pencil, chalk, ink wash, watercolour, 49.5 x 60.4 cm (19½ in x 23¾ in) . Henry Moore Foundation: bequeathed by Gérald Cramer 1991; formerly Geoffrey Grigson

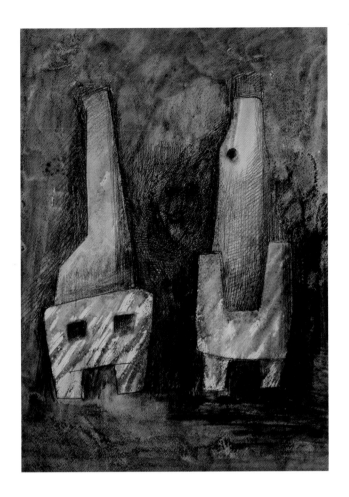

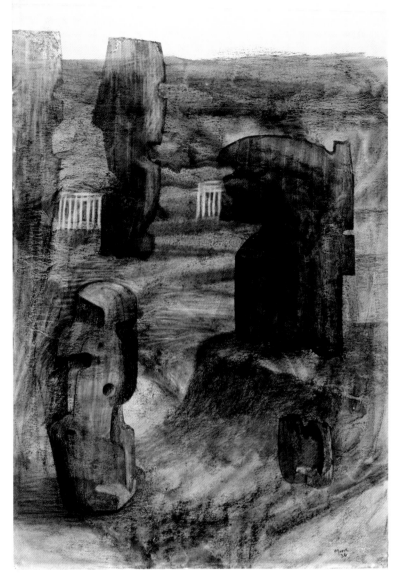

63 *Two Upright Forms*, 1936.
HMF 1254. Crayon, charcoal (rubbed),
wash, wax crayon, pen and ink,
49.5 x 35.3 cm (19½ x 13⅞ in).
British Museum, Kenneth Clark bequest

64 *Stones in a Landscape*, 1936.
HMF 1259. Charcoal, watercolour wash,
pen and ink, 55.9 x 38.1 cm (22 x 15 in).
Henry Moore Foundation: acquired 2007
in memory of Bernard Meadows

to set against the abstractness (largely the result of the, unusual for Moore, separation of areas of colour from drawing) and austerity of the overall design. This was a drawing that belonged to Geoffrey Grigson, who had extensive topographical and antiquarian interests. He wrote to Moore in 1942 when he was working on the Penguin Modern Painters book – in which this drawing is reproduced in colour – recalling a visit Moore had made to his home at Broad Town, Wiltshire, in 1935, and mentioning that he was himself going the next day to Wales to visit the biggest cromlech in Britain.[18] Grigson was crucial in helping to keep Moore's early interest in Stone-

henge alive and, as a Wiltshire resident, may have visited the Neolithic sites with him.

The darker cast to Moore's treatment of stones continued into 1936 with *Two Upright Forms* (plate 63) and *Stones in a Landscape* (plate 64), for both of which Moore used rubbed charcoal alongside ink and watercolour. None of these darker drawings relate directly to sculpture, indeed their boundless space and heavy shading is essentially pictorial. While the mask facing out of the shadows between the stone personages of *Two Upright Forms* belongs to the theatre, it is not expressive of that kind of theatrical menace from which escape

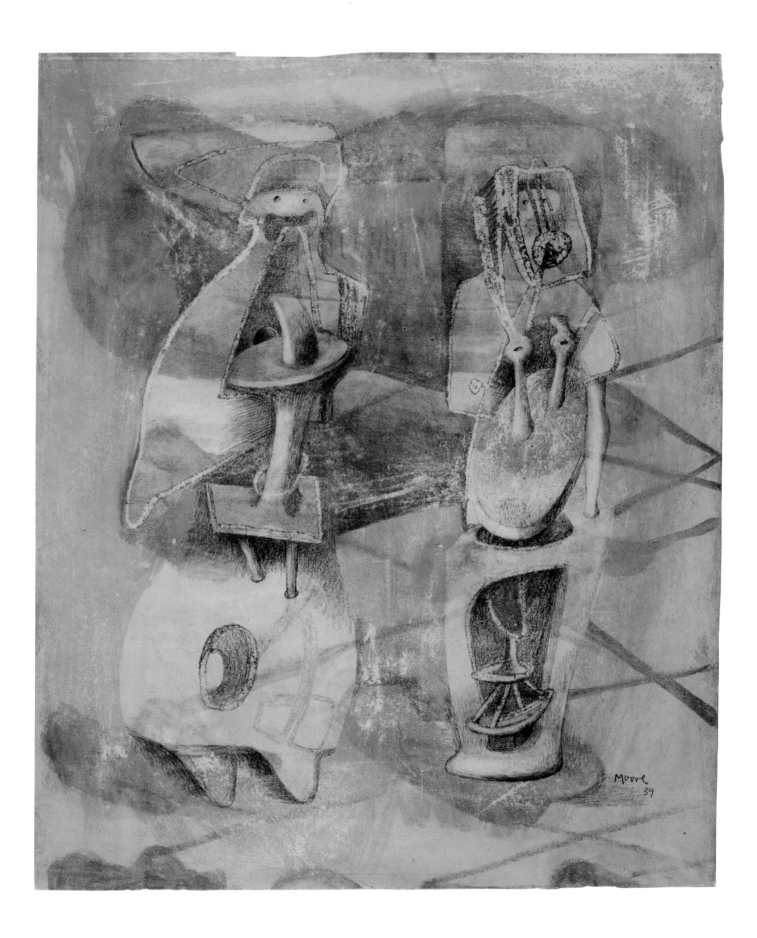

and return to the real world is easy: it is resonant, rather, with the involuntariness of nightmare. *Stones in a Landscape*, with white temple fronts dwarfed by standing stones, suggests not so much the emergence of classical civilisation from barbarity as the collapse of Europe in face of a renewed threat. Ambiguity, as Sylvester was to point out in a passage already referred to,[19] was part of Moore's pictorial language and one should not look for fixed messages. It is clear, however, that Moore's approach to the primitive is now different from what it had been before. The 'primitive' image no longer involves the simple reproduction of an artefact of non-European origin to be admired for its formal strength and vitality. A work reflecting the 'primitive' is now to be the product of a different frame of mind and emotional response to life, one that finds analogies between the present and an ancestral past. In so far as this response correlates with the Surrealist notion of the marvellous, the marvellous itself must be seen as having savage connotations.

Moore's response now was to find ways of representing what he saw as the primitive in modern society and modern man. Moore's skeleton figures, like *Drawing for Sculpture: Two Women*, 1939 (plate 65), are not related directly to standing stones, even if formal similarities between figures and stones suggest that his mind saw links between the two. By the late 1930s his work is peopled by a race of stripped down, hollowed out figures, half alive, half mummified, suspended between life and death. Moore now seems representative of Meyer Schapiro's reflection on the 1930s: 'Picasso and other moderns have discovered for art the internality of the body, that is the inner image of the body as conjured up by fear and desire, pleasure and pain. But this inner image is communicable only as related contrast to the outer.'[20]

Landscape

Moore's feeling for landscape was positive: he saw no contradiction in a sculptor being interested in landscape, even if it was traditionally a painter's rather than a sculptor's subject. He stressed the importance of landscape in interviews, particularly with John Hedgecoe in 1968.[21] He liked to see his work placed in natural surroundings, and he photographed his work against the local landscape – *Reclining Figure*, 1937 (plate 66), is an example. One of the sketches in *Ideas for Sculpture*, 1937? (plate 67), feeds directly into the 1937 *Reclining Figure*, which has references to tumuli and perhaps standing stones as well.[22] The figure-landscape relationship is one Moore mastered in sculpture in the later 1930s, and though he invents forms, as here, that are certainly unfamiliar in European sculpture, they do not seem discomforting.

Moore seems to have photographed sculpture against landscape to stress sculpture's natural qualities and effects,

but he wanted something different from landscape drawings that were not related to sculpture. From 1935 monoliths in drawings occupy a barren space that is perhaps best not described as landscape at all. *Stones in a Landscape* was included among a group of Moore drawings in the International Surrealist Exhibition in London in 1936, in which darkness, both of colour and emotional overtone, helps define what Moore thought appropriate for a Surrealist exhibition at this point. In drawing Moore seems to have found a completely open medium in which material and technique were flexible and guided him to no particular end result. His imagination had free flow in these pictorial designs. Drawing did not involve 'truth to materials'.

Carola Giedion-Welcker, an acquaintance of Moore, published an article 'Prehistoric Stones' in 1938, illustrated with her own photographs taken in several countries. She argued that the monolith, prehistoric and recent, was a fundamental form, international and common to many places and times. Moreover, it represented not only form but meaning that was passed down from pre-history to the Greek stela, the Roman tomb and frontier stone, early Christian wayside crosses, and so on. Prehistoric art had been thought decadent and rigid, which was the same fallacy, she argued, as the common criticism of modern art that it did not approximate nature. We are not assuming equality between prehistoric and modern, she says, because conditions alter, 'but this does not change the fact that the creators of today are working again in basic values and efficacity of form, colour and expression. In all the genuine creations of civilisation ... we find both early and recent humanity, that is, an interpenetration of past, present and future'.[23] In the 1920s Moore had held to an idea of a 'world sculpture', defined by a standard of formal excellence. Giedion-Welcker confirmed what was already in Moore's mind: that this formal account could be given breadth and distinction by being linked to the ceremonial and spiritual. Her article ends: 'The faith in the dark magic of these ritualistic stones is still alive today.'

In 1938 Moore filled two sheets (plates 68 and 69) with designs that situate his own sculptures, or designs very similar to them, in landscape. Plate 68 includes the designs for a twelve-inch metal sculpture of 1939 (LH 202), while plate 69 includes the large elm wood *Reclining Figure* of the same year (LH 210). Though Moore is no longer dealing with standing stones but sculptures he had made or planned to make, the contexts he sets them in, an orchard or a walled field (plate 68) or the hedged around and caged figures of plate 69, suggest Moore seems to be thinking in terms of shrines for an earth goddess. As with the sculptures these drawings allude to, there is a sobriety and enjoyment of the English landscape that marks a withdrawal from the 'dark' Surrealism of 1936.

65 *Drawing for Sculpture: Two Women*, 1939. HMF 1445. Charcoal (part rubbed and washed), crayon, pastel, watercolour wash, 45.1 x 38.1 cm (17¾ x 15 in). British Museum, Kenneth Clark bequest

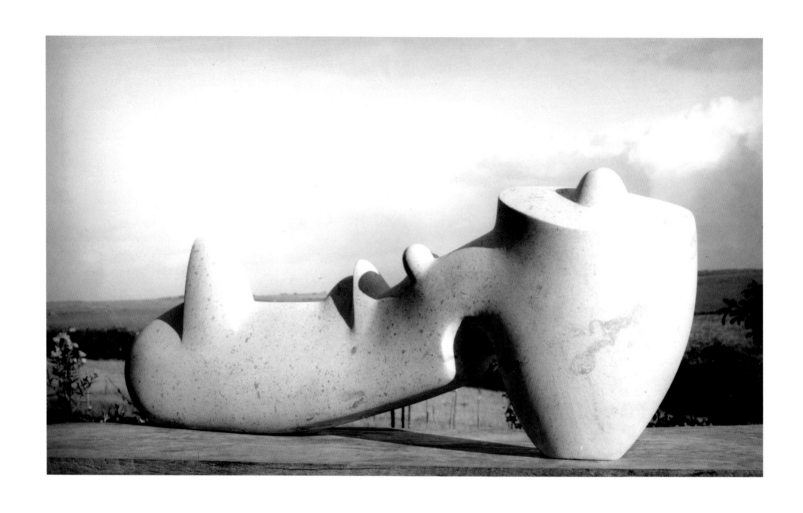

66 *Reclining Figure*, 1937. LH 178.
Hopton Wood stone, length 79.2 cm
(31⅛ in). Fogg Art Museum,
Harvard University Art Museums,
gift of Lois Orswell

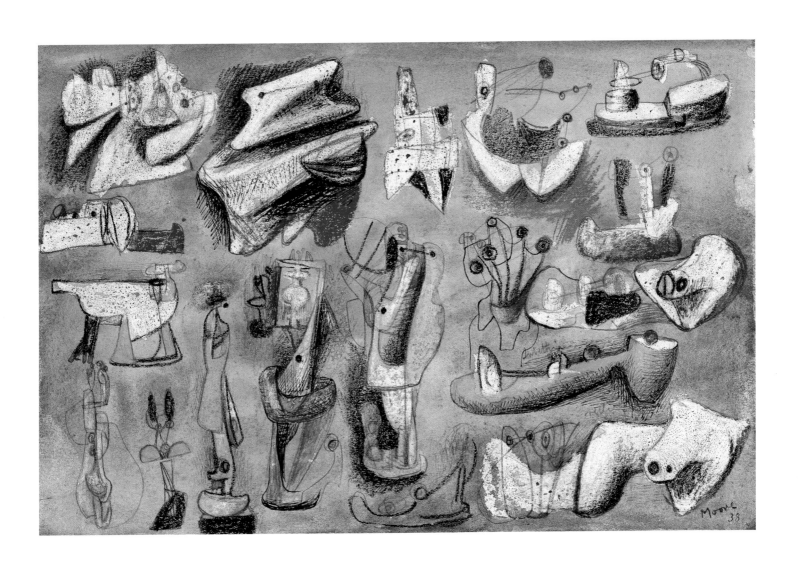

67 *Ideas for Sculpture*, 1937?.
HMF 1392b. Pencil, crayon, chalk,
watercolour, wash, pen and ink,
18.5 x 27.7 cm (7⅜ x 10⅞ in).
Henry Moore Foundation

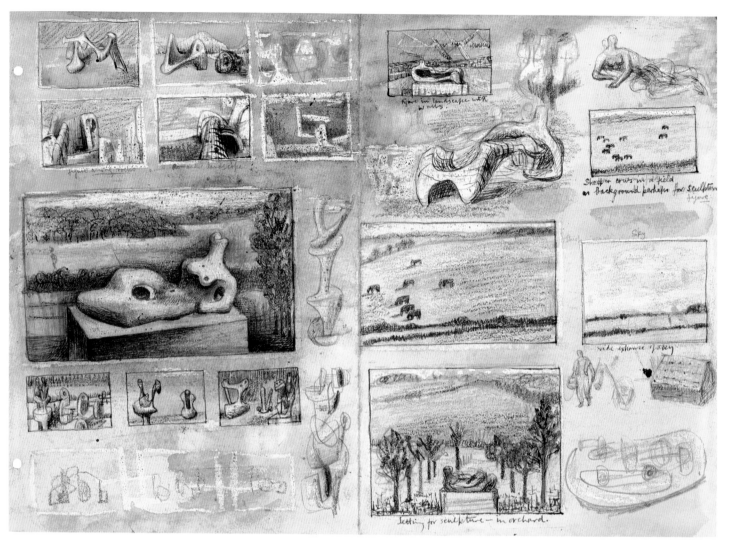

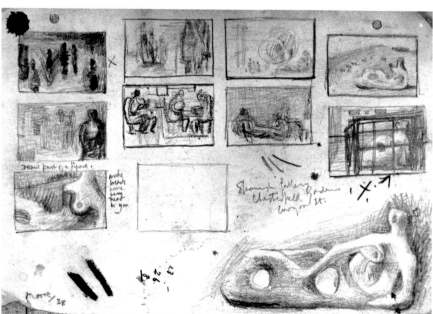

68 *Ideas for Sculpture in Landscape,*
*c.*1938. HMF 1391a. Pencil, wax crayon,
watercolour, pen and ink,
27.7 x 38.1 cm (10⅞ x 15 in).
Henry Moore Foundation

69 *Sculptural Ideas in Settings,* 1938.
HMF 1416. Pencil, crayon,
188 x 277 mm (7⅜ x 10⅞ in).
Private Collection

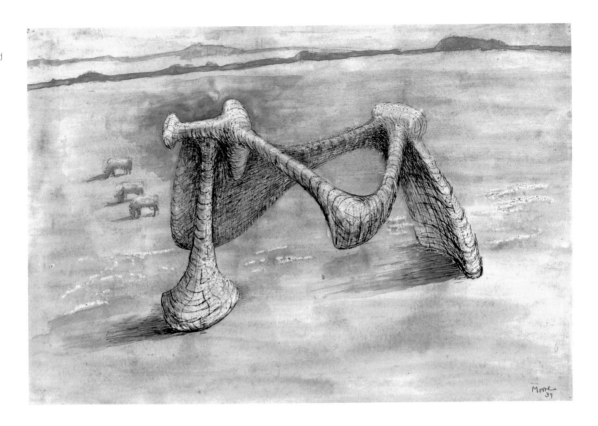

70 *Sculptural Object in Landscape*, 1939. HMF 1441. Pencil, wax crayon, watercolour wash, pen and ink, coloured crayon, 37.5 x 54.6 cm (14¾ x 21½ in). University of East Anglia, Norwich, Robert and Lisa Sainsbury gift

But Moore's drawings are still volatile in mood: in 1939 the top left sketch of a composite of bones in plate 68 is enlarged into *Sculptural Object in Landscape* (plate 70), which Melville regarded as a 'sinister construction [that] could only have been erected to be venerated'.[24] The cattle, drawn as a separate vignette in plate 68, are now included within the design, to register change of scale and maybe contribute a deceptive sense of calm, since they are as yet unaware of the threat to their safety.

Unknown Africa

'Ideas for Drawings' is a title used only for three drawings made in 1937, two of which consist mainly of sketches that are direct or modified transcriptions from a book Moore owned

and is still in his library, Leo Frobenius's anthropological study published in 1933, *Das Unbekannte Afrikas* [*Unknown Africa*]. Moore had copied ideas for sculpture from books into his notebooks before, but not images like these, most of which are purely pictorial and could not have been developed as sculpture. At the top of plate 71 the sketch with Moore's inscribed title 'Figure in a Tunnel' relates to two of Frobenius's illustrations, a modern Egyptian barrel-vaulted room and a half-sealed grave in a cave in Southern Rhodesia. The architectural drawing below is of granaries in the Sudan; below that is a sketch based on a group of cult stones in Abyssinia (plate 72), and two further drawings are copies from the same book. Frobenius also has illustrations of cave paintings, both prehistoric and modern. Moore had been fascinated by these since his

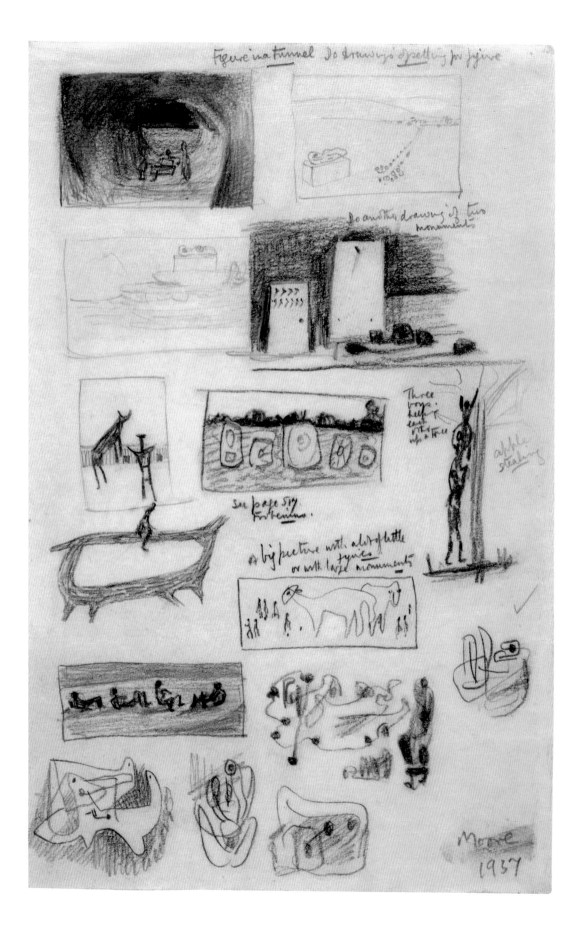

71 *Ideas for Drawings*, 1937.
HMF 1340 verso. Pencil, chalk
(part rubbed and washed), crayon,
27.3 x 17.9 cm (10 ¾ x 7 in).
Henry Moore Foundation

trip to northern Spain and southwest France in 1934. Plate 73 is a modern cave painting in west Sudan illustrated by Frobenius and composed of figures, reptiles and half-human stela-like designs.

These final images seem to have suggested to Moore ways to fill a page, loosely and apparently randomly, and take advantage of the fall of light and shadow due to the unevenness of the cave wall. Moore's design of standing and seated figures in *Sculptural Group*, 1939–40 (plate 74), and his *Standing Figures*, 1940 (plate 75), are like crowded, uneven walls on which he has not engaged with the original artists' forms, but has inscribed his own characteristic figures. He is not copying the primitive African, but inserting himself into the other artists' place: Moore becomes the primitive of a

cavernous world of his own creation. The drawings can seem at first scrubby and even indistinct, because his effort to describe the feel of a cave wall led him to create the effect of patchiness, which he did by using watercolour over wax crayon and, in a semi-automatist way, letting the water run off the waxy chalk and find its own place on the paper. Paradoxically, recreating the primitive involved greatly increased technical sophistication.

Moore's hollowed out figures in plate 75 are recognisably people (some, at the top, carry babies) but at the same time are so disembodied as to seem primitive themselves. It is a purgatorial, in-between world, reminiscent of Wyndham Lewis's designs of the same period, which Moore joined Grigson and others in championing publicly.[25] Like Lewis, Moore was able

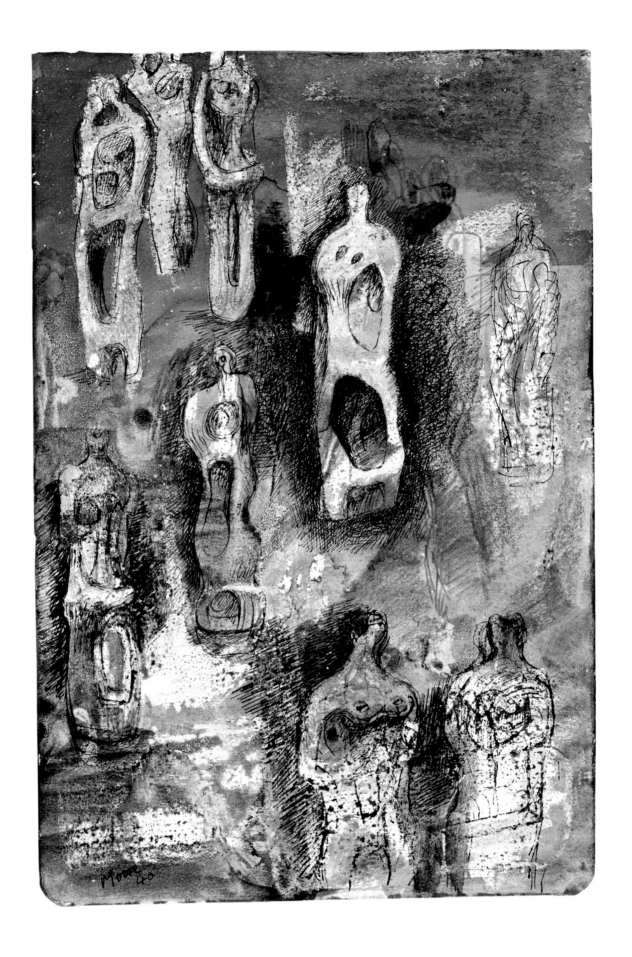

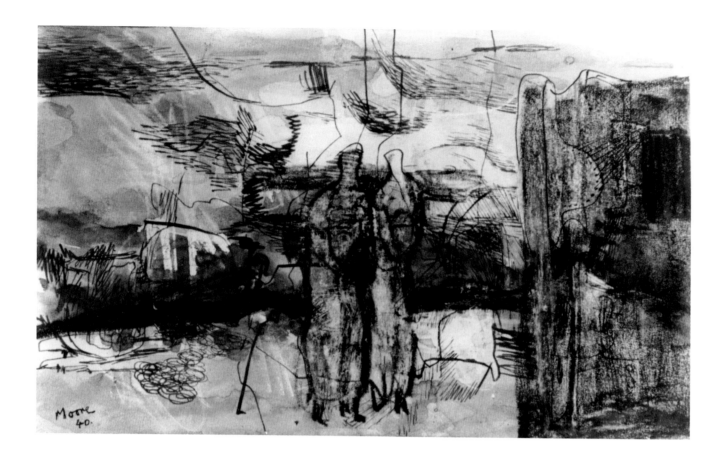

to think at the same time in terms of different worlds widely separated historically: Dante and Virgil are easily imagined in *Figures in a Landscape: Stringed Figures in Lead*, 1939–40 (plate 76). This kind of wide-ranging imagination, firmly anchored to neither present nor past but coursing between the two, needs to be understood if the drawings of Londoners sheltering in the London Underground that immediately followed – and are often wrongly imagined to be direct reflections of what he saw – are to be given their full meaning.

Figure, Mechanism, Still Life

Mechanisms is the title of a drawing of 1938 (plate 77), highly finished, rich in colour, and part of a group from 1937–8 that contains forms that are just recognisable as part of Moore's sculptural family but seem purposely malformed when seen against the much more sensuous sculptures of the same time. There is no period of Moore's work when drawings and sculptures diverge more markedly from one another in mood, and yet are evidently, on account of the forms created, the work of the same artist. Poised between subhuman personages and disabled machines, these graphic presences are discomforting.[26]

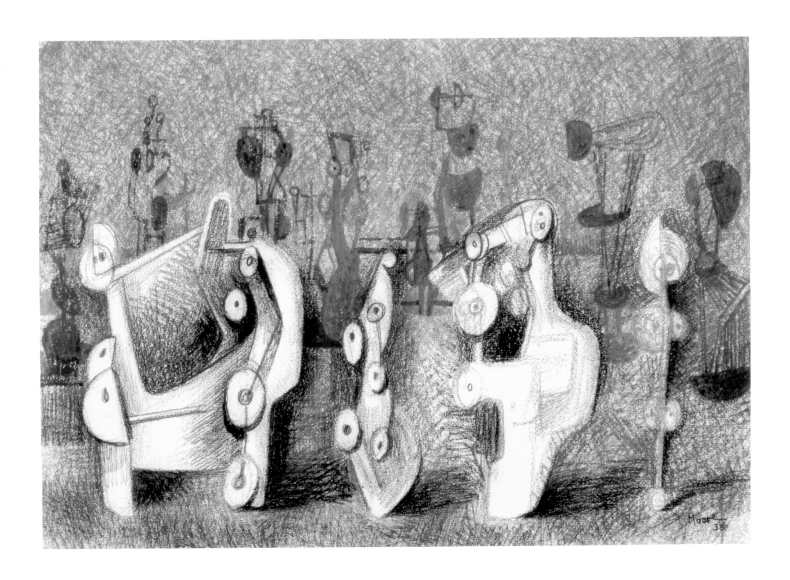

76 *Figures in a Landscape: Stringed Figures in Lead*, 1939–40. HMF 1522a. Pencil, crayon, watercolour wash, pen and ink, 13.7 x 21.5 mm (5⅜ x 8½ in). Private Collection

77 *Mechanisms*, 1938. HMF 1367. Chalk, wash, 39.7 x 57.2 cm (15⅝ x 22½ in). Henry Moore Foundation

These are 'indoor' forms, in spaces that are stage-like and theatrical. *Mechanisms* is a theatre of ghosts, with the implication that this is not all; more may be going on behind and at the sides, and what we see is just the immediately visible aspect of a world of unquiet spirits. Robert Melville wrote well that these 'object-presences are ... powerfully charged with malevolence ... and convey the impression that they might break into overt and destructive action'.[27] Of the contemporary drawing of stones filling the sky (plate 78), he observed: 'In another sheet hectic with macabre forms, a settlement of statuary is being invaded from the air by an alien species. The

humanoid figures on the ground are accompanied by pointed forms that have the appearance of defensive weapons. The invaders filling the sky are huge pebble-like objects with gaping holes.'[28] Moore presents a storm of missiles, a tormented visualisation prophetic of the aerial bombardment Britain was soon to undergo.

In phrases like 'overt and destructive action' and 'defensive weapons', Melville uses military terms but, like Moore's other contemporary critics, does not relate them to actual war or threat of war. Moore was a socialist, fervently anti-fascist and anti-appeasement, while commitment to a non-political

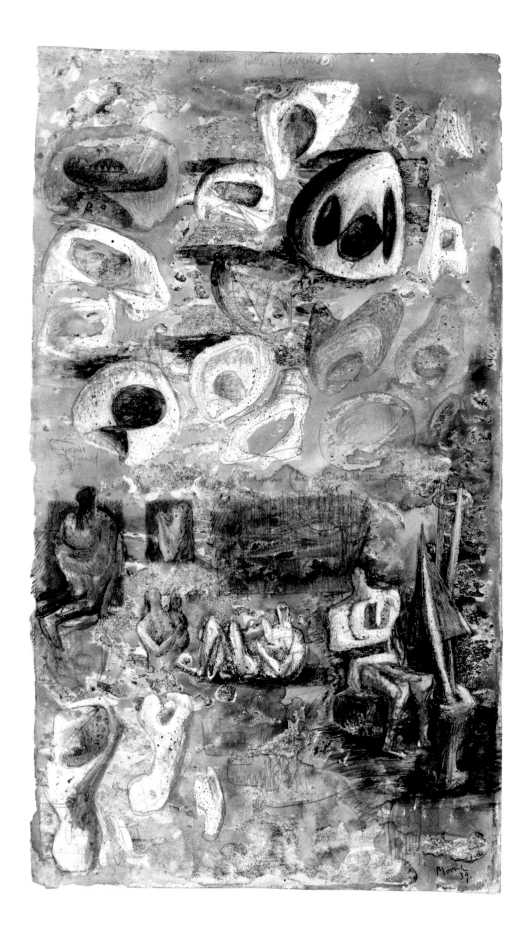

modernism closed off the possibility of direct expression of this. Artist contemporaries as different as Paul Nash and Wyndham Lewis, whether they came from the political left or right, engaged at some level with issues of moral decay, violence and war. Apart from other reasons, these were artists – Moore included – who had fought in the First World War and who had direct experience of the horror of war. Moore's drawings are not political in a documentary sense and are the stronger for that. But there is no way that Moore's work from 1937 to 1940 can, despite the sharp perceptions of a critic like Melville, be detached from the deteriorating conditions of the time. Recently, Julian Stallabrass has described *Mechanisms* as, perhaps, a 'parade or procession watched by a crowd. In this way it can be read as a premonition of war'.[29] This strikes the right level, allowing that Moore's drawings at this period cannot be regarded as proposing exclusive explanations. *Mechanisms* is alarming but also ludicrous. Whether these forms are regarded as persons or machines, they are disabled. They are still life objects more than potentially active combatants, and the strange wheels that seem to be screwed on to their surfaces are like bandages over wounds from limbs removed. Incapable and castrated, there is an element of satire in Moore's work which was his way of relaying contempt in the form of seriousness.

Many 'ideas for sculpture' of this period could only have become sculpture through adoption of materials Moore never used. Some might be constructed from iron rods welded to steel plate, but there is no evidence that Moore thought either of learning to weld or of employing the equivalent of Picasso's collaborator Julio González to do this for him. Some sketches look forward to the way the American David Smith was to develop forms drawn from Picasso in the 1940s. Though Moore never made a sculpture out of more than one material (apart from strings attached to certain late 1930s sculptures), there is evidence that he may have considered doing so: the 1939 *Drawing for Sculpture: Two Women* (plate 65), was known in early reproductions as *Two Women: Drawing for Sculpture Combining Wood and Metal*.[30]

Forms of the kind found in *Mechanisms* sometimes reappear in more than one drawing. The left figure in *Mechanisms* is second from the left in *Ideas for Sculpture in a Setting*, 1938 (plate 79), and has a second row position on the left side of *Drawing for Metal Sculpture* ,1937 (plate 80). In front of it in *Drawing for Metal Sculpture* is an abstracted image of a copulating couple that has a similar existence in drawings: it appears once again on the right hand side of *Five Figures in a Setting*, 1937 (plate 82), and prominently again in Ideas for Sculpture,1937 (plate 81) among some of the most innovative designs that were never made. *Ideas for Metal Sculpture: Three Standing Figures* (plate 83) also has, on the right,

a pyramidal metal object on a raised base which appears in several other drawings and is the object of study of the figures sitting in front of it in *Seated Figure and Pointed Forms* (plate 78). At no other point in Moore's work are there so many strange, imaginative shapes that have independent circulation in drawing without emerging into sculpture.

However, the central image of *Five Figures in a Setting* (plate 82), depicting tongue contact, does relate to a sculpture already made, the elm wood *Family* of 1935 (plate 84). Moore's use of colour, especially the lurid pink planes that represent faces, makes the drawing unlike the sculpture. As Moore never added colour to sculpture, a major tool for figurative representation was denied to his sculpture but available to drawings. The same image reappears in different colours and in a new spatial context in *Sculpture in a Setting*, 1937 (plate 85). An early photograph of *Family* (plate 86) shows that originally it also had a 'tongue' linking the two figures which at a later date Moore, who had this sculpture for many years in his studio, removed in the 1960s. *Family* was Moore's own title to indicate two upright figures and a child hinted at lower down. Moore was not averse to making drawings of, or at least based on, sculptures. Though it is natural to assume that for a sculptor drawing precedes three-dimensional work, there is no reason why this should be so, especially with an artist as concerned with pictorial composition as Moore was. Norbert Lynton speculated that Moore ultimately removed the 'tongue' for technical reasons – because the wood did not need this extra support.[31] But another possible reason is that Moore was using sculpture and pictorial art for different purposes. He wanted us to see the connection between them, but sculpture was to be elegantly crafted and formally resolved while drawings might suggest sexual imagery or carry overtones of violence.

Many late 1930s drawings show Moore agitated and pessimistic but able to express a sense of fate that is broader in intellectual compass than anything earlier. His conviction that art had a role to play in the interstices between life and death was partly an outcome of the uniquely tense situation of public life at the end of the 1930s. Moore, Nash and Lewis, older artists who had fought in the First World War, reacted individually to the situation but shared knowledge of the fearsomeness of world war that younger artists did not. Some of Moore's best work in sculpture and pictorial art was made under the pressure of adversity, and personal experience contributed to his appreciation of the narrow line between life

78 *Seated Figure and Pointed Forms*, c.1939. HMF 1497. Pencil, crayon, chalk, watercolour, pen and ink, 43.2 x 25.4 cm (17 x 10 in). Private Collection, formerly Roland Penrose

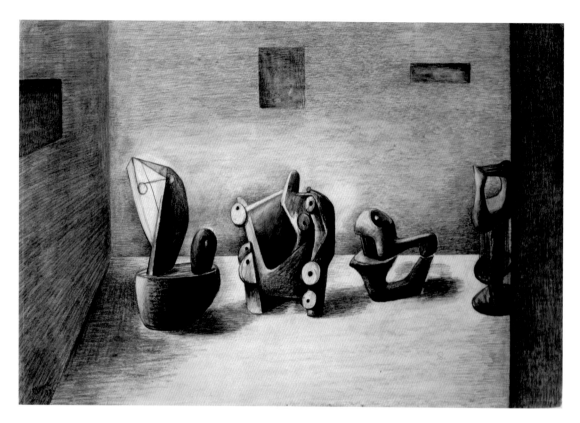

79 *Ideas for Sculpture in a Setting*, 1938. HMF 1374. Chalk, wash, pen and ink, 38.1 x 55.7 cm (15 x 22 in). Henry Moore Family Collection

80 *Drawing for Metal Sculpture*, 1937. HMF 1315. Chalk, 39.4 x 54.9 cm (15½ x 21⅝ in). Private Collection

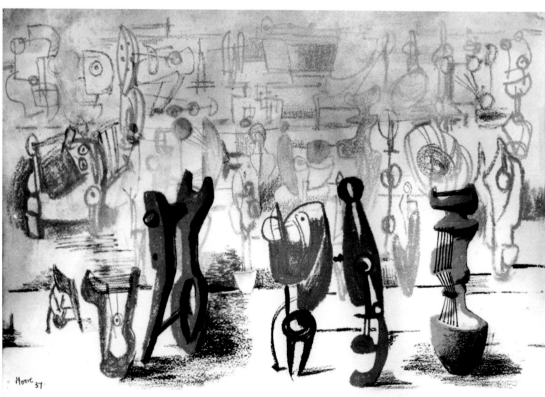

81 *Ideas for Sculpture*, 1937.
HMF 1337. Pencil, chalk, 27.9 x 19 cm
(11 x 7 ½ in).
Private Collection

82 *Five Figures in a Setting*, 1937.
HMF 1319. Charcoal (rubbed),
pastel (washed), crayon,
38 x 55.5 cm (15 x 21⅞ in).
Henry Moore Family Collection

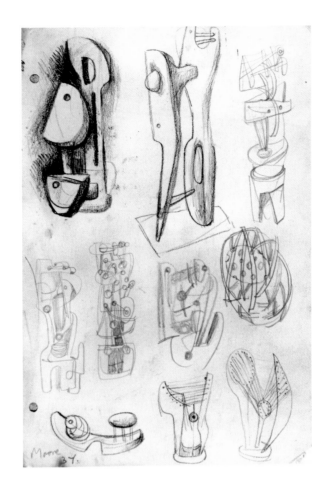

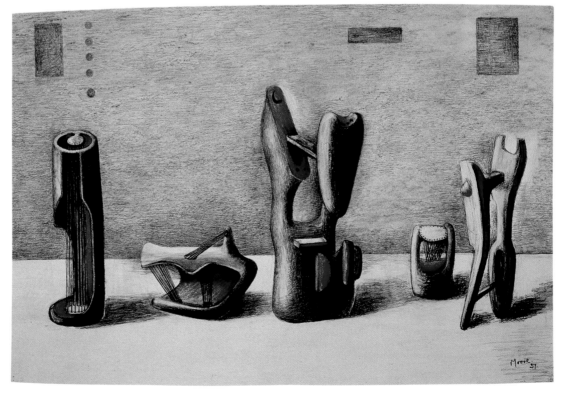

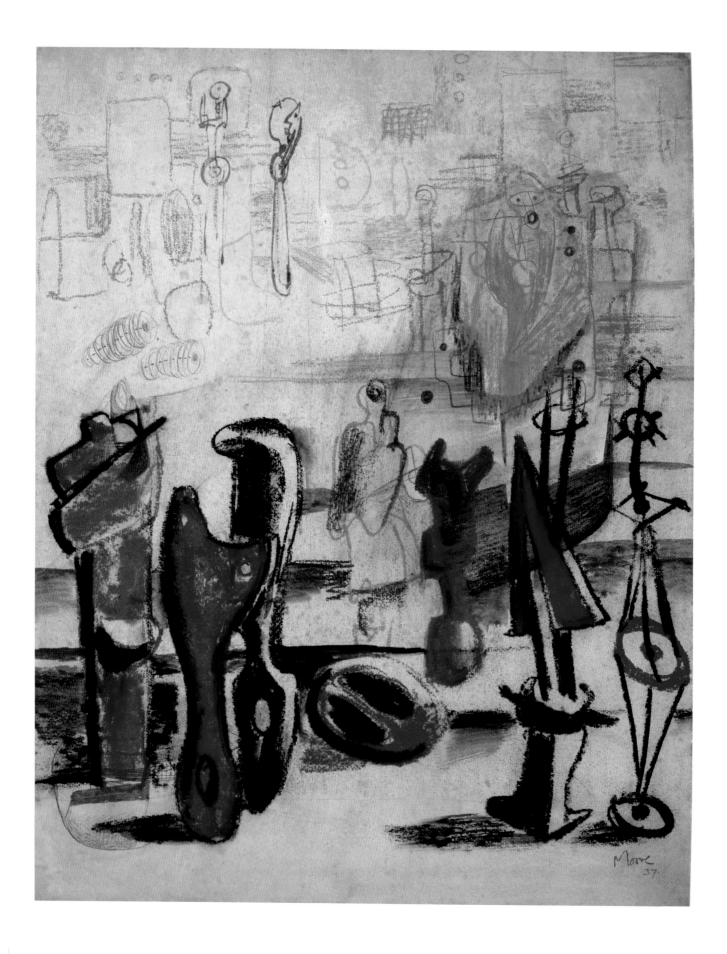

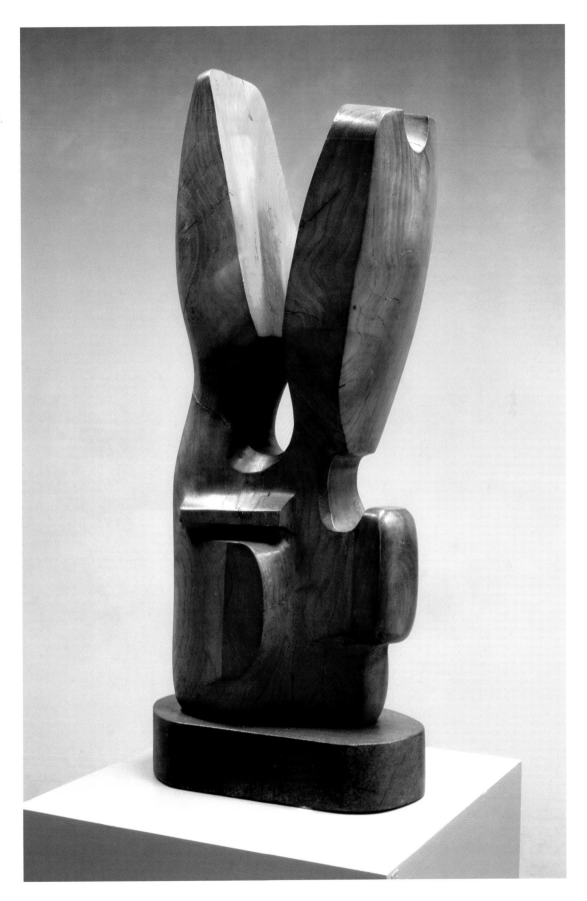

83 *Ideas for Metal Sculpture:*
Three Standing Figures, 1937.
HMF 1311. Pencil, pastel (washed),
58.5 x 47.6 cm (23 x 18¾ in).
Private Collection

84 *Family*, 1935 with later reworking.
LH 157a. Elmwood, 101.6 cm (40 in) high.
Henry Moore Foundation

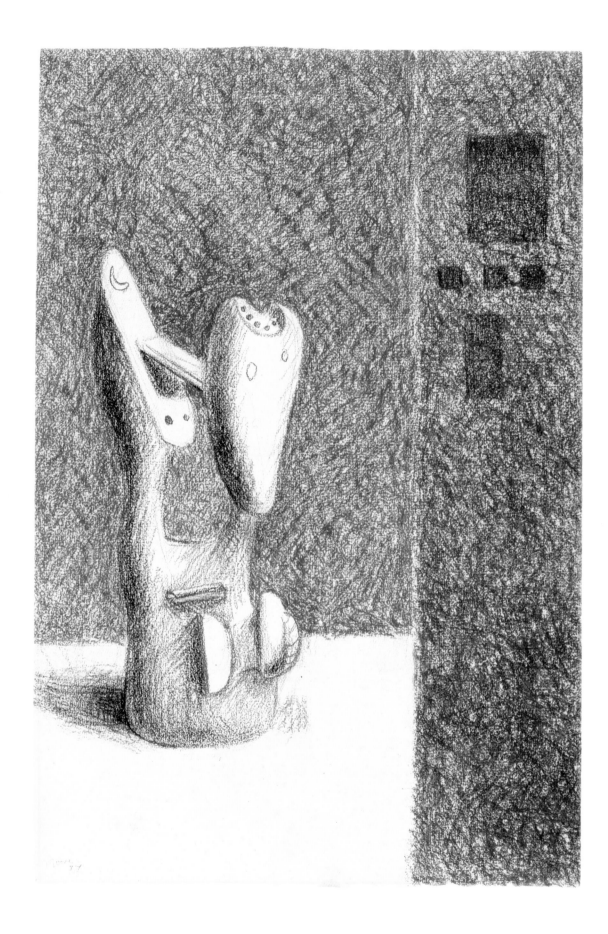

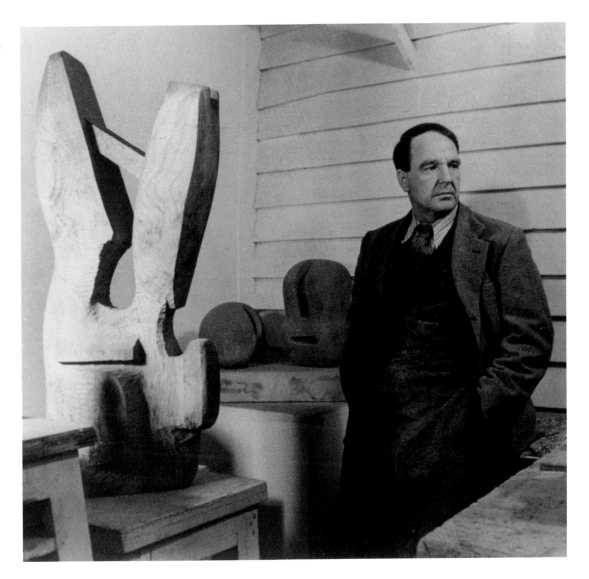

and death. At the end of the 1930s, the distinction in Moore's
art between the human figure and still life becomes barely
perceptible.

Immobility of form in these drawings associates them with
still life. Several that could be described thus were included
by Melville in the 1953 ICA show, where the most interesting
critical observations came from a negative review in *The Times*:

> In almost every drawing here ... Mr Moore might be
> thought to have represented, as if he were a painter of
> still-life, some object already carved or modelled; his
> work never suggests that he is feeling his way towards
> the production of such an object. Thus a drawing entitled
> 'Ideas for Wood Sculpture' gives the impression of being

nothing of the kind, but rather an attempt to produce
a pictorial design out of four abstract ornaments that
happened to be in the artist's studio; if this were really
a step towards the production of sculpture why should
the object to the left be partly hidden by an upright strip
in front of it which was evidently put in to balance the
composition of the picture? ... It is rather disconcerting
to find that nowhere is there any evidence of drawing
used as a means to an end, as a method of exploration, a
tentative and experimental research into sculptural form.[32]

Which particular drawing the critic is referring to is not known,
but plate 79, in which the edge of one form is concealed, illus-
trates the point that Moore was not exploring form here but

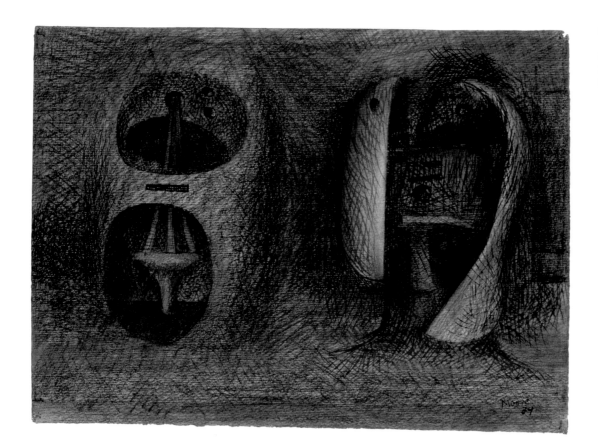

87 *Drawing for Metal Sculpture: Two Heads*, 1939. HMF 1462. Charcoal, wash, pen and ink, 27.7 x 38.1 cm (10⅞ x 15 in). Henry Moore Foundation

drawing complete objects and situating them in a silent, penumbral world in which life seems to have stopped and action is impossible.

Implicit in Moore's drawings for most of the decade had been a sense of semi-independence from sculpture: the idea that forms in his drawings might resemble sculptures by Moore while being recognisably different and even serving a different function. The issue in these drawings of 1937–8 is of the same kind: they are still marginally recognisable as Moore-like sculptural forms, but where sculptures are formally resolved and smooth in finish, the drawings seem to exhibit objects that are passive and defunct. They show the collapse of those properties that make the human figure human. It hardly needs to be said that there is no incapacity here on Moore's part; the results are what he intended. The difference in his means of expression is between sculpture, where his handling of figure and landscape in natural materials translates a traditional Englishness into modernist terms, and drawings in which he is freer with himself in revealing decay, lack of vitality and will to action, beneath the skin of society.

Armouring for War

Moore's representative composition at the outbreak of war is *Drawing for Metal Sculpture: Two Heads,* 1939 (plate 87), a variant on the mechanist theme and precursor of *The Helmet,* 1939–40 (plate 88), one of the first sculptures designed for metal (initially lead and later bronze). Roger Berthoud has written of the sculpture that 'the helmet itself is womb-like and slightly sinister, and it is hard to say whether the nervous, spaghetti-like creature within is being protected or imprisoned'.[33] If the sculpture is sinister, the drawing is more so: Moore's hatching and shading create dark corners and uncomfortable spaces. Unlike the sculpture, which consists of two complete, measurable objects, the drawing gives the effect of forms in the process of emerging from an uncertain ambience. Nowhere is it clearer than here that Moore understood how shadowed backgrounds could be used to generate mystery, a resource available to drawing but not to sculpture.

The semi-human personage on the left, enclosing an embryonic figure within a larger form, looks back to Epstein's *Rock Drill* (plate 89), made in the corresponding moment at

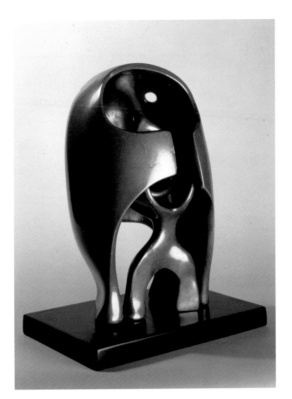

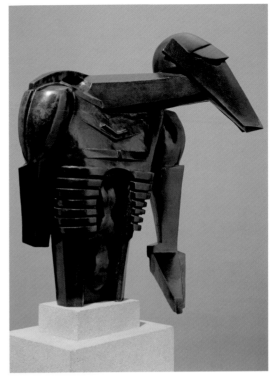

88 *The Helmet*, 1939–40. LH 212.
Lead, 27.6 cm (10⅞ in) high.
Scottish National Gallery of Modern Art,
Edinburgh

89 Jacob Epstein, *The Rock Drill*,
1913–16. Bronze, 705 mm (27¾ in) high.
Tate, London

the beginning of the First World War. Epstein's driller has a visored face so that, like Moore's work here, no humanity remained. Like the helmet figure, Epstein's driller has an embryo within his ribcage, which is protected – or imprisoned, if thought of as seized from its mother. During Moore's encounters with Surrealism and biomorphism, the pre-war avant-garde – Epstein, Gaudier and Lewis – had not been at the front of his thoughts. The threat of a new world war changed that.

Geoffrey Grigson was the link between Moore and Lewis, having promoted them, in *Axis* in 1935, as the two British artists of exceptional talent and potential.[34] Moore supported Lewis in 1937, as noted, and Lewis in turn wrote positive reviews of Moore's work when art critic for the *Listener* after the Second World War.[35] Lewis's 1930s repertoire of recent subjects include war and armour, and it is interesting to find Moore, in conversation with David Mitchinson, in 1980, explaining that his interest in 'internal-external' forms, such as found in this drawing and sculpture, was stimulated by 'many hours in the Wallace Collection, in London, looking at armour'.[36] In another account Moore explained his interest

in armour as stemming from explorations in the Victoria and Albert Museum in lunch hours when he was a student (the RCA sculpture school was close by). And in this account, in 1967, he also recalled Lewis, who was obsessed by the idea of the hard carapace or outside protective cover, 'talking about the shell of a lobster covering the soft shell inside'. 'The helmet is a kind of protection thing, too', Moore said, and added his curiosity about 'the mystery of semi-obscurity where one can only half distinguish something. In the helmet you do not quite know what is inside.'[37] This last seems particularly appropriate to Moore's drawing where, much more than in the sculpture, it is shadowy drawing that creates the disturbing uncertainty about what is there.

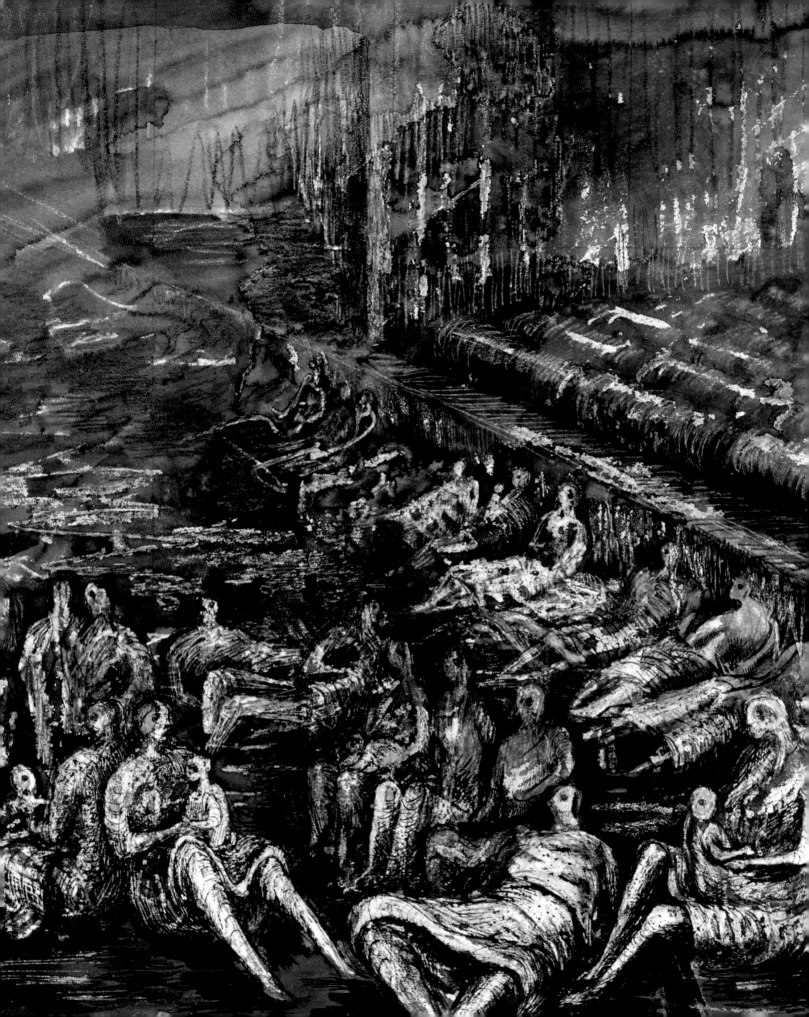

4 | Visionary of the Real

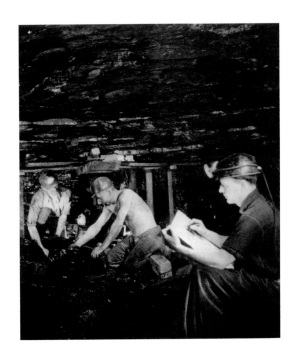

Red Cliffs

On the day war was declared, the Moores and Bernard Meadows had gone swimming below Shakespeare Cliff near Dover. The eight bathers in the drawing that marked the day, *September 3rd, 1939*, 1939 (plate 91), are apprehensive and immobile, covered by a solid-looking sea only to their shoulders though they are some distance from the shore. There is no other instance of Moore commemorating a particular day or event in this way.

Moore, a veteran of the First World War who had been gassed at the battle of Cambrai in 1917, had been anti-appeasement, and was now, reluctantly, pro-war. The 'white cliffs of Dover', long regarded as emblematic of Britain and traditionally immigrants' first sight of the country, are here

depicted in red. In Paul Nash's ironically titled *We are Making a New World*, 1918, the top half of a painting of a wrecked Flanders landscape was a hard, evenly painted red sky. Nash's painting has been regarded as the final word in British painting on the First World War, Grigson in 1948 calling it 'a masterpiece of English painting of this century ... simply formed, rich, real and visionary.'[1] Nash's elegiac painting evoked the blood of the dead rising out of the mud at the end of the earlier war, and it is hard to see Moore's reddening of the white cliffs as anything other than admonitory of bloodshed to come. Moore did not normally use colour symbolically like this, and the equivalence of Moore's to Nash's painting was surely conscious on Moore's part.

War Artist

With his appointment as chairman of the War Artists' Advisory Committee, the director of the National Gallery, Kenneth Clark, invited Moore to contribute drawings of a bomb factory. Moore, reluctant to accept commissions unless they complemented existing plans, declined the offer. He only agreed to contribute to the war artists' project when he encountered people taking shelter on the platforms of London Underground stations when travelling home one evening soon after the start of the Blitz in September 1940.

Londoners had taken personal safety into their own hands despite the government's initial refusal to sanction public use of the Underground rail system as a refuge from the bombs at night. They feared that people would try to escape the war by remaining below permanently. 'I saw people lying on the platforms of all the stations we passed ... I was fascinated by the sight of people camping out deep under the ground',[2] Moore said, and later expressed his surprise and pleasure at 'seeing so many Henry Moores lying on the platform'. The last quotation is from an interview with the American journalist Carlton Lake in 1962, and one wonders to what extent Moore really saw people like this at the time and how much his vision of 'so many Henry Moores lying on the platform' was a later perception engendered, in part, by his own drawings.[3] Documentary photographs of the shelters show untidier scenes than any in Moore's drawings. It was Moore's initiative to show Clark the drawings. When he saw a new opening that complemented an existing direction, he seized the opportunity. It is useful to look, alongside Moore's war work, at what else he was doing at the same time, because the links between the shelter and other contemporary drawings are clear. *Reclining Figures: Studies for Sculpture*, 1940 (plate 92), shows recumbent figures who are also hollowed out tree trunks, and continues the association of figure and landscape Moore had been exploring in sculpture and drawings through the 1930s. Though this drawing comes at the human figure from the

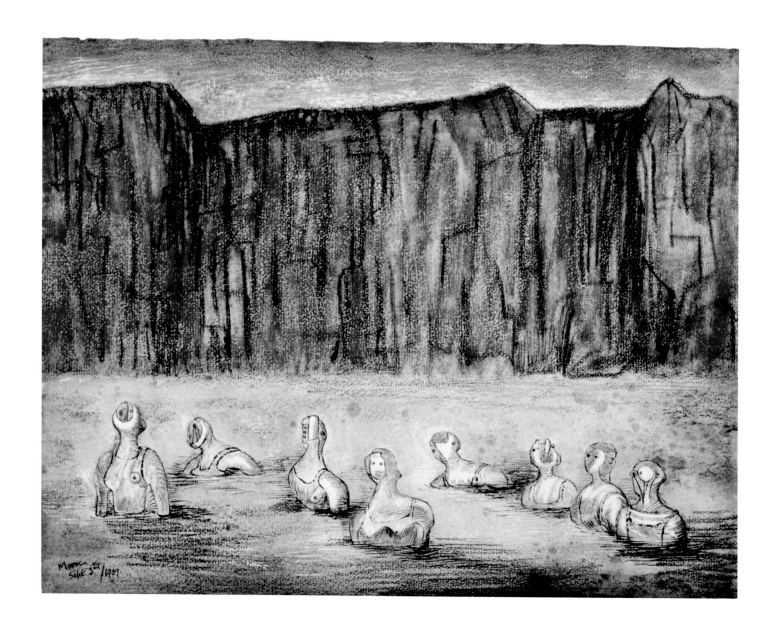

91 *September 3rd, 1939*, 1939.
HMF 1551. Pencil, wax crayon, chalk,
watercolour, pen and ink, 30.6 x 39.8 cm
(12 x 15⅝ in). Henry Moore
Family Collection

92 *Reclining Figures: Studies for Sculpture*, 1940. HMF 1534.
Pencil, wax crayon, coloured crayon,
watercolour wash, pastel, pen and ink,
27.4 x 18.1 cm (10¾ x 7⅛ in).
Henry Moore Foundation

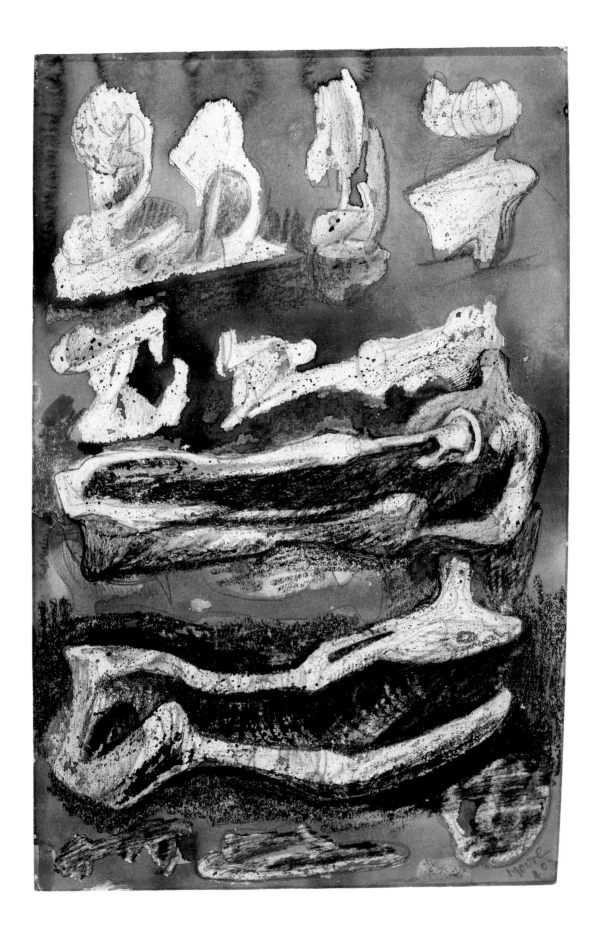

direction of vegetable nature, and the shelterers start from the human figure and point in the direction of stone memorials, both have the metamorphic character that had been Moore's original point of entry to Surrealism.

The process of making the war drawings was complex and, as Adrian Lewis has pointed out, 'Moore's drawings of shelter motifs involved considerable distance, artifice and transformation'.[4] Out of respect for people's vulnerability, Moore did no drawing directly in front of his subjects; photographs that show Moore, sketchbook in hand among shelterers, were specially posed for Jill Craigie's 1944 film on war artists, *Out of Chaos*. Returning home, Moore would fill sketchbooks with designs, quickly drawn but detailed, sometimes with more than one design to a page. The contents of two major sketchbooks survive, alongside the remains of three others to which a smaller number of sketches can be attributed. From these small pages, a group of large drawings was developed. Moore did not mind if his drawings were not conventionally accurate. His niece Ann Garrould has recalled how she and Irina would become unwitting models for him when he was making shelter drawings at home.[5] The time gap between experience and creative work suited Moore: drawing at home the following day gave imagination time to work on memory, but not so long a time that the vividness of the experience had faded. Other artists, Feliks Topolski, Edward Ardizzone, Edmond Kapp, and John Farleigh, all worked in the shelters to produce results that may be more true to the moment than Moore's, but lacked his vision, gravity and breadth of reference.

Shelter Drawings

'A visionary of the real' was Melville's phrase to describe the Moore who shaped an extraordinary but real situation of thousands of people sleeping underground in public with wide ranging historical understanding of art and vivid imagination.[6] The shelter drawings are of people sleeping, sitting, talking and occasionally knitting or reading, on London Underground station platforms. Some show the bunk beds that were eventually provided by a reluctant government lined up on station platforms, others show double rows of sleepers in the tunnel of the Liverpool Street extension, a recent pre-war engineering development where tracks had not yet been laid. Moore particularly liked the Tilbury shelter, which was not part of the transport system but a large basement in Whitechapel used for storing newsprint for Fleet Street. He also made numerous sketches of the bombed London streets he found on leaving the shelters in the morning.

The shelter sketchbooks contain drawings of ruins and collapsing buildings as well as shelter scenes, but also ideas for sculpture that pick up pre-war themes and attach them to the Blitz. *London Skyline*, 1940–41 (plate 93), includes architectural ruins, a vignette of three people sitting in a pod under the ground, and above them in the open air a monumental skeleton, an animal or perhaps a reclining figure. The idea of the lying figure, long familiar in Moore's work but now metamorphosed into a skeleton so big that it can only be thought of as prehistoric, gives an idea of how Moore re-conceived as atavistic objects of terror images previously thought of as beneficial. The theme of metamorphosis continues, potent and nightmarish.

Eighteen Ideas for War Drawings, 1940 (plate 94), represents a range of Moore's interests in the early days of the Blitz: reading from the top left, the first three images are of aerial warfare, several of the next ones are based on contrast – night and fire as against figures in daytime. Notes on the drawings include 'contrast of peaceful normal with sudden devastation'. Several others involve fire, including one of burning cows. Another is simply called 'nightmare'. Moore liked the contrast of calm and catastrophe, not just cows grazing one moment and the next on fire, but also the contrast of night and burning against the morning after, a single black shell hole rimmed with red. In October 1940 his Hampstead studio was damaged by a bomb and the Moores moved permanently to the country, at Perry Green, some 30 miles north of London but close enough for the red sky of the burning city to be visible. Cows and fire seem to stand for this combination of peaceful countryside and burning city.

Air Raid Shelter Drawing: Gash in Road, c.1940 (plate 95), shows a group exposed in a bombed air raid shelter, now just a cavity below the road, unable or unwilling to leave despite the danger of their predicament. Moore had been interested in 'below ground' since his visit to the prehistoric painted caves in 1934. *Figures in a Cave*, 1936 (plate 96), based on illustrations from Frobenius' *Das Unbekannte Afrikas*, presages tunnel entrance designs like *Tube Shelter Perspective: the Liverpool Street Extension*, 1941 (plate 98). The figures in the latter have limited animation, some talk to the person next to them and a few sit up and look around. But their white clothing resembles winding sheets and, by no means for the first time, Moore searches for an image that is both alive and dead, person and sculpture. He told Donald Hall in 1966 that he had been aware, presumably from illustrations to histories of the slave trade (plate 97), of the way Africans were tightly wedged together and kept barely alive in slave ships transporting them to America,[7] a precedent for Moore's treatment here of people as objects, as forms of still life.

Moore never saw himself as simply a visual journalist and his shelter drawings are about the here and now but also take into account the whole range of visual information and ideas Moore had acquired, including his interest in Italy and the old masters. Moore told Grigson in 1943 that the shelter drawings

93 *London Skyline*, 1940–41. HMF 1574. Pencil, wax crayon, coloured crayon, watercolour wash, pen and ink, 16.2 x 20.4 cm (6⅜ x 8 in). From the first Shelter Sketchbook. British Museum, gift of Jane Clark

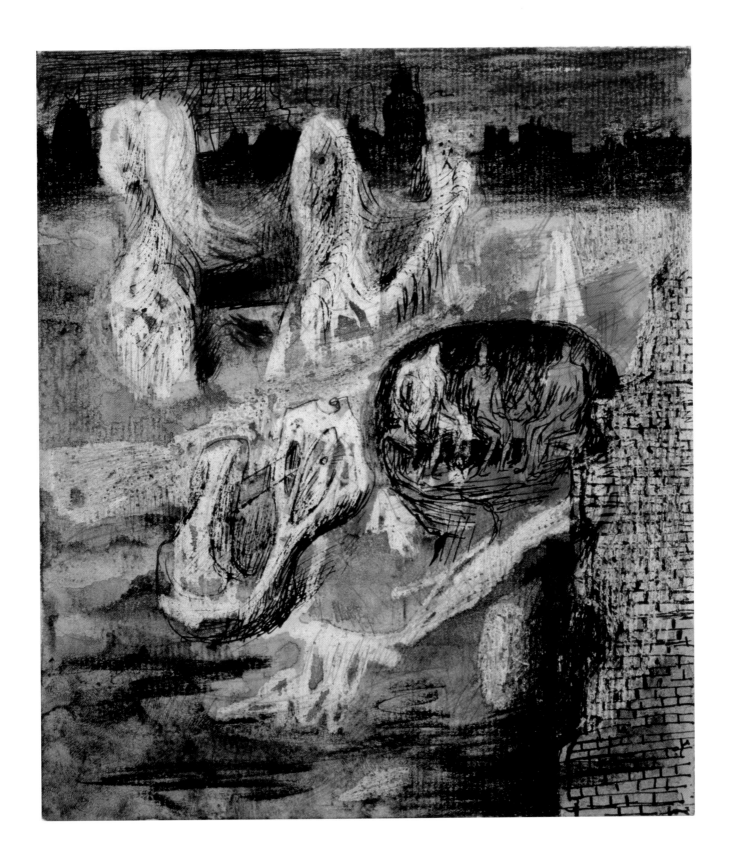

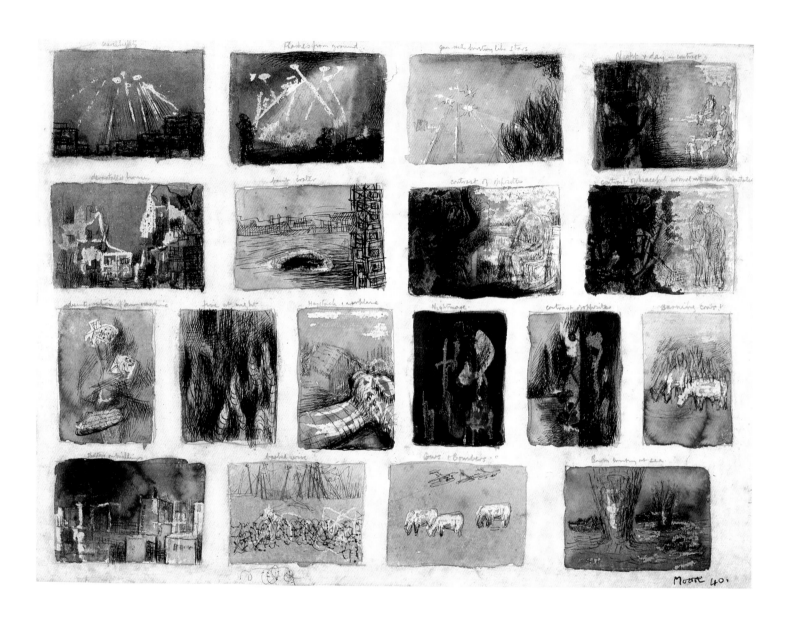

94 *Eighteen Ideas for War Drawings*,
1940. HMF 1553. Pencil, wax crayon,
coloured crayon, watercolour wash, pen
and ink, 27.4 x 37.6 cm (10 ¾ x 14 ¾ in).
Henry Moore Foundation

95 *Air Raid Shelter Drawing: Gash
in Road*, *c*.1940. HMF 1557. Pencil,
wax crayon, chalk, watercolour, pen
and ink, 38.1 x 27.9 cm (15 x 11 in).
Private Collection

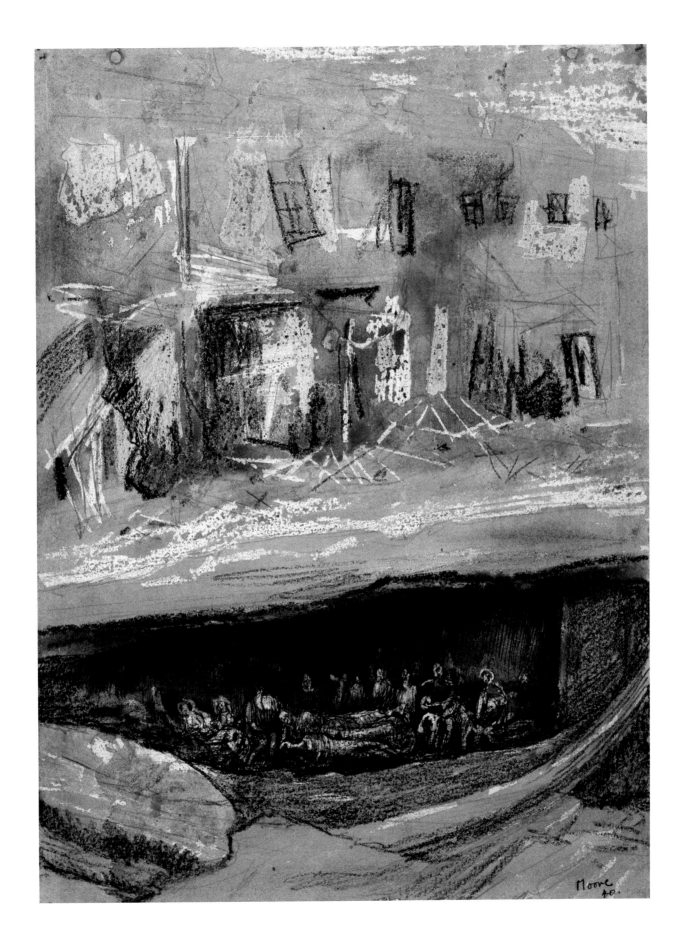

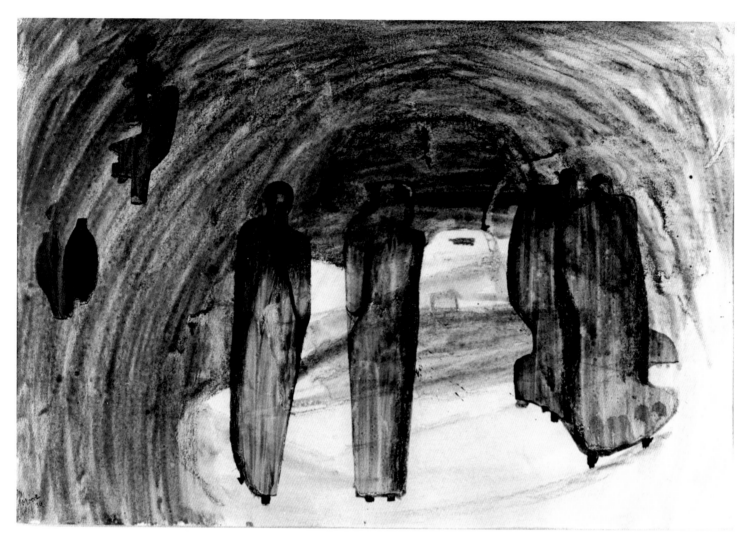

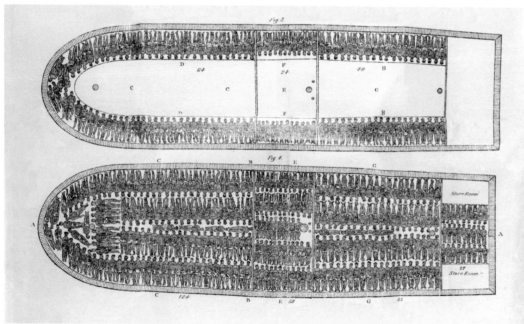

96 *Figures in a Cave*, 1936. HMF 1260.
Chalk, brush and ink, wash,
38.1 x 55.9 cm (15 x 22 in).
Henry Moore Family Collection

97 The Slave Ship 'Brookes'.
British Library, London

98 *Tube Shelter Perspective:
the Liverpool Street Extension*, 1941.
HMF 1801. Pencil, wax crayon, coloured
crayon, chalk, watercolour wash, pen
and ink, 47.7 x 43.2 cm (18¾ x 17 in).
Tate, London, from the War Artists'
Advisory Committee

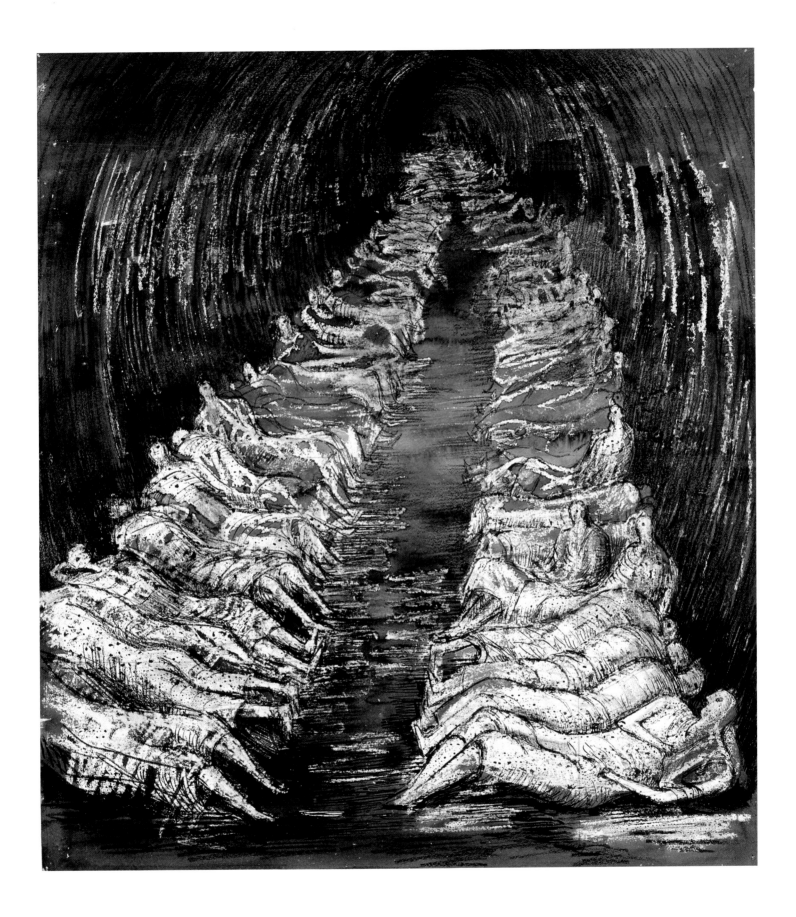

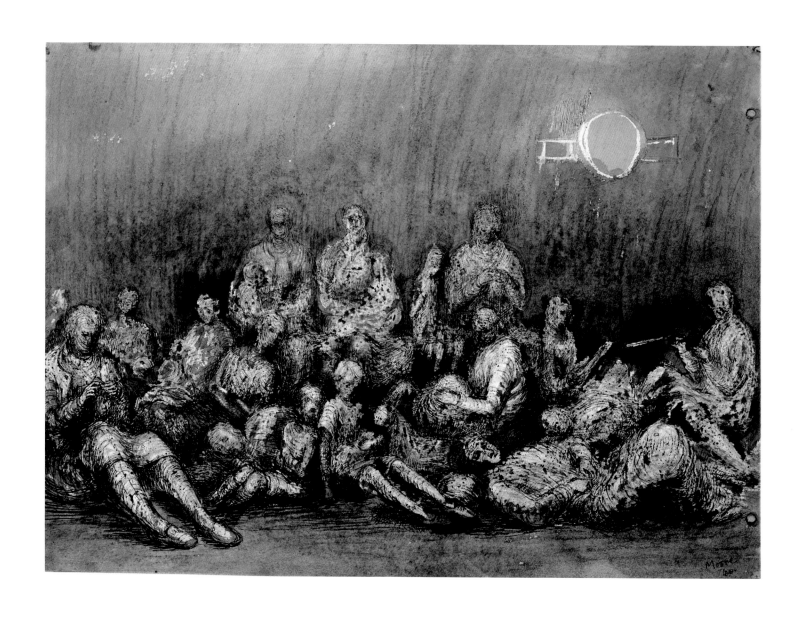

99 *Grey Tube Shelter*, 1940. HMF 1724.
Pencil, wax crayon, coloured crayon,
watercolour wash, pen and ink,
27.9 x 38.1 cm (11 x 15 in).
Tate, London, from the War Artists'
Advisory Committee

100 *Sleeping Shelterer*, 1940–41.
HMF 1964. Pencil, wax crayon, coloured
crayon, watercolour wash, gouache,
20.4 x 16.5 cm (8 x 6½ in).
Henry Moore Foundation

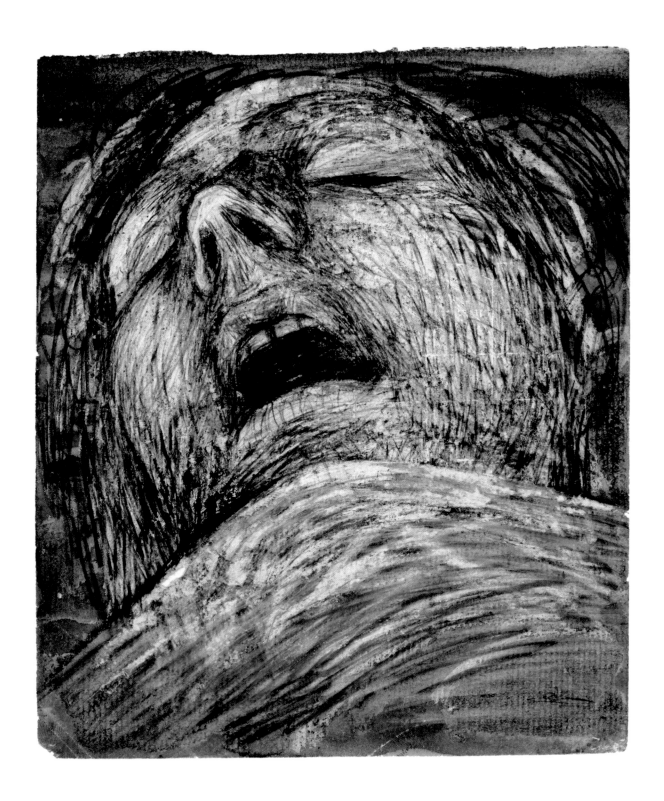

101 Giovanni Bellini, *Agony in the Garden*, *c.*1463. Oil on wood, 81.3 x 127 cm (32 x 50 in). National Gallery, London

showed him the significance of his Italian journey in 1925. The pyramidal arrangement of figures in *Grey Tube Shelter*, 1940 (plate 99), recalls a Renaissance religious composition, at the expense of the shelterers who are marshalled into this carefully managed design rather than allowed to accommodate themselves as best they could to the adverse conditions. Sylvester observed that Moore omitted what was most local – clothes, facial features – to give credibility to the whole. 'The result was that a figure or group of figures became on paper a single expressive gesture: one cannot resist the comparison with Giotto.'[8] Moore's shelter drawings are impressive because he knew how to work each scene into a single coherent whole. It was not because he conveyed the atmosphere of the shelters in detail – he did not – but that his designs create their own emotional environment.

As director of the National Gallery, now stripped of its collections, which were in safe storage for the duration of the war, Clark used some of the galleries for changing exhibitions of war commissions and wanted artists like Moore to make pictures that would be worthy of their position. In its turn, the

prospect of showing in the National Gallery was a stimulus to Moore for reconnecting with Italian art. Clark had published in 1938 a book on the National Gallery's collections with details of the two renowned depictions of the *Agony in the Garden* by Giovanni Bellini and Andrea Mantegna showing the sleeping disciples.[9] With Clark and Moore meeting regularly in 1940 it is hardly fanciful to imagine that they looked at these together and that Moore's sleeping shelterers owe something to the Italian paintings (see plate 101).

Moore's declared interests in Italian art extended only to 1500, allowing also his respect for the late sculpture of Michelangelo. Friendship with Clark and increased familiarity with the National Gallery led to a broadening of his sympathies, with the actual places he worked in playing a part. The Tilbury shelter, a spacious, high-roofed warehouse, seems to have suggested parallels with sixteenth-century Venetian painting. The figures are numerous and more animated than in the other war drawings, and the effect is of the theatricality of Tintoretto (plates 102 and 103).

102 *Tilbury Shelter Group of Draped Figures*, 1941. HMF 1817. Pencil, wax crayon, watercolour wash, pen and ink, gouache, 38.1 x 55.9 cm (15 x 22 in). Hiroshima Museum of Art

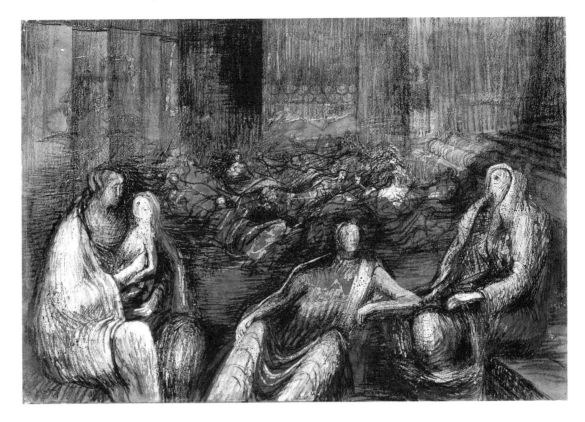

103 *Tilbury Shelter Scene*, 1941. HMF 1800. Pencil, wax crayon, pen and ink, wash, gouache, 42.5 x 38.1 cm (16¾ x 15 in). Tate, London, from the War Artists' Advisory Committee

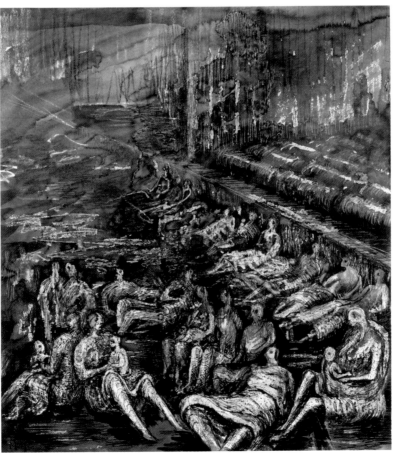

Critical Reception

Moore was shocked by what he saw in the shelters and, while not unsympathetic to the shelterers, was disgusted by the situation they found themselves in: 'The queues before four o'clock outside some of the Tube stations, of poor working women and children waiting to be let into the shelter for the night – and the dirty old bits of blankets and clothes and pillows stretched out over the tube platforms – it's about the most pathetic, sordid and disheartening sight I hope to see ... This fearful and miserable nightly Tube life seems scandalous.'[10] This down to earth view is not reflected in his drawings, not because Moore wanted to conceal the truth – which would have been pointless anyway, as the insanitary conditions were reported daily in newspapers – but because he was not a documentary artist. For Moore the aim was to shape the common man into a universal rather than localised being, one who suffered and endured, always on the edge of immobility.

In the long term, the shelter drawings were pivotal in building Moore's reputation. But ordinary people who saw them in the National Gallery were, for the most part, unimpressed and the widely held notion that the shelter drawings were an immediate success has slender basis in fact. The artist Keith Vaughan, a Moore enthusiast, wrote anonymously in *New Poetry*:

> It is a tragedy, nevertheless understandable, that so many Londoners, confronted with these drawings feel baffled and insulted. Here is a whole new underground world from which they feel themselves totally excluded, though the elements were all so familiar. The difficulty, of course, lies with Moore's concept of the human form, and some familiarity with his sculpture is essential I think to a full understanding of these drawings ... [The forms are not] devised in terms of a draughtsman's equipment from a contemplation of living people, but are essentially translated into this medium from a sculptor's conception in terms of wood and stone.[11]

The drawings were viewed by people not necessarily accustomed to going to the National Gallery in good times and not customary art lovers. The collections of war drawings were also circulated in the regions where modernist art was little embedded and there was negative criticism. As Eric Newton, a critic who prided himself on making difficult art comprehensible to a broad audience, wrote in 1945, 'quite a number of people find Moore's symbolism difficult and even feel impatient with it'.[12] For them, Moore was engaging in a field within their range of experience but treating it in terms of his own, very different, background and objectives.

Moore was not concerned to help build a feel-good factor round the shelters. Donald Newton, a student at Goldsmiths College in London when Moore gave a talk there in 1950, recalled him saying that in the First World War the Underground had been a real refuge, but by the Second World War it was a tomb for some.[13] Moore was right: a bomb at Balham on 14 October 1940 burst a water main and 60 people were drowned, and on 11 January 1941, a bomb at Bank station killed 57 people on the concourse.[14] That the shelters saved lives is beyond question, but danger remained. Contrary to the camaraderie that grew to surround the shelters in people's memories and the myths that grew from them, sudden death was a real issue and present in Moore's mind.

The Liverpool Street extension, as Moore drew it, was like a mausoleum with figures as crowded tomb sculptures. Even in the more recognisably human drawings, like *Pink and Green Sleepers*, 1941 (plate 104), the colours are inhuman, with green especially pointing to putrefaction. Other drawings of sleepers further abstract the figures from any definite environment, and overall pattern starts to take precedence over the human aspect. One small sketch is titled 'sea of sleepers', a theme developed in *Shelter Drawing*, 1941 (plate 105), with its extensive space unrelated to any location Moore worked in and figures in white crayon who seem to float on the darker ground that surrounds them. Though this work is sketchier than *Sleeping Shelterers*, 1941 (plate 106), the two are variants of a theme rather than sketches one for the other because both are large format drawings of similar size. Paul Nash's *Totes Meer* made over the winter of 1940–41, also for the War Artists' Advisory Committee, is an imagined sea not of figures but of wrecked German aircraft which, in describing the painting, Nash referred to as at one moment dead and at the next as possibly alive. Nash was also concerned with metamorphosis, and specifically the point at which it is not possible to say with certainty that a thing or person is animate or lifeless. For both artists Surrealism was still very much alive.

Some writers saw the issue of the shelter drawings as one of time and timelessness, with the overnight stay on a station platform equated with something more permanent – a kind of death. W. R. Valentiner, wrote in 1946 that he did not feel Moore rendered

> a specific passing event of modern war ... [but] that he adds an eternal character to these life studies, which takes them out of the atmosphere of momentary happenings. The figures ... [have] something supernatural about them. They appear like ghosts of the earth, as if they had lived for eternities under the ground of which they are a part. Their connection with the protecting earth around them is complete.[15]

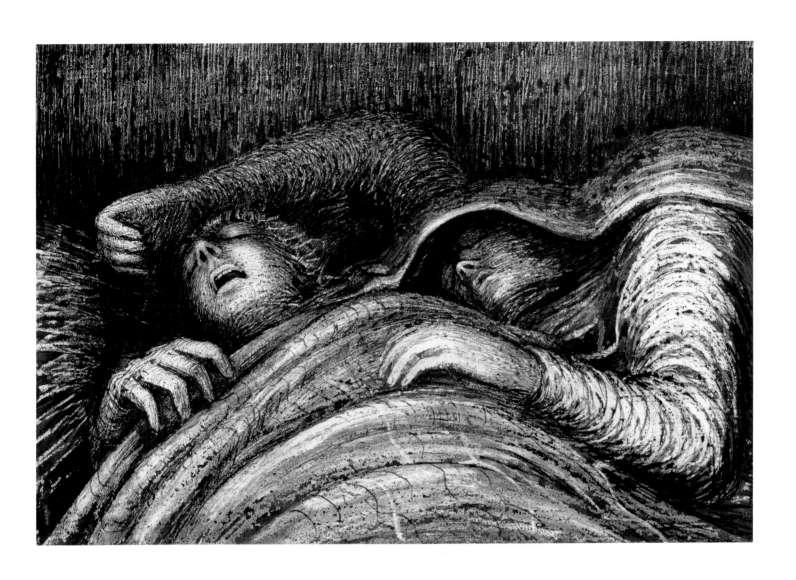

104 *Pink and Green Sleepers*, 1941.
HMF 1845. Pencil, wax crayon, coloured
crayon, chalk, watercolour wash, pen
and ink, 38.1 x 55.9 mm (15 x 22 in).
Tate, London, from the War Artists'
Advisory Committee

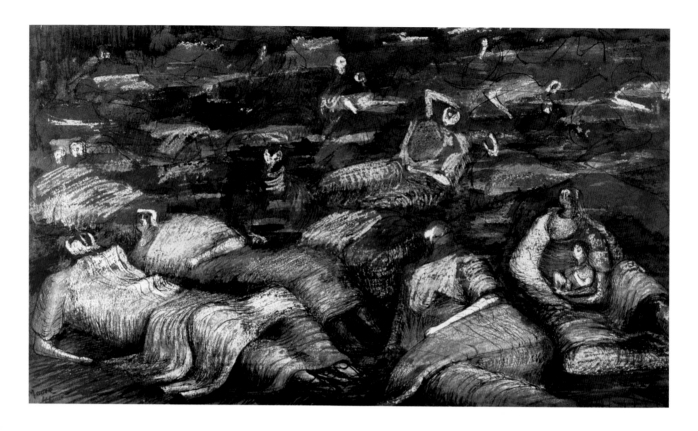

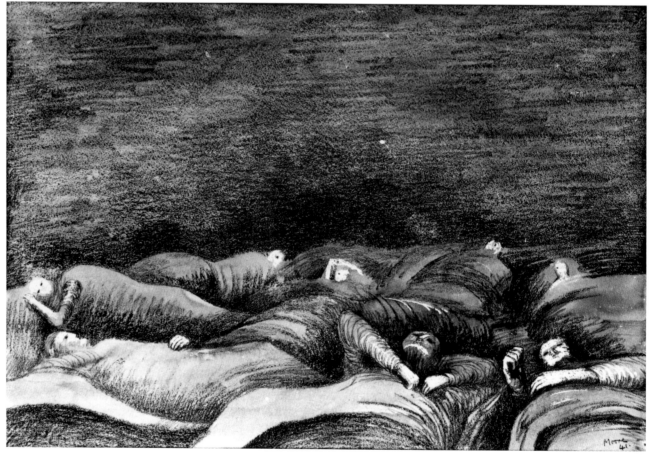

Frederick Wight, in 1948 described the sculpted reclining figures and shelterers together as having

a curious air of being aroused to a different kind of life to ours, to be looking about after a revival from a trance. They have a static life, more intense than ours, that is devoid of incident. They have the Lazarus look; they are brought like Alcestis from the grave. Moore is dealing here with mortality and immortality.[16]

More specifically than other writers, Wight associates the shelterers with death and resurrection: the Christian tradition of Lazarus and the rescue from Hades of the Greek princess Alcestis, subject of a play by Euripides. Both Americans, Valentiner and Wight were distant from the events portrayed and were writing with hindsight after the end of the war. This gave them an advantage over British critics of the wartime shows, enabling them to see a wider context and establish beyond question that the figures are more than casual shelterers. They are effigial, sleeping, beyond time, entranced, with the possibility, maybe, of some kind of resurrection or return to life. They are resigned rather than heroic, enduring what is beyond comprehension.

Neo-Romanticism

The shelter drawings have been seen by some writers as an interpolation in Moore's art, reflecting a special moment in British history and Moore's acceptance of a temporary role in public life, following which he returned to sculpture. In 1940 Moore had no sculpture studio and materials for sculpture were hard to acquire. But the argument that he was *forced* into drawing – and drawing of this kind, in particular – is not convincing. He had found in Surrealism both the excitement of new developments in sculpture coming from Paris, but also ideas that were essentially pictorial or graphic. Long before the war, Moore had been conscious that there were things relevant to himself that drawing and painting could do and sculpture could not. Wartime Neo-Romanticism found its typical expression in painting, drawing, the graphic arts, book illustration, and design for film, theatre and opera. Among the visual and performing arts, sculpture alone was not its favoured medium of expression. To say that in 1940–41 making war drawings was a logical decision is not to deny that Moore saw himself primarily as a sculptor and intended to return to sculpture when circumstances allowed. Moore saw no contradiction in a sculptor drawing ideas and strength from painting. He told Wilkinson in 1984:

Although I am primarily a sculptor, I've never separated my interest or appreciation of painting from sculpture.

On my travelling scholarship, in my own collection, in one's gallery going, I have probably looked at painting as much as sculpture: I've got as much sustenance, inspiration and nourishment out of Masaccio as I've got from any sculptor's work. I would as soon look at Cézanne's *Bathers* as Rodin's sculpture. It is quite natural that this should come out in one's drawing.'[17]

There was a strong historical orientation in Moore's work now, not only to Masaccio and other Italians, but to earlier British art. His work had in common with Neo-Romanticism a desire to reconcile modernism with tradition, and there is no doubt that Grigson, a prime mover in the recovery of Romantic painting of the early nineteenth century, influenced Moore's thinking. In his Penguin Modern Painters book, Grigson proposed the influence of Blake, Turner and James Ward.[18] Moore's *Eighteen Ideas for War Drawings* (plate 94) include images of explosions and fires marked by the kind of curiosity and wonder that Joseph Wright of Derby towards the end of the eighteenth century found in fireworks at night above the Castel Sant'Angelo, Vesuvius erupting, and a Derbyshire mill by moonlight. Moore's interest in caves parallels Wright's for the coastal grottoes around Naples. Fire at night was the subject of Turner's *Burning of the Houses of Lords and Commons*, 1835, a painting with obvious meaning for an artist working in the Blitz. One of the drawings of the Tilbury shelter, *In a Large Public Shelter*, 1940–41 (plate 107), and, among the later mining drawings, *Miners Walking into Tunnel*, 1942 (plate 108), both have cavernous spaces dwarfing the crowded figures contained in them in the spirit of the Romantic John Martin.

The characteristics of Neo-Romantic painting include strong colour, a heavily worked surface with use of different materials, absence of prejudice against watercolour, and treatment of the human figure – often in the context of landscape. All these except, perhaps, landscape connect with Moore. The term Neo-Romanticism in relation to British art had been introduced by Raymond Mortimer.[19] Mortimer's review of Moore's exhibition at the Leicester Galleries in the *New Statesman* February 1940, in which he remarked on the importance of colour for Moore was quoted earlier (see above p. 14).[20] An earlier, anonymous, commentary on Moore's drawings show at the Mayor Gallery in the same journal, and perhaps also the work of Mortimer, had suggested that 'there are some exercises in coloured shapes which make one wonder whether he is not at least as gifted for painting as for sculpture'.[21] *The Times* critic of the Mayor exhibition suggested that 'his use of colour to reinforce form is so apt that one would like to see paintings by him'.[22] Later, in 1974, Kenneth Clark wrote of his own drawing, *Drawing for Sculpture: Two Women*, 1939 (plate

105 *Shelter Drawing*, 1941.
HMF 1815. Pencil, wax crayon, chalk, watercolour wash, pen and ink, 33 x 55.9 cm (13 x 22 in). Private Collection

106 *Sleeping Shelterers*, 1941.
HMF 1814. Pencil, wax crayon, coloured crayon, watercolour wash, 37.4 x 55.8 cm (14¾ x 22 in). Fitzwilliam Museum Cambridge: on deposit from Keynes Trust, King's College, Cambridge

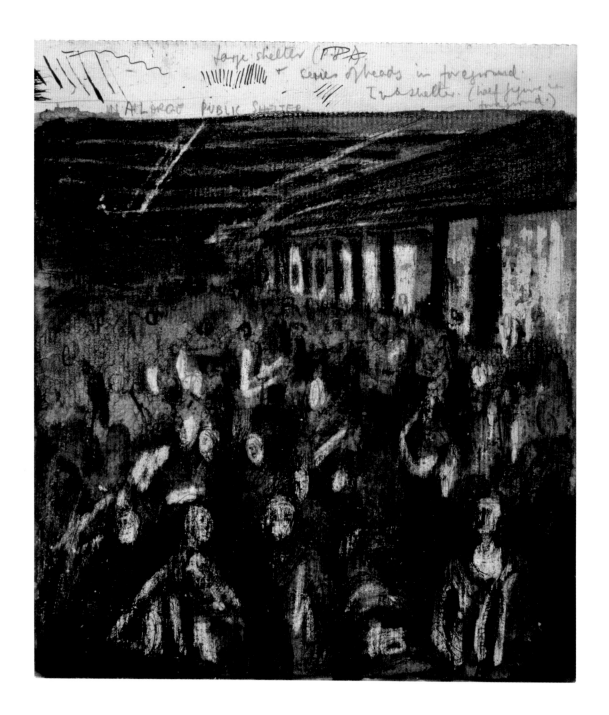

65): 'Of course it is not a drawing for sculpture in any medium, but a creature of his imagination which has taken so strong a hold on him that he made it into a painting.'[23] Clark continued to persuade Moore to make paintings for the WAAC and in the summer of 1941 Moore agreed to make paintings of 'medical aid posts' in Bermondsey and Stepney.[24] The contract for the mining drawings intervened in the autumn and the 'medical aid posts' project was forgotten until May 1943 when the committee came up with a substitute idea for Moore to paint 'objects dropped from the air' which had been assem-

bled at a Ministry of Home Security's Research and Experiment Station,[25] and as late as 1944 the WAAC instructed the artists' colourmen, Lechertier Barbe in Jermyn Street, to send Moore six medium to large sable brushes at their expense.[26] By that time Moore was fully engaged with sculpture. However, enthusiasm on the part of the committee did not abate, and still in July 1945 they were following up a much earlier commission for Moore to complete work at the Bomb Museum at Princes Risborough.[27] The story is worth telling because it shows how Clark's initial confidence that Moore was potentially

107 *In a Large Public Shelter*, 1940–41. HMF 1592. Pencil, wax crayon, coloured crayon, watercolour wash, pen and ink, 16.2 x 20.4 cm (6⅜ x 8 in). From the First Shelter Sketchbook. British Museum, gift of Jane Clark

108 *Miners Walking into Tunnel*, 1942. HMF 1943. Pencil, wax crayon, coloured crayon, watercolour wash, pen and ink, 20.3 x 16.2 cm (8 x 6⅜ in). Henry Moore Foundation

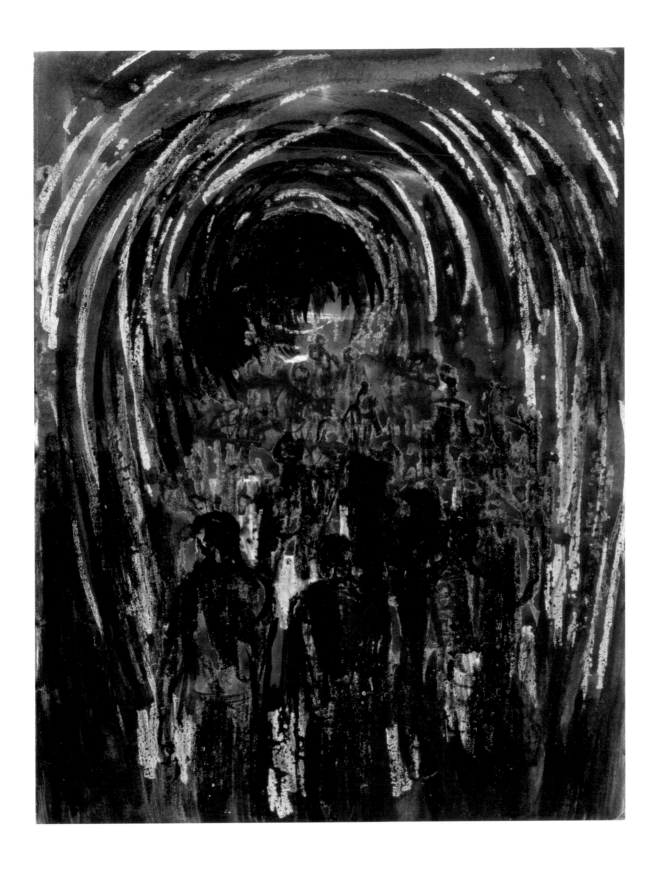

a serious painter endured, and also that despite Moore's achievement in the field, he never doubted – signed contracts notwithstanding – that he was primarily a sculptor.

Moore was interested in pictorial techniques. His niece Ann Garrould recalled being taken to see him as a child in the 1930s. Moore borrowed her wax crayons for a drawing and observed how when he then covered the sheet with watercolour, it ran off from the waxed areas. Moore would then take a pen and finish the drawing with black India ink.[28] The 'wax resist' technique transformed his drawing into something that could fairly be called painting at a time when, even before the shelter drawings, he was developing pictorial images in deep space. Moore's rich colours have the depth and luminosity of coloured inks rather than ordinary watercolour, and in this he is like Graham Sutherland and John Piper, artists who are more conventionally linked to the Neo-Romantic movement. But there are reasons other than his use of colour to associate Moore with Neo-Romanticism. Moore's theatricality had been increasingly obvious in the drawings of 1937–8 of machine-personages on stage. Finally, the 1940s was the only decade when he agreed to commissions for book illustration.[29]

A principle advocate of Neo-Romanticism was Robin Ironside, a painter and curator at the Tate, who included Moore in 1947 in his *Painting since 1939*, a primary document of Neo-Romanticism, praising the vividness of Moore's drawings without denying that he was 'properly a sculptor'.[30] Ironside was to be a prime mover of the short-lived revival of Pre-Raphaelite painting in the 1940s and had already published an article comparing Gustave Moreau with Edward Burne-Jones in Cyril Connolly's journal *Horizon*, in which Moore's drawings were occasionally reproduced. The article reproduced a version of Burne-Jones's *The Sleeping Knights*, 1871 (plate 109), from the Briar Rose series, and was published in September 1940, the first month of the Blitz and also of the first of Moore's shelter drawings.[31] Ironside saw Burne-Jones's soldiers as being so close to the earth that they were virtually identified with it. 'Heaped together, their congealed figures have almost the character of an igneous deposit once instinct with life, but eventually to be merged into the soil on which it fell.'[32]

Ironside's words could almost be a description of Moore's great sculptural reclining figures of the late 1930s, their earth-bound gravity modified by the cavities cut into them, but in their similar motionless calm devoid, like the earth, of any implication of movement. In discussing the nature of myth in nineteenth-century British art, Leonée and Richard Ormond have pointed out that what the Victorians liked were not big, dynamic subjects, bacchanals and battles, but sombre subjects involving personal tragedy and doomed love, subjects involving life and death, and contrasts between the human and the

underworld.[33] The sense, particularly in the shelter drawings, of calm introspection, of an in-between world of sleep intervening between life and death, continues a Victorian approach in modern terms.

Humanism

Uncertainty as to who the shelterers really were – where were they on the scale between everyday people and funerary effigies? – stimulated discussion of humanism. Herbert Read championed Moore's humanism, describing the shelter drawings in 1944 as the 'most authentic expression of the special tragedy of this war – its direct impact on the ordinary mass of humanity, the women, children and old men of our cities'.[34] It is a fair summary, even if Moore's blunt expression of disgust at the shelterers' physical condition was less than approving.[35] In later interviews, at a distance from the war and when his shelter drawings had gained more widespread approval, Moore shifted his position somewhat, allowing that the shelter experience was 'an absolute human sympathetic thing'.[36] Later, however, Read championed Moore as humanist on the over-simple grounds that 'like the humanist sculptors of Greece

109 Edward Burne-Jones, *The Sleeping Knights*, 1871, from the Briar Rose series. Oil on canvas, 59.1 x 82.6 cm (23¼ x 32½ in). Walker Art Gallery, Liverpool

and Italy, he expresses himself mainly through the human figure'.[37] However, at least since 1930, Moore's focus on the human figure had not reflected the concerns of Greece or Renaissance Italy, and it is odd that Read should have thought this, because he has already been quoted as referring in the previous paragraph to Moore saying that 'the realistic ideal of physical beauty in art which sprang from fifth-century Greece was only a digression from the main world tradition of sculpture, whilst, for instance, our own equally European Romanesque and Early Gothic are in the main line.'[38]

Melville, who had a deep antipathy to Read's writing, identified a shift in Read's post-war writing that he himself, resolutely committed to Surrealism, felt was a betrayal of Read's pre-war values. Melville wrote later, looking back on what Read had written in 1944, that 'because animism represents a primitive stage in human development, Sir Herbert Read specifically rejected the idea that modern art could be in any way identified with animism, and considered the work of Moore to be 'inherently humanist.'[39]

The shelter drawings certainly did not show intelligent, rationalising man in control of his fate so much as barely animate man in flight from a hostile world. Already by the late 1930s, Moore's man was victim rather than hero, not so much 'doing' as 'done to', and by the 1940s he was relegated to a sunless, underground world, awaiting an unknown destiny. Moore's drawings were truthful to the human condition at a time when there were few grounds for optimism. His re-connection with Renaissance art during the war was neither a reconciliation with the humanism of the Renaissance, nor a manifestation of the rationalising power of the human mind. The formal strength and power of expression he had admired in Masaccio in Florence in 1925 is not reflected in the hollowed out shells of figures in the 1940s (see plates 75 and 92) or the shelterers. Moore's telling Sweeney in 1947 that the shelter drawings brought him to a better understanding of his Italian visit meant no more than that he was returning to a more representational form of art.[40] An alternative approach to the humanist debate was taken by Nikolaus Pevsner in 1945. He wrote that what Moore

did discover in the Tubes was only a re-discovery. Again he found below the visible forms of these inert sleepers a sub-human newt-like existence. No human beauty, no human pride, and certainly no *ratio* left in them. But we cannot say that Henry Moore abandons mankind to this cavernous gloom without sympathy and commiseration.

... Why does Henry Moore go on insisting on a hard core of humanity? The answer, if my interpretation of the *Shelterers* is acceptable, would be that the born abstract artist is a law-giver, not one who patiently listens. Henry

Moore does; his notebooks show how he lets forms grow. But in growing they lose their humanistic values, and they lose all their freedom of action. The power they gain is blind and awful. Is it the only power which we can express today without giving up sincerity? I am inclined to answer No, and to call upon the Northampton statue as my witness.[41]

The *Madonna and Child* in the church of St Matthew, Northampton, 1943–4 (LH 226), is one of the most representational sculptures in Moore's oeuvre. Pevsner acknowledged Moore's importance without actually liking most of his work because of his own limited appreciation of modernist art. The statement is interesting because, despite Pevsner's personal reservations, his analysis has insight into the tragedy that absence of *ratio* and freedom of action bring. It is as if Pevsner had no problem with Moore except that he himself did not like such deeply pessimistic art.

Miners

Towards the end of 1941 Moore returned to Castleford, where his father had been a miner, to make drawings for the War Artists' Advisory Committee (plate 90). Sketches were made at Wheldale Colliery, Castleford (plate 110), and finished drawings (plates 111–12) were accepted by the committee in May 1942. Moore did not want to do them and showed little interest in them later. As Clark wrote in 1974, 'the spectacle of miners at work did not move him. It was, he said, "a commission coldly approached" and I suppose we must take his word for it. But the drawings show no signs of the dutiful deadness that is apparent in some of his sculptural commissions ... and personally I think they are underrated, both as works of art and as influences on his development.'[42] In an interview with Joseph Darracott of the Imperial War Museum in 1975, Moore pointed out that he had almost no experience of drawing male figures and 'the poses in my sculpture were very static. But here I had to look at men in violent action'.[43]

The drawings were an unusual departure for Moore but no worse for that. Critics have pointed to the lack of movement in Moore's drawn figures, some of them likened to still lifes. Clark recognised that the mine drawings were different, representing vigorous movement of figures within very restricted spaces. They are the only example of Moore drawing ordinary people at work and may even suggest that everyday people who could not be mythologised, in the sense of being depersonalised and drawn into a wider debate about survival, death and the effigial, did not really interest him. The shelter drawings could be merged into the continuity of his work while the mine drawings could not. They are excellent of their kind and, if they do nothing else, they show that

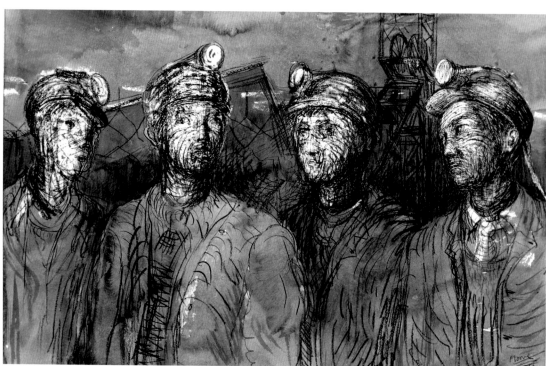

110 *Miner at Coalface with Tupping Machine*, 1941–42. HMF 1907. Pencil, crayon, 12.7 x 20 cm (5 x 7⅞ in). Henry Moore Foundation

111 *Pit Boys at Pithead*, 1942. HMF 1985. Pencil, wax crayon, coloured crayon, watercolour wash, pen and ink, 49.3 x 49.5 cm (19⅜ x 19⅜ in). Wakefield City Art Gallery, from the War Artists' Advisory Committee

112 (opposite) *Coalminer with Pick*, 1942. HMF 1987. Pencil, wax crayon, coloured crayon, watercolour wash, pen and ink, 49.3 x 49.5 cm (19⅜ x 19⅜ in). Imperial War Museum, from the War Artists' Advisory Committee

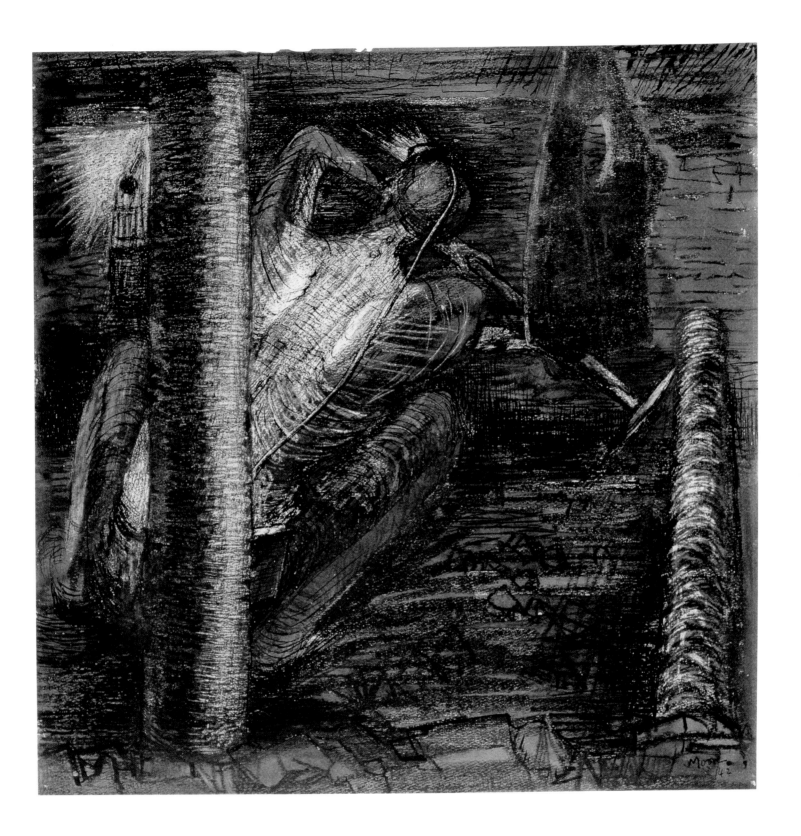

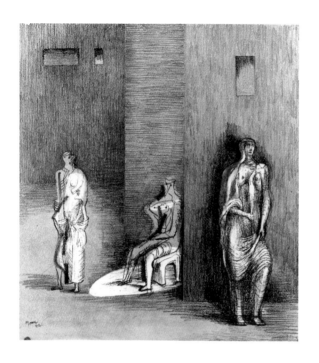

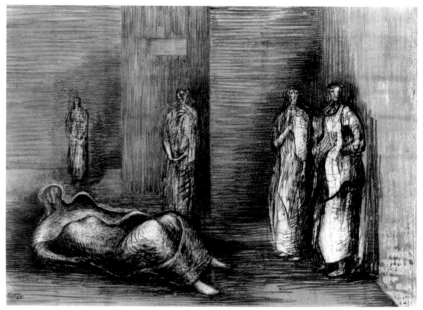

Moore was technically capable of a type of documentary drawing of men at work in confined, awkward spaces, which does not appear elsewhere in his work. Talking to Darracott, Moore contrasted the miners with the shelter drawings which, he emphasised, allowed him to engage with humanity, ordinary people under stress.[44]

Figures in a Setting

'Figures in a Setting' (plates 113 and 114) describes a group of drawings Moore made in 1942. Like the shelter drawings, these theatrical ensembles take place in shadowy spaces where people converse and a woman holds a child without any real sense that domestic life exists or action is possible. The same passivity is evident as existed in the shelter drawings, with figures, standing, sitting or occasionally lying on the ground, waiting for what happens next. There is a reminiscence also of the 1937-8 'mechanisms', not in the figures themselves – who are now, following the shelter drawings, relatively naturalistic – but in the sense of theatre, of people as objects put on display. Blind windows in the form of dark slits in the wall reappear and despite the spaciousness of the rooms there is a sense of containment and constraint.

Kenneth Clark recognised in these drawings 'the fateful air of antique tragedy',[45] and later alluded to 'the Aeschylean sense of menace' that was 'present in all Moore's drawings of the 1940s'.[46] American critics who saw them in Moore's first one-man show in America, at the Buchholz Gallery in New York, in 1943, were cautious. Edward Alden Jewell of the *New York Times* wrote that 'the drawings, even though they may indicate a genuine plastic talent, seem aloof, frigid, mannered'.[47] Jewell was right in what he observed, but did not understand that it was Moore's intention, drawing inspiration from Greek tragedy, to create effects of the ritualised and static. Moore saw how Greek theatre kept much of the action off stage, and depended on messengers delivering news of events to women and children waiting at home. Moore was an enthusiastic theatregoer and an unreserved admirer of T. S. Eliot, whom he met first in the 1930s. Eliot as playwright achieved what Moore does here: the creation of figures with a foot in real life but on the edge of some ultimate darkness that they seem in part aware of but unable to respond to. This was Moore at his most deeply pessimistic.

The 'Figures in a Setting' series overlaps a series that surfaces intermittently between 1940 and 1946 on the theme of the artist in his studio and Moore's own sculpture on exhibition. *Figures in an Art Gallery*, 1943 (plate 115), shows three upright human forms in the same kind of space, the same darkened window openings, the same pool of theatrical light illuminating Moore's sculpture as in *Three Figures in a Setting* (plate 113). There is tension between the naturalistically

113 *Three Figures in a Setting*, 1942. HMF 2099. Pencil, wax crayon, coloured crayon, wash, pen and ink, 45.7 x 43.2 cm (18 x 17 in). Santa Barbara Museum of Art, gift of Wright Ludington

114 *Figures in a Setting*, 1942. HMF 2095. Pencil, wax crayon, coloured crayon, wash, pen and ink, 37.5 x 53.6 cm (14¾ x 21⅛ in). Fine Art Museums of San Francisco, Ruth Haas Lilienthal bequest

115 *Figures in an Art Gallery,* 1943.
HMF 2161. Pencil, wax crayon, pastel,
coloured crayon, watercolour wash, pen
and ink, 48 x 51.1 cm (18⅞ x 20⅛ in).
Private Collection

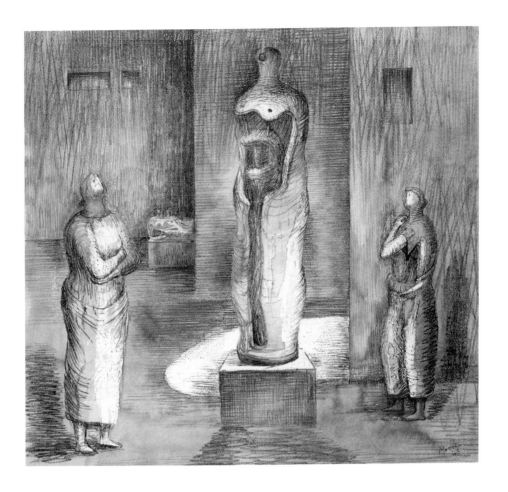

116 *In the Sculptor's Studio,* 1946.
HMF 2380. Pencil, wax crayon,
coloured crayon, was, pen and ink.
Size and collection unknown

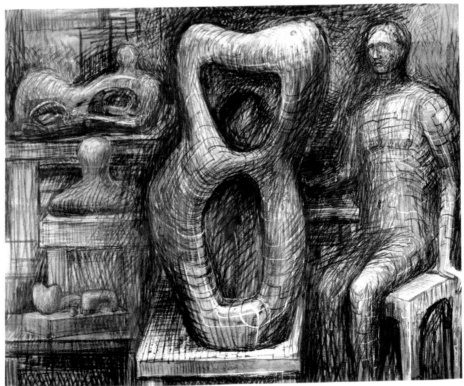

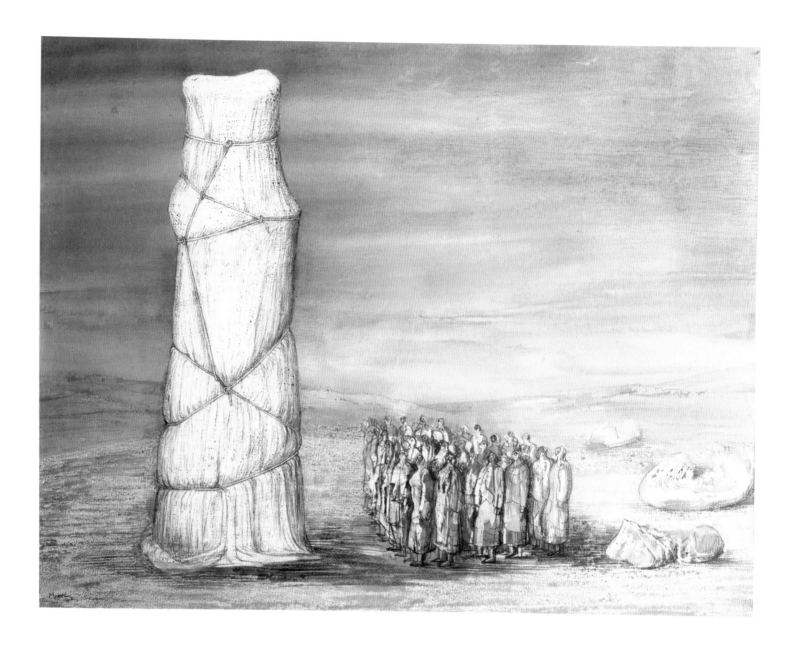

drawn human observers and the sculpture, which mirrors them except that its inner workings are exposed. The 'mechanisms' of 1937–8, in so far as they were human at all, had the outside layer, the protective carapace, removed so that one could see the interior organs that would normally remain hidden. As Moore turns to more representational images, the epidermis is partly restored to the object on display so that the two observers see mirrors of themselves but in a state of partial exposure. Moore is still driven by the force behind Schapiro's argument that, after Picasso, probing the human meant looking inwards, and it was the role, he could be saying here, of sculpture to exhibit this.

The series ends in 1946 with *In the Sculptor's Studio* (plate 116) which shows a sculptor with, in the centre, a Moore-like sculpture that had not actually been made and, on the left, three sculptures, two of which are identifiably Moore works of the 1930s. This is a sculptural 'retrospect' made in the year of the artist's first full-scale retrospective exhibition, at the Museum of Modern Art, New York. Though the sculptor figure in the drawing is not identifiably Moore, it is difficult not to see it as a self-portrait. The sculptor is naturalistic, a classic integral form, touching an abstract sculpture that is scarcely – if at all – identifiable as human.

In different ways, both *Figures in an Art Gallery* and *In the Sculptor's Studio* are about people looking at themselves: the first suggests that sculpture can expose to a gallery goer some-

thing about themself that they would not otherwise see; the second shows the sculptor juxtaposed with his own work. In each case the mirror can be seen as an instrument of distortion, if one observes that the reflection is not the same as the original image. Alternatively, the mirror can be seen as the instrument of truth, if true understanding of self is connected with the idea of looking inside or self examination.

Open Spaces

Crowd Looking at a Tied-up Object, 1942 (plate 117), derives its title from an inscription on the study for it (plate 119). The finished work is one of the most enigmatic of Moore's drawings, and yet its concerns are similar to the contemporary *Figures in an Art Gallery*. Its subject is people looking at mirror effects of themselves, though now the distortion is more radical, the two sides – crowd and object – unalike, and the result more of what we normally think of as a collage of images than any collage Moore actually made. Numerous explanations of the tied-up object have been proffered. Moore told Ann Garrould that the idea for the tied-up object came from the practice every evening at the Royal College of putting wet cloths over clay to stop it drying out.[48] Max Ernst, visiting Moore's studio in 1938, recalled Moore keeping cloths over his sculptures, presumably referring to his clay maque-

ttes.[49] Kenneth Clark, who owned the drawing, recalled Moore telling him that 'he saw a tied-up piece of stone being transported by a lorry, and this made him feel how mysterious such an object can be, half revealing its form by the tension of the cords, and half arousing our curiosity as to its real shape.'[50] A photograph exists in the Henry Moore archive which shows what appears to be one of Moore's own sculptures (probably the tall, thin 'Shawhead' *Standing Figure* of 1950) encased in plaster after casting and roped around to prevent the plaster sections falling away.[51] Wilkinson has suggested the inspiration of an illustration of Nupe tribesmen draped in white sheets from Frobenius's *Kulturgeschichte Afrikas* as the source for the draped object.[52] Clark suggested that the object 'has become a sort of fetish, the *objet de culte* of a primitive community. But I think there was also present in his mind an etching by Goya in *Los Proverbios* in which a group of soldiers is terrified by a huge draped figure who appears to them on the left of the frame [plate 118]'.[53] One might add to these Man Ray's the *Enigma of Isidore Ducasse*, 1920, the best known example at that point of an object wrapped and tied in order to create tension and uncertainty.

Moore's work is not to be held to a single account, and any of these observations or historical precedents could have fed into this drawing. None, however, helps account for the neat

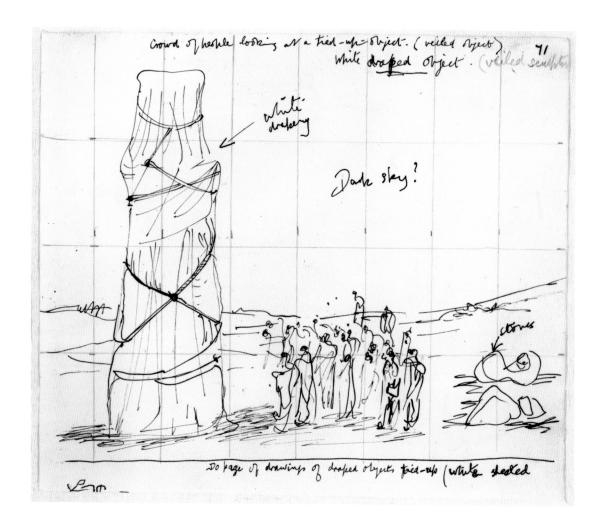

119 *Study for Crowd Looking at a Tied-up Object*, 1942. HMF 2045. Pencil, pen and ink, 15 x 17.5 cm (5⅞ x 6⅞ in). Private Collection

120 *Sculptor Carving a Colossal Figure*, 1942. HMF 2053. Pencil, pen and ink, 22.5 x 17.5 cm (8⅞ x 6⅞ in). Private Collection

urban crowd, well dressed and equipped with handbags in this desert-like setting. They are clearly displaced from an urban context as if an element in a collage of a kind Moore never actually made. The crowd forms a tight phalanx as if from nervousness or fear of separation from one another in front of an unknown threat – or perhaps, more simply, because the urban space from which they have been relocated was itself constricted. The crowd is itself 'tied up', in the sense of compressed, and is to that extent the equivalent of the object. The earlier examples of this kind of mirroring – such as *Figures in an Art Gallery* (plate 115) – had had the effect of exposing internal organs and sculptural workings to view. In contrast, mirroring here derives from covering and conceal-ment. Clark's reference was to Goya's *Disparate de Miedo* [*Folly of Fear*], *c*.1816–24, which shows a colossal white-cloaked figure on the left and a company of soldiers, some falling terrified to the ground, others in headlong flight. There are other Goya prints, from the *Caprichos* (1799), which show cloaked forms facing scared crowds. One of them, *What a*

Tailor Can Do!, shows a small tree draped to conceal all but its branch tips and made to look like a human colossus; another, *Here Comes the Bogeyman*, was a child frightener. Goya was interested in human foolishness as well as the sources of terror in the colossal, featureless (in these examples) and the inexplicable. If Clark was right, and Goya's was at least one influence here, the effect is to show not only a likeness between the two artists but also a distinction. Goya was master of the demonic and, as Clark pointed out, some of the best of Moore's pre-war drawings were also demonic. But Goya stands behind only a certain aspect of Moore's work. Goya's monster in *Folly of Fear* instils terror, while the response to Moore's tied-up object is curiosity. Goya and Moore were both artists involved with people's experience of war. Goya's concern in *Folly of Fear* is with flight as a response to terror. Moore's war work as a whole is underpinned by a different kind of flight, which is not violent or even sudden, but is a withdrawal as much as a flight into a womb-like underground, where death is expressed as immobility.

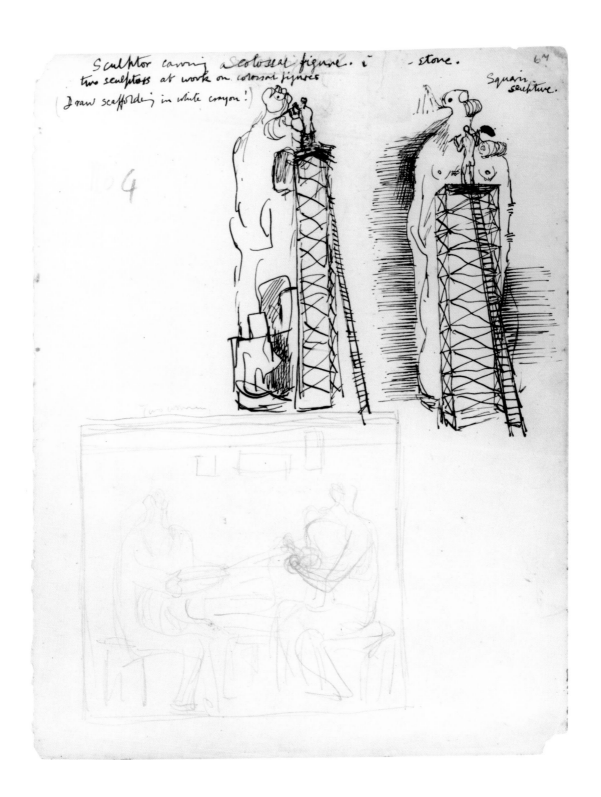

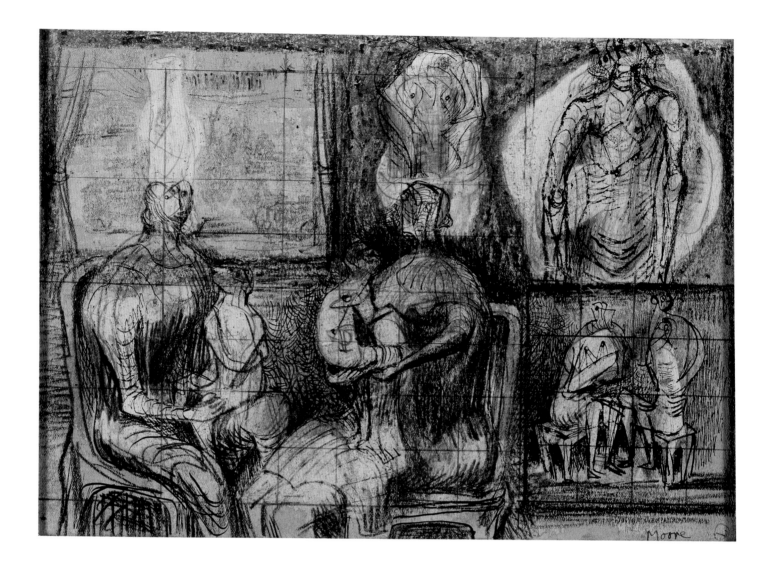

Mother and Child Studies, 1942 (plate 121), shows women with babies in the foreground and a curtained window opening onto a variant of *Crowd Looking*, in which the monument is in the middle and the crowd behind and perhaps also to the right. This was developed around 1946 into the finished drawing *Girl Reading to a Woman and Child* (plate 122), in which – as with the sketch – it is impossible to tell if we are looking at a picture on the wall or a scene through the window. The arrangement of figures in relation to the monument in the 1942 sketch tends to bear out Wilkinson's argument that Moore's scene derives from the procession of Nupe tribes-

men in northern Nigeria in Frobenius. The 1942 sketch and the 1946 *Girl Reading* are different from *Crowd Looking* because of the domestic settings and the presentation in both of *Crowd Looking* merely as a picture on the wall or a scene 'out there'. Putting *Crowd Looking* into a domestic setting lessens its capacity to disturb. Re-presenting an object of fear as a picture on the wall (if that is what it is) turns it into a memento, a memory image which no longer has the power to harm.

Sculptor Carving a Colossal Figure, 1942 (plate 120) – the title taken from Moore's inscription – shares the concern of

121 *Mother and Child Studies*, 1942. HMF 2024a. Pencil, wax crayon, coloured crayon, charcoal, pen and ink, watercolour wash and gouache, 17.8 x 35.4 cm (7 x 14 in). Private Collection

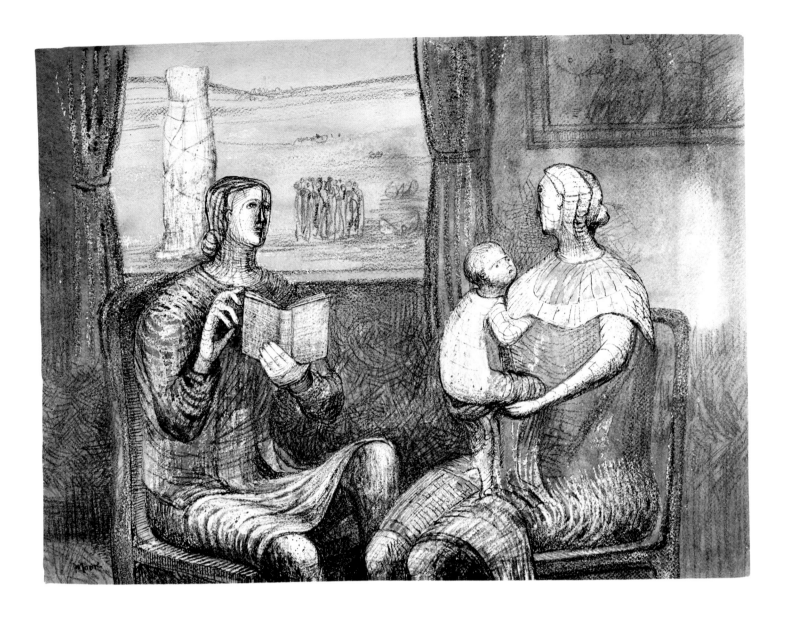

122 *Girl Reading to a Woman and Child*, 1946. HMF 2385. Pencil, wax crayon, coloured crayon, watercolour wash, pen and ink, 44.5 x 61 cm (17½ x 24 in). Private Collection

Crowd Looking at a Tied-up Object with scale and implications of gigantism. The colossal had long interested Moore. The uncarved pillars of stone in Burcroft garden (plate 59) had been Moore's monolithic reminders of Stonehenge and other ancient sites, and though like Gill and Epstein in 1910, he never had the opportunity to create his own Stonehenge, the idea of doing so was always somewhere in his mind. Among drawings of sculptures set in landscape, the 1939 *Sculptural Object in Landscape* (plate 70) marks a moment when Moore developed the idea of enlargement of forms – bones in this case – which were small in origin but were presented as monstrous.

The landscape here was a simplified version of the view from Burcroft and what we see is not a wholly imagined scene but the intrusion of the monstrous into the domestic. Moore returned to the idea of wrapping in 1950–51 with eight versions of *Wrapped Madonna and Child* (see plate 123).

In 1946, W. R. Valentiner explored landscape elements in Moore's work in the context of the modern world and its anxieties. His theme was that man retains the earliest memories of the race in his subconscious, undisturbed so long as modern life offers security. But when our cities, in wartime, threaten to bury us, we return to nature. 'More than any other

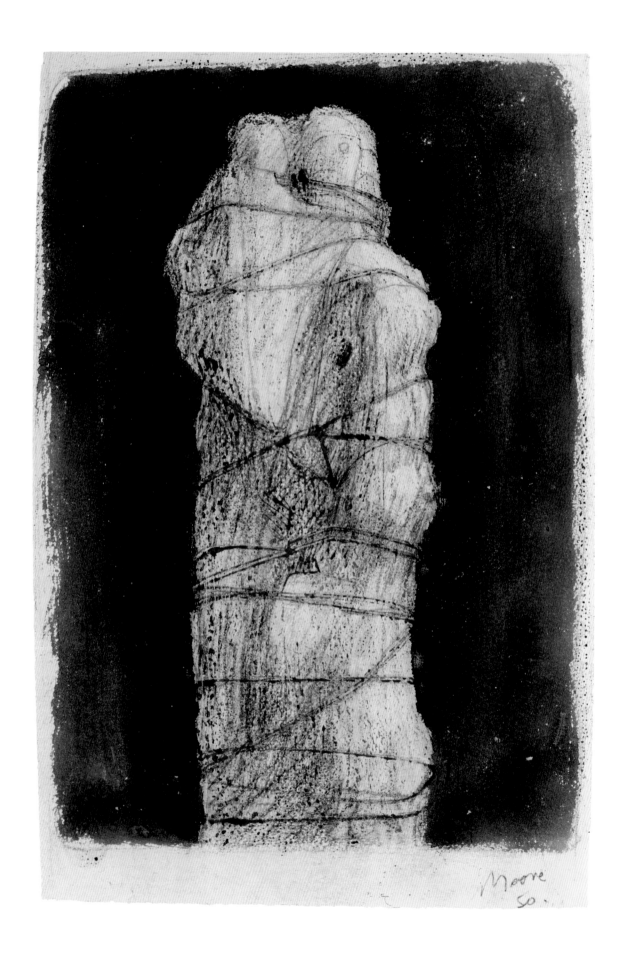

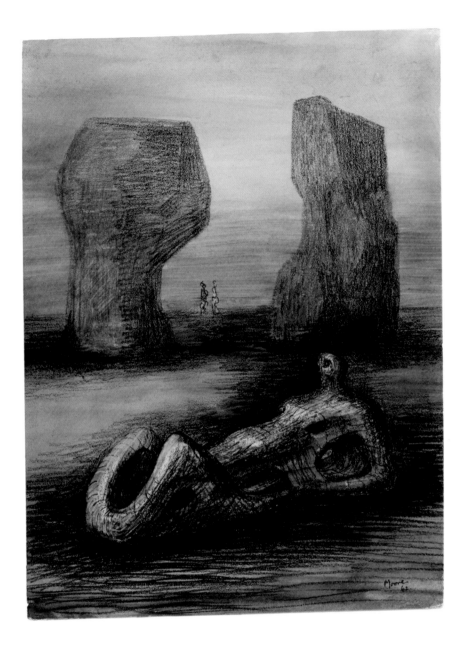

contemporary sculptor ... [Henry Moore] expresses our deep longing for a closer connection with the elemental forces of nature as found in primeval deserts, mountains and forests, away from cities, away from artificial life guided by intellect instead of by emotional energies.'[54] Moore's work 'conjures up the spirit of wild, uninhabited nature in a manner never to be found in other sculptures of recent times.'[55] Valentiner describes the effects of the war, the bombing and the shelters as 'bringing about a complete change in social conditions'.[56] He reproduced sculptures by Moore against land-scape settings at Burcroft as well as drawings that include *Stones in a Landscape*, 1936 (plate 64) and *Wood Sculpture in Setting against Red Rocks*, 1942 (plate 124), both of which reflect the primeval desert conditions he speaks of. Using some of Giedion-Welcker's photographs for his illustrations, Valentiner reinforced her approach with reproductions of Menec in Brittany, the Men-an-Tol in Cornwall, the Ming Tombs near Beijing, and a text reference to Stonehenge (none of them specifically related to Moore). But Valentiner's sense that sculpture needed to connect with its earliest roots, that it should have a public role, and had spiritual meaning, would all have appealed to Moore. Within the war period, but after he had ended the shelter series, Moore brought the clusters of figures, as found, for example, in *Grey Tube Shelter* (plate 99), above ground and established them in a Stonehenge-type environment. *Figures with Architecture*, 1943 (plate 125), is an example. The environment is primeval, as Valentiner says, and alien: the figures remain estranged, as they had been in the shelters, isolated in their absence from domestic surroundings. Even if he assented to Valentiner's reading, the evidence from the drawings is that flight from cities did not represent for Moore restitution of the domestic landscape.

Moore's sculptures, carved from natural materials, wood and stone, acquire a feeling of 'Englishness' from connections with nature and craft. Moore enhanced the sense that his sculptures were 'natural', giving them a picturesque touch by photographing them out of doors against the Kent landscape, which was itself crafted from nature. It is Moore's drawings, rather than his sculptures, that reflect Valentiner's 'wild unin-habited nature'.

The Family Group

The Family Group theme stemmed from a proposal by Henry Morris, the founder of Impington Village College near Cam-bridge, for Moore to make a sculpture for the college (opened in 1939, the school was designed by Walter Gropius and Maxwell Fry). Morris's idea was to bring every stage of education together under one roof, so that parents and children would use the same building. He conceived both 'village' and 'college' as kinds of families. The project with

123 *Wrapped Madonna and Child: Night Time*, c.1951. HMF 2714. Pencil, wax crayon, watercolour wash, pen and ink, 35.6 x 26.7 cm (14 x 10½ in). Israel Museum, Jerusalem, gift of Charlotte Bergman to the American Friends of the Israel Museum

124 *Wood Sculpture in Setting against Red Rocks*, 1942. HMF 2066. Pencil, charcoal, wax crayon, wash, pen and ink, 48.6 x 36.2 cm (19⅛ x 14¼ in). Museum of Modern Art, New York, gift of Philip Goodwin

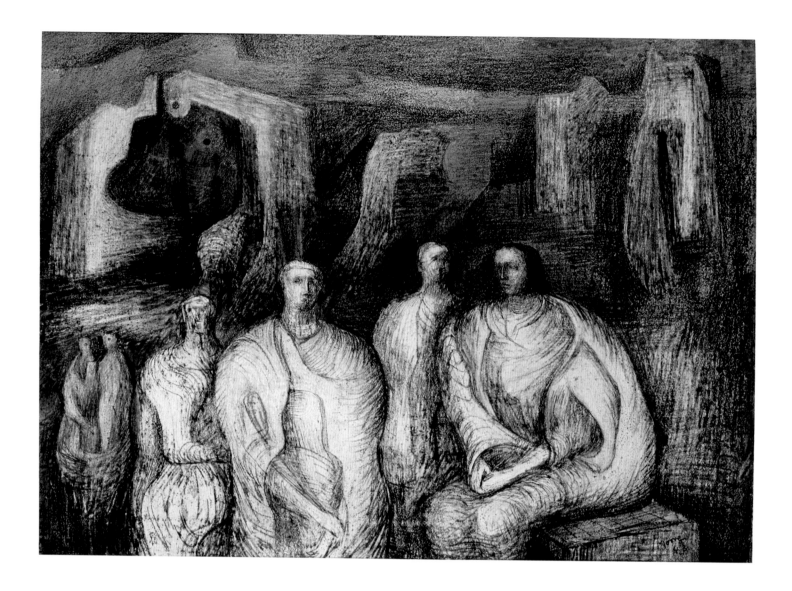

Moore did not come off, though the *Family Group*, 1948–9 (plate 126), at the Barclay School, Stevenage, was an outcome of Moore's many sketches in 1943–4 for Impington. Kenneth Clark used the phrase 'dutiful deadness' of Moore's figurative commissions of this kind,[57] arguing that the family groups – whether drawings or sculptures – represented Moore's view of happiness based on human affection, but lacked the demonic power of other drawings. Clark was at least partly right; the whole of Moore's fruitful encounter with Surrealism looked at risk from sculptures as bland as this. The theme is worth looking at further because one aspect of Clark's assumption, that drawings and sculptures speak the same language and are equally 'dead', is open to challenge. The Barclay School *Family Group* is life-size and naturalistic and blends comfortably into its environment, as was presumably intended. Moore's large *Family Group* drawings (plate 127, 56.4 x 69.7 cm,

and plate 128, 50 x 42 cm) are among the largest he made. They are carried out in what he called 'sectional line drawing', which divides the surface of a body into panels that emphasise sculptural three dimensionality and, used in the same way over the whole figure group, gives a sense of solidity and coherence to the whole. The sculpture being life-sized and in public space, leaves little to be discovered because it resembles people and occupies space in the same way people do. Because the background of the drawing is carried out in even strokes of white crayon, there is nothing to match the human figures against, no scale and nothing to help calculate size. As against the naturalism of the sculpture, the drawing has a frozen, statuesque appearance, tempered only a little by human activity, a boy holding a book, a child in her mother's lap. Moore's sectional line drawing can be thought of as an artist's equivalent of an engineer's technical drawing: it does

125 *Figures with Architecture*, 1943. HMF 2169. Pencil, wax crayon, coloured crayon, watercolour wash, pen and ink, gouache, 46.2 x 65.4 cm (18⅛ x 25¾ in). Shalleen Investments, London

126 *Family Group*, 1948–9. LH 269. Bronze, 1440 mm (56⅝ in) high. Barclay School, Stevenage

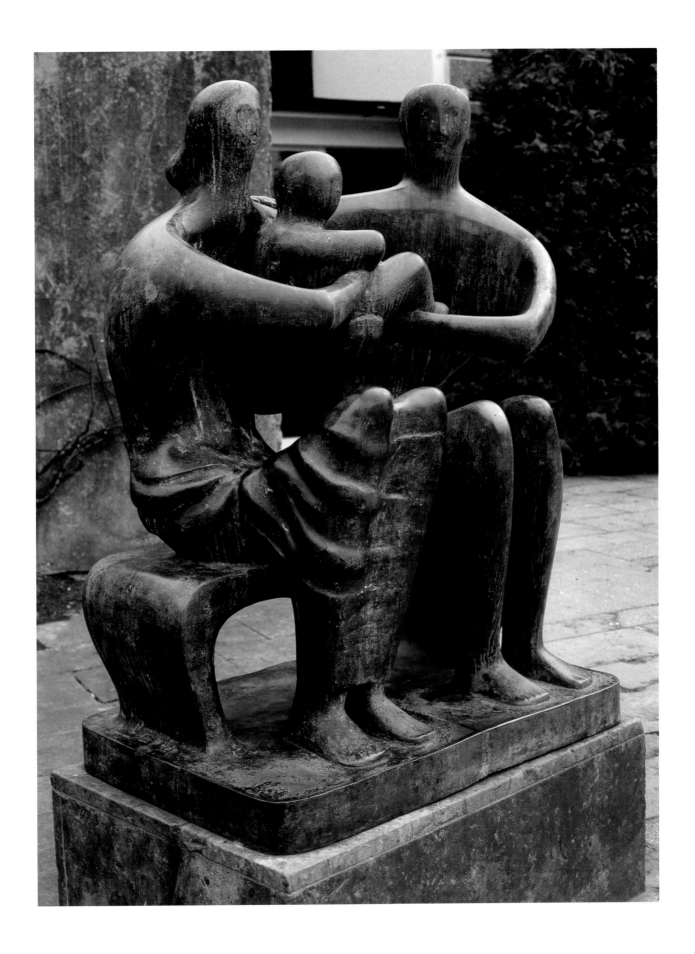

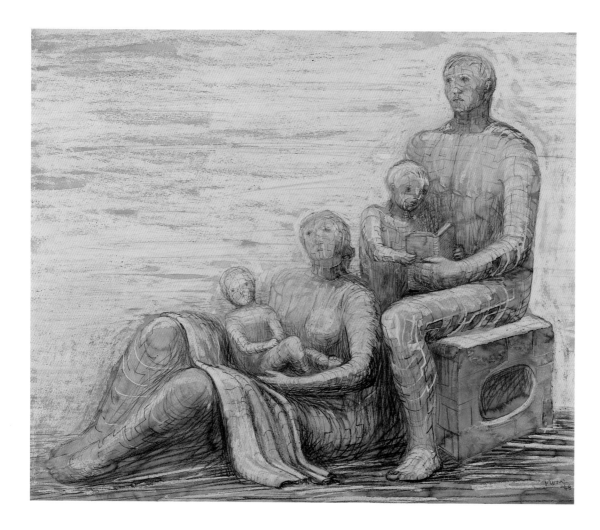

127 *Family Group*, 1948. HMF 2504.
Pencil, wax crayon, watercolour wash,
pen and ink, brush and ink, gouache,
50 x 42 cm (19⅝ x 16½ in).
Art Gallery of Ontario, Toronto

128 *Family Group*, 1944. HMF 2237a.
Pencil, wax crayon, coloured crayon,
watercolour wash, pen and ink,
56.4 x 69.7 cm (22¼ x 27½ in).
Scottish National Gallery of Modern Art,
Edinburgh

not explore or analyse form, or guide one to an understanding of how something came to be. It simply presents a consistent picture of an object that already exists, according to a set of draughtsman's conventions. With technical drawing, scale is not deduced from technique, but added in a different language: that of words and figures. Moore is not actually a technical draughtsman, and he does not add words or figures, with the result that we have no scale. A natural response, stimulated by the extensive featureless background, is that the sculpture of which this is a drawing is very large. We know from drawings already discussed, from the 1939 *Sculptural Object in Landscape* (plate 70) to the 1942 *Crowd Looking at a Tied-up Object* (plate 117) how interested Moore was in shifts of scale and the over-large. This gives us a context for imagining this as monumental, and that it is different from post-war East European monuments only because of the

temperate, non-heroic expressions. Size and scale are one issue, another is temporality. The argument here is the same as it was in an earlier comparison of Moore with Picasso in the 1920s. The less detail of background and circumstance that are divulged, the more a painting or sculpture is thought of as enduring unchanged through time. This drawing has a universal presence because few particulars are given. As after the First World War, the healing process seems to involve a *rappel a l'ordre* in the form of mother and child earlier, and parents and children now. Timelessness and lack of background detail recall Picasso's figures and families of around 1920.

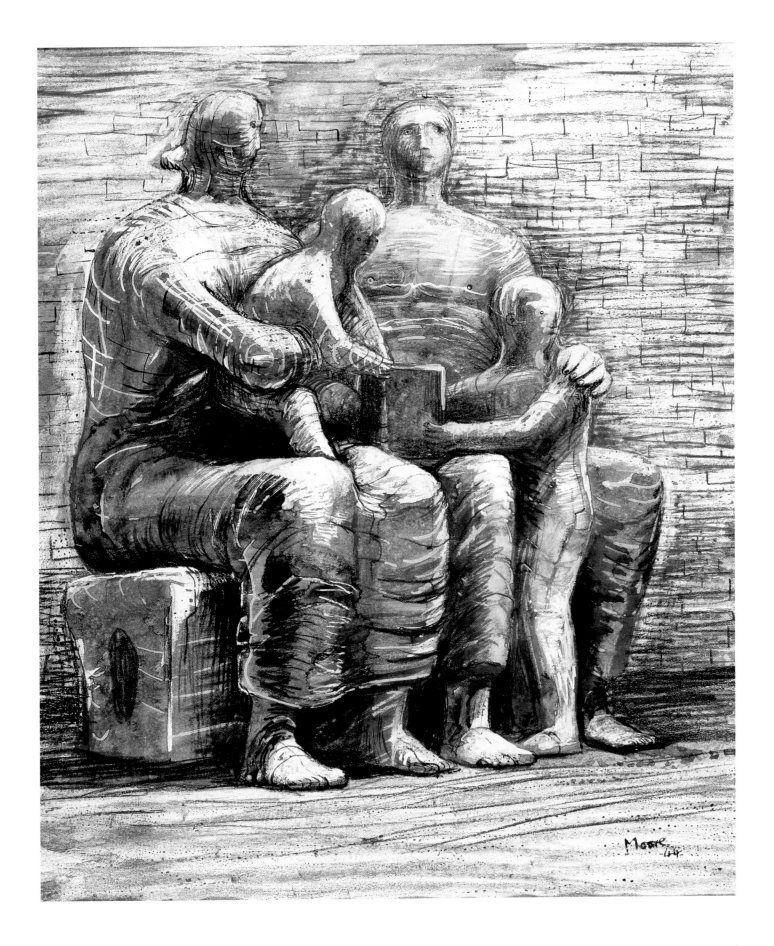

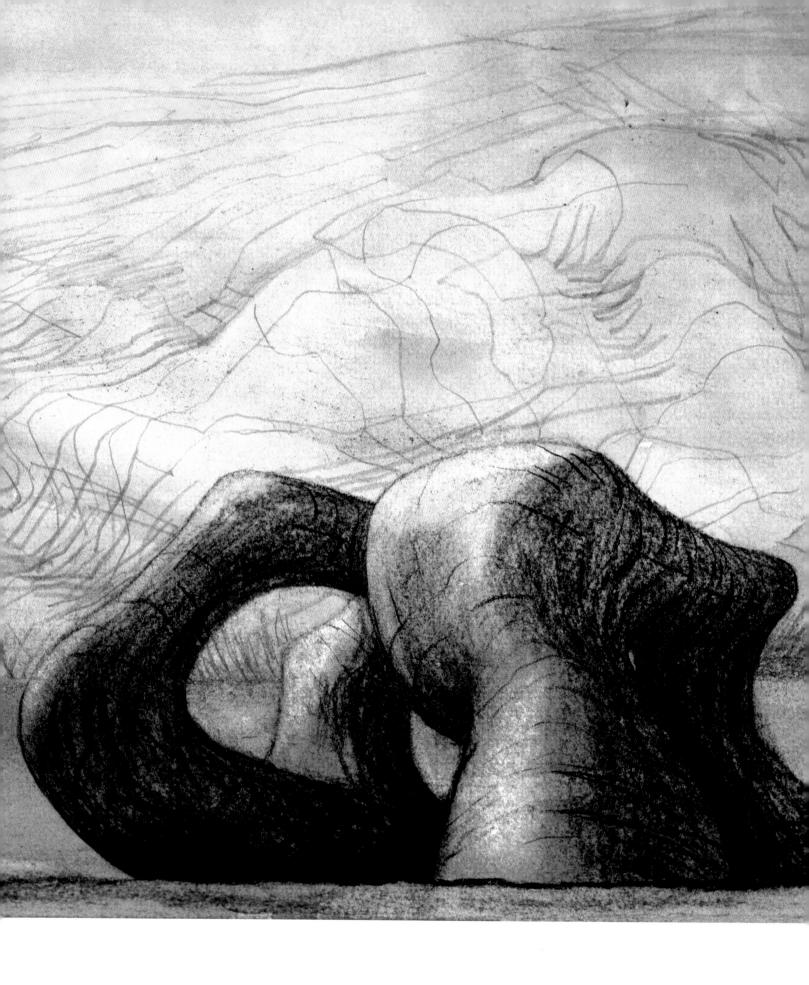

5 | The Black Drawings

129 Henry Moore in his studio with an elephant's skull given to him by Julian and Juliette Huxley, late 1960s.

Opposite: Detail from plate 135

The reduction after the war in Moore's use of carving technique and the increase in modelling in clay or plaster for bronze casting involved the use of hands in a way he felt eliminated some of the need for drawing. At the same time long experience made resolving formal problems easier. Pressure of sculptural work as commissions multiplied was also a factor in lessening the importance of drawing. The *Reclining Figure* outside UNESCO headquarters in Paris (1956–8) was over 5 metres (17 feet) long and a carving project on a scale Moore never tried to repeat. Moore never gave up drawing, and work of the 1950s and 1960s includes life drawings (which are rare after the early 1930s), drawings from primitive artefacts, after old masters, and innovations in colour.

Moore's renewed impetus in drawing came around 1970 from late commissions for print portfolios, which needed sustained concentration on a single subject. Kenneth Clark, preparing the book on Moore's drawings published in 1974, initially ended his text around 1950, but finding at the last moment that Moore was hard at work drawing again, added a postscript. Moore sent Clark a note about his present work headed 'The "Black" drawings', in which he mentioned the influence of the miners of 1941–2 and his experience then of getting light into drawings done in pitch dark. He referred to the importance of his two Seurat drawings (see plate 130) which he said he looked at every day, and he talked about the Stonehenge lithographs he was presently engaged on, and his memory of the first visit there in 1921 under moonlight. 'I now like *black* for its blackness – for its strength, its drama, its seriousness (and unsweeetness)', he told Clark.[1] He was interested in the touches of white showing through: '*The white of the paper showing through the black chalk gives off light* (almost real light) like the night sky reflected in water.'[2] In adopting the phrase 'Black Drawings', Moore may have intended a reference to Goya. Certainly he was aware that this was his own late work as Goya's Black Paintings had been his, and it was now, in the 1974 book, that Clark raised the comparison between Goya and Moore discussed earlier (see plate 118). Moore may have learned technically from Goya's prints but he never represented violence with Goya's ferocity. His emotions ran deep but were sublimated in art. Moore was thinking back over his past, to dark drawings like *Stones in a Landscape*, 1936 (plate 64), with its contrast between the tall shadowy stones and pale pedimented temple, a theme which reappears in *Rock Landscape with Classical Temple*, *c.*1972 (plate 131). The black drawings, Moore said, 'are connected also ... with my liking for the mystery of caves and holes, with something half hidden – as in my interior-exterior and helmet sculptures'.[3]

The 'black' print portfolios started with the *Elephant Skull*, published in 1970, was followed by the *Stonehenge* lithographs. The skull itself was a gift from Julian Huxley and his wife and stood in front of Moore in the studio mounted on a turntable. The drawings (plate 132) were close-ups, with Moore working with pencil, charcoal, ballpoint and felt tipped pens, and chinagraphs, feeling his way over the surfaces, searching out the forms nestling within one another. It was a tactile procedure with touch and feel translated into drawing. The *Stonehenge* drawings (plate 133) are also close-ups. Moore did not revisit the monument, which he knew well by then from experience, and his aim, as he told Clark, was 'to recapture my first impression of Stonehenge – which was seeing it in 1921 one late summer's night, by moonlight'.[4] Moore at this late stage was unconcerned with Stonehenge as a

130 Georges Seurat, *Les deux charrettes*, c.1883. Conté crayon, 26.7 x 33 cm (10½ x 13 in). Jan Krugier and Marie-Anne Krugier-Poniatowski Collection; formerly collection of Henry Moore

131 *Rock Landscape with*
*Classical Temple, c.*1972. HMF 3432.
Crayon, chalk, charcoal,
21.3 x 29 cm (8⅜ x 11½ in).
Henry Moore Foundation

132 *Elephant Skull*, 1969. HMF 3187.
Charcoal, ballpoint pen, felt-tipped pen,
chinagraph, 17.6 x 35.4 cm (7 x 14 in).
Private Collection

133 *Stonehenge*, 1972. HMF 3431.
Chalk, charcoal, pen and ink, wash,
27 x 19.7 cm (10 ⅝ x 7 ¾ in).
Henry Moore Foundation

whole as he explored the relationship between individual and groups of stones. Moore's close-ups give strength to these mysterious presences which he felt, from his first moonlit view, were objects of the night. The excitement of darkness and its association with dream shows not just an affinity with Surrealism, but also links to Romanticism. Commentators on British Surrealism, like Herbert Read, associated it with Romanticism to help define an indigenous propensity to the strange and irrational. Moore's late drawings retain their Surrealist links but their underlying strength relates to Romanticism and the sublime. Turner was the artist exemplar of Moore's old age, and Moore's drawing is spacious and elemental. He may start from something small, like a bonfire Irina was making in the garden (plate 134), but he lifts it out of its local context to make it an elemental occurrence in a broad featureless landscape. He uses his own sculptures (plates 135 and 136) as primitive presences which seem enlarged, more impressive and a little threatening by being seen close to, and from below, in an imaginary landscape.

134 *Bonfire with Sheep*, 1975.
HMF 75 (27). Pen and ink, brush and ink, charcoal, pencil, chinagraph, 18.8 x 24 cm (7⅜ x 9½ in).
Henry Moore Foundation

135 *Large Two Forms in Landscape*, 1974. HMF 73/74 (37). Pencil, charcoal, pastel, watercolour wash on blotting paper, 21.9 x 28.4 cm (8⅝ x 11⅛ in). Private Collection

136 *Reclining Figure*, 1973, 1976. HMF 74/76 (7). Pencil, charcoal, watercolour wash, chinagraph, 17.6 x 25.4 cm (7 x 10 in). Private Collection

Conclusion

Moore's drawings are not of any one type and no single definition of his aims in drawing is possible. Drawing was something Moore enjoyed, he drew in the evenings after a strenuous day working on sculpture, and in later years, with his strength diminishing, and assistants increasingly taking change of sculptural processes, drawing remained a rewarding activity. Viewing Moore's career as a whole, one is most struck by his readiness to bring in drawing to achieve things sculpture could not do. 'Drawing' is a barely adequate word to describe the elaborate and often haunting pictorial compositions and the remarkable handling of colour that Moore achieved in the middle sections of his career. These have been given special attention here. The visual arts side of the cultural movements with which Moore has been associated here, from Romanticism to Surrealism and Neo-Romanticism, leant in all cases towards pictorial in preference to sculptural expression. Moore turned to pictorial art in parallel to sculpture because he needed the freedom of a colourist and the right to invent spaces, encounters and situations that only the pictorial arts offered. An aim of this book is to enlarge Moore's reputation by suggesting a more varied artist than is presently allowed. It needs stressing, though, that Moore's primary activity was sculpture, and that drawing and sculpture were almost always interrelated practices and not separate developments.

137 *Study for Dante Stone III*, 1976.
HMF 74/76 (37). Charcoal, chinagraph,
gouache, 25.4 x 17.6 cm (10 x 7 in).
Private Collection

Credits

References

Introduction

1 Clement Greenberg, 'Art', *The Nation*, 8 February 1947. Reprinted in John O'Brian, ed., *Clement Greenberg, The Collected Essays and Criticism, vol. 2, Arrogant Purpose, 1945–1949*, University of Chicago Press, 1986, pp 125–8.

2 Robert Melville, 'Communities of Statuary', in *Henry Moore, Figures in Space. Drawings*, Institute of Contemporary Arts, London, 1953.

3 'The Sculptor Speaks', the *Listener*, vol.18 no.449, 18 August 1937. Reprinted in Alan Wilkinson, ed., *Henry Moore, Writings and Conversations*, Lund Humphries, London, 2002, pp 193–8.

4 Herbert Read, ed. and intro., *Henry Moore, Sculpture and Drawings, 1921–1948,* Lund Humphries and A. Zwemmer, London, 1944.

5 Henry Moore, 'The Sculptor Speaks', 1937. Wilkinson, *Writings*, pp 193–8.

6 James Johnson Sweeney, *Henry Moore,* Museum of Modern Art, New York, 1946, pp 49–50.

7 Anon, 'A Sculptor's Drawings', *The Times*, 9 June 1953.

8 See Moore's conversation with Wilkinson in Alan Wilkinson, *The Drawings of Henry Moore*, Garland, New York, 1984, p.317.

9 Kenneth Clark, *Henry Moore Drawings*, Thames and Hudson, London, 1974, p.11.

10 For correctives to this misreading, see Adrian Lewis, 'Henry Moore's Shelter Drawings', in P. Kirkham and D. Thomas, *War Culture*, Lawrence and Wishart, London, 1995, p.115.

11 Clark, *Drawings*, 1974, pp 291–2.

12 Vera and John Russell, 'Conversations with Henry Moore', *Sunday Times*, 17 December 1961. Wilkinson, *Writings*, p.55.

13 Nigel Vaux Halliday, *More than a Bookshop, Zwemmer's and Art in the Twentieth Century*, Philip Wilson, London, 1991, p.119.

14 Moore to Clark, 29 November 1938. Clark papers, Hyman Kreitman Research Centre, Tate, 8812.1.3.2028.

15 *Drawing for Metal Sculpture*, 1931, HMF 856.

16 Ann Garrould, *Henry Moore. Complete Drawings, Volume 1, 1916–1929*, Henry Moore Foundation in association with Lund Humphries, London, 1996, p.ix.

17 Raymond Mortimer, 'The Leicester Galleries', *New Statesman*, 17 February 1940, p.203.

18 Letter from WAAC to artists' colourmen, Lechertier Barbe, 22 September 1944, IWM Archives, GP 55 104.

19 Letter to William Rothenstein, 12 March 1925, quoted in John Rothenstein, *Modern English Painters, Volume 2: Lewis to Moore*, Eyre and Spottiswoode, London, 1956, pp 314–15. Wilkinson, *Writings*, p.52.

20 Robin Ironside, *Painting since 1939*, Longman, London, 1947, pp 173–4.

21 Geoffrey Grigson, 'Comment on England', *Axis*, 1 January 1935, p.8.

22 Geoffrey Grigson, *Henry Moore*, Penguin Books, London, 1943, p.16.

23 Robert Melville, *Henry Moore, Sculpture and Drawings*, Thames and Hudson, London, 1970, p.7.

24 Melville, 'Communities of Statuary', 1953.

25 Herbert Read, 'The Drawings of Henry Moore', *Art in Australia*, vol.4 no.3, September–November 1941, p.14.

26 Herbert Read, *Henry Moore*, Venice Biennale, 1948.

27 John Hedgecoe, *Henry Spencer Moore*, Nelson, London, 1968, p.49.

28 Wilkinson, *Drawings*, 1984, p.10.

29 Garrould, *Complete Drawings*, vol.1, p.ix.

Chapter 1

1 Donald Hall, *The Life and Work of a Great Sculptor*, Gollancz, London, 1966, p.50.

2 Hedgecoe, *Henry Spencer Moore*, 1968, p.105.

3 In his obituary of Epstein (*Sunday Times*, 23 August 1959), Moore put the first meeting in 'the mid twenties', but Berthoud (*The Life of Henry Moore*, de la Mare, London, [1987] 2003, pp 82–83) argues for 1921.

4 Wilkinson, *Drawings*, 1984, p.7.

5 John Hedgecoe, *Henry Moore. My Ideas, Inspiration and Life as an Artist*, Ebury Press, London, 1986, p.45. Wilkinson, *Writings*, p.48.

6 Hedgecoe, *Henry Spencer Moore*, 1968, p.38, quoted in Wilkinson, *Drawings*, 1984, p.9.

7 Russell, 'Conversations', 1961.

8 Moore discovered Roger Fry's *Vision and Design* (1920) when a student in Leeds. See Grigson, 1943, p.5, and James Johnson Sweeney, 'Henry Moore', *Partisan Review*, vol.14, no.2, March–April 1947, p.182. The latter is in Wilkinson, *Writings*, p.44.

9 'Vortex. Gaudier-Brzeska', in Wyndham Lewis, ed., *Blast*, 1 June 1914, p.155.

10 Ezra Pound, *Gaudier-Brzeska, A Memoir*, New Directions, New York, [1916] 1970, p.20.

11 In a letter to Kenneth Clark, 29 November 1938, Moore recalled having visited the gallery of Paul Rosenberg – who had examples of these Picasso works – on his first visit to Paris in 1922. Clark papers, Hyman Kreitman Research Centre, Tate, 8812.1.3.2028.

12 Alan Wilkinson, *The Drawings of Henry Moore*, Tate Gallery, London, 1977, p.50.

13 Denys Sutton, 'Henry Moore, A Sculptor's Vision', *New York Times*, 23 March 1959. Reprinted in Philip James, *Henry Moore on Sculpture*, Macdonald, London, 1966, p.117.

14 Huw Weldon, *Monitor. An Anthology*, Macdonald, London, 1962. Moore himself was later to own a small version of Cézanne's *Bathers* (30.5 x 33 cm, 12 x 13 in, *c*.1873–7).

15 For example, Hedgecoe, 1986, pp 150–51. Wilkinson, *Writings*, p.146.

16 Russell, 'Conversations', 1961.

17 Roger Fry, *Cézanne. A Study of his Development*, Hogarth Press, London, 1927.

18 Pound, *Gaudier-Brzeska, A Memoir*, 1970, p.20. Pound's memoir of Gaudier was second only to Fry's *Vision and Design* as a formative influence. See Donald Hall 'An Interview with Henry Moore', *Horizon* (New York), vol.3 no.2, November 1960. James, *Moore on Sculpture*, p.49.

19 Geoffrey Grigson, *The Arts Today*, John Lane, the Bodley Head, London, 1935, p.101.

20 See Sylvie Patin, 'The Collectors of Cézanne's Early Works', in Lawrence Gowing, ed., *Cézanne The Early Years*, Royal Academy, London, 1988, pp 54–65. Relevant early Cézannes previously in the Pellerin collection include *Déjeuner sur l'herbe*, *c.*1870–71, now private collection, and *Pastoral Idyll*, *c.*1870, now Musée d'Orsay, Paris.

21 Robert Burstow, 'Henry Moore's "Open-Air" Sculpture: a Modern, Reforming, Aesthetic of Sunlight and Air', in Jane Beckett and Fiona Russell, eds, *Henry Moore. Critical Essays*, Ashgate, Aldershot, 2003, p.164.

22 Sir Frederick Kenyon's memorandum, *Royal Commission Minutes*, p.58, quoted in Edward Miller, *That Noble Cabinet. A History of the British Museum*, André Deutsch, London, 1973, p.326.

23 Berthoud, *Henry Moore*, 2003, pp 48–9. The details from Notebook No.3 are in Garrould, *Complete Drawings*, vol.1, *1916–1929*, 1996, p.52 under HMF 86.

24 Sweeney, 'Henry Moore', 1947, p.183.

25 Henry Moore, 'Primitive Art', the *Listener*, vol.25, no.641, 24 August 1941. Wilkinson, *Writings*, pp 102–06.

26 ibid.

27 'Contemporary English Sculptors, Henry Moore', *Architectural Association Journal*, May 1930. Wilkinson, *Writings*, pp 187–8.

28 Roger Fry, 'Negro Sculpture' in *Vision and Design* [1920] 1970, p.70.

29 ibid, p.71.

30 Henry Moore, Unpublished Notes, *c.*1925–6, HMF Archive, quoted by Wilkinson, *Writings*, p.98.

31 Letter to William Rothenstein, 12 March 1925. Reprinted in Wilkinson, *Writings*, p.52.

32 ibid.

33 Marilyn Lavin, ed., Giorgio Vasari, *Lives of the Most Eminent Painters*, Verona, 1966, p.101, quoted in Grigson, 1943, p.6.

34 Sutton, *New York Times*, 1959.

35 'The Classical in Modern Art', *Drawing and Design*, New Series, vol.1, no.5, November 1926.

36 Wilkinson, *Drawings*, 1984, p.254.

37 Elizabeth Cowling, *Picasso. Style and Meaning*, Phaidon, London, 2002, p.414.

38 Jennifer Mundy and Elizabeth Cowling, intro., *On Classic Ground, Picasso, Léger, de Chirico and the New Classicism 1920–30*, Tate Gallery, London, 1990, p.25.

39 Carlo Carrà, quoted by Mundy, *On Classic Ground*, 1990, p.54.

40 Cowling, *On Classic Ground*, p.214.

41 Henry Moore, 'Primitive Art', the *Listener*, 24 April 1941. Reprinted in Wilkinson, *Writings*, p.102–06.

42 ibid.

43 Henry Moore, 'Mesopotamian Art', the *Listener*, 5 June 1935. James, *Moore on Sculpture*, pp 164–5.

Chapter 2

1 Meyer Schapiro, 'Abstract Art', *Marxist Quarterly*, January–March 1937, reprinted in Schapiro, *Modern Art. Nineteenth and Twentieth Centuries*, George Braziller, New York, 1978, p.211.

2 Moore showed four sculptures made between 1931 and 1934 as well as recent drawings. Nash showed *Harbour and Room*, started in 1932 from a watercolour of 1931, as well as more recent work. Five of Burra's six exhibits were made between 1931 and 1933–4.

3 Geoffrey Grigson, 'Comment on England', *Axis*, 1 January 1935, pp 8–10.

4 Henry Moore, 'On Carving', *New English Weekly*, 5 May 1932, p.65. Wilkinson, *Writings*, pp 188–91. In 1968 Moore told Hedgecoe (p.105) that he had been picking up flints in Norfolk, Broadstairs (Kent) and Dorset for 50 years. But it was clearly *c.*1930 that they became significant for his art.

5 David Sylvester, *Henry Moore*, Arts Council of Great Britain [Tate Gallery exhibition catalogue], 1968, p.44. As a student Moore lived on the South Kensington/Chelsea borders close to the national museums, with which he was without doubt familiar before the Natural History Museum became important for his art.

6 Henry Moore, 'On Carving', 1932. Wilkinson, *Writings*, pp 188–91.

7 David Sylvester, 'Henry Moore's Drawings', *Britain Today*, November 1948, p.32.

8 ibid, p.32.

9 ibid, p.32.

10 'Henry Moore Talking, A Conversation with David Sylvester', the *Listener*, 29 August 1963, p.305.

11 Sweeney, *Henry Moore*, 1946, p.31.

12 David Sylvester, Henry Moore, Wakefield and Manchester City Art Galleries, 1949.

13 ibid.

14 Henry Moore in Herbert Read, ed., *Unit One*, Cassell, London, 1934. Wilkinson, *Writings*, pp 191–3.

15 Herbert Read, *Art Now*, Faber and Faber, London, 1933, p.116.

16 The relevant text is Wilhelm Worringer, *Abstraction and Empathy* (German edition 1908), especially the first, theoretical section. The book was translated into English only in 1953, but Read was a German speaker and had already translated Worringer's second book, *Form in Gothic*, in 1927.

17 Moore in *Unit One*, 1934. Reprinted in Wilkinson, *Writings*, pp 191–3.

18 Geoffrey Grigson, 'Comment on England', *Axis*, 1 January 1935, p.8.

19 ibid, pp 8–10.

20 ibid, p.8.

21 ibid, p.8.

22 ibid, p.10.

23 Jennifer Mundy, 'Biomorphism', unpublished PhD thesis, University of London, Courtauld Institute, 1986, p.18.

24 Geoffrey Grigson, *The Arts Today*, 1935, pp 102–03.

25 Grigson, *Henry Moore*, 1943, p.9.

26 John Grierson, 'The New Generation in Sculpture', *Apollo*, vol.12, November 1930, pp 347–51.

27 Moore in *Unit One*, 1934. Reprinted Wilkinson, *Writings*, pp 191–93.

28 J. B. S. Haldane, *The Philosophical Basis of Biology*, Doubleday, Doran, New York, 1931, p.17, and see chapter 1 in general.

29 'Vortex Gaudier-Brzeska', *Blast*, 1 June 1914, p.155.

30 G. H. Luquet, *The Art and Religion of Fossil Man*, Yale University

138 *Standing Figure: Knife Edge*, 1978.
HMF 78 (14). Watercolour, charcoal
(washed), chalk, collaged photograph,
ballpoint pen, 30.8 x 19.7 cm
(12⅛ x 7¾ in). Henry Moore Foundation

Press, New Haven, and Oxford University Press, Oxford, 1930,
pp 140–41.

31 ibid, p.114.

32 ibid, p.146.

33 Ovid, *Metamorphoses*, intro. E J Kenney, trans. A D Melville, Oxford
 University Press, Oxford, 1987, Book 1, lines 400 ff.

34 Christopher Green, *Cubism and its Enemies*, Yale University Press,
 New Haven, 1987, p.100.

35 ibid, p.358.

36 ibid, pp 103–04.

37 Albert Elsen, 'Henry Moore's Reflections on Sculpture', *Art Journal*,
 26 no.4, Summer 1967.

38 Elizabeth Cowling, 'Objects into Sculpture', *Picasso
 Painter/Sculptor*, Tate, 1994, p.229.

39 Quoted by Cowling, *Picasso*, 2002, p.515.

40 John Golding, intro., *Picasso Painter / Sculptor*, Tate, 1994, p.26.

41 Cowling, *Picasso*, 2002, p.508, refers to prehistoric cairns and
 megaliths. Golding, intro., *Picasso Painter/Sculptor*, 1994, p.24
 refers to dolmens.

42 Golding, *Picasso Painter / Sculptor*, 1994, p.28.

43 Cowling, *Picasso*, 2002, p.508.

44 John Golding, 'Picasso and Surrealism', in Roland Penrose and John
 Golding, advisory eds., *Picasso in Retrospect*, Paul Elek, London,
 1973, p.154.

45 *Documents*, vol.2, no.3, 1930.

46 Grigson, *Henry Moore*, 1943, p.8.

47 John Russell, *Henry Moore*, 1968, p.79.

48 Quoted by Mundy in 'Biomorphism', 1986, p.21.

49 Melville, 'Communities of Statuary', 1953.

50 John Read in David Mitchinson, ed. and intro., *Celebrating Moore*,
 Lund Humphries, London, 1998, p.114.

Chapter 3

1 For further details of British artists' interest in the Neolithic in the
 1930s, see Andrew Causey, 'Barbara Hepworth, Prehistory and the
 Cornish Landscape', *Sculpture Journal*, vol.17, no.2, 2008, pp 9–22.

2 Ernst to Giedion-Welcker, letter of summer 1934, see Reinhold
 Hohl, *Alberto Giacometti*, Thames and Hudson, London, [1971]
 1972, p.273.

3 Quoted in Stephen Spender, intro., *Henry Moore. Stonehenge*,
 Ganymed Original Editions, London, 1974.

4 Wolfgang Fischer, interview with Henry Moore, 13 July 1971, in
 Henry Moore 1961–1971, Staatsgalerie Moderner Kunst, Munich,
 1971.

5 Wilkinson, *Drawings*, 1984, p.318.

6 Eric Gill to William Rothenstein, 25 September 1910, in William
 Shewring, ed., *The Letters of Eric Gill*, Jonathan Cape, London,
 1947, pp 32–3.

7 Information from Ann Garrould, 13 February 2009.

8 Moore to Paul Nash, 15 September 1933, quoted in Andrew
 Causey, *Paul Nash*, Oxford University Press, Oxford, 1980, p.256.

9 John Hedgecoe, 1968, p.93, reprinted in Wilkinson, *Writings*, p.59.

10 Russell, 'Conversations', 1961.

11 'Bernard Meadows Remembers Henry Moore', *Apollo*, vol.128,
 no.320, October 1988, p.243.

12 Henry Moore, letter to Raymond Coxon, 14 September 1937,
 quoted in Berthoud, *Henry Moore*, 2003, p.169. There is some
 uncertainty about dates. Both Meadows (see note 11) and Moore

remembered that erecting the stones was Meadows's first task as Moore's assistant. Meadows joined Moore in April 1936 but the letter to Coxon is from September 1937.

13 Hedgecoe, *Henry Spencer Moore*, 1968, p.95.

14 Frank Stevens, *Stonehenge Today and Yesterday*, HMSO, 1919, p.58.

15 F. Adama van Scheltema, 'Le Centre Feminin Sacré', *Documents*, vol.2, no.7, 1930.

16 Julie Summers, '*Drawing for Stone Sculpture*' in David Mitchinson, intro., *Celebrating Moore*, Lund Humphries, London, 1998, p.157.

17 'Bernard Meadows Remembers Henry Moore', 1988, p.243. Useful information about Meadows' work with Moore is contained in Meadows' interview with Julie Summers in 1995 of which a transcript exists in the HMF Archive.

18 Letter from Grigson to Moore, 12 September 1942. HMF Archive.

19 Sylvester, *Henry Moore. Sculpture and Drawings*, 1949.

20 Meyer Schapiro quoted by Leo Steinberg, 'The Eye is Part of the Mind', *Partisan Review,* vol.20, no.2, March–April 1953, p.206.

21 Hedgecoe, *Henry Spencer Moore*, 1968, pp 7–8.

22 There is uncertainty about dates here: plate 67 is normally dated 1938 and plate 66 1937, which assumes the drawing was made after the sculpture. This seems unlikely given that the drawing is in a cluster of 'ideas for sculpture'.

23 Carola Giedion-Welcker, 'Prehistoric Stones, *Transition*, 27, April–May 1938, p.342.

24 Melville, *Sculpture and Drawings*, 1970, p.9.

25 Letter in *The Times*, 22 December 1937, with many eminent British arts figures as signatories. Moore's is the first name on the list and Grigson's the last. Grigson, a very strong supporter of Lewis, was probably the initiator. The letter advocated the purchase of a painting by Lewis for the Tate. The painting that (for one reason or another) the Tate bought was *Red Scene*, 1937, an 'underground' painting somewhat reminiscent of Moore's *Figures in a Cave* (plate 96).

26 A fuller analysis of these drawings by Moore is: Andrew Causey, 'Henry Moore and the Uncanny', in Jane Beckett and Fiona Russell, eds, *Henry Moore. Critical Essays*, Ashgate, Aldershot, 2003.

27 Melville, *Sculpture and Drawings*, 1970, p.17.

28 ibid, p.16.

29 Julian Stallabrass, 'Mechanisms', in *Celebrating Moore*, 1998, pp 164–5.

30 It is titled thus in Grigson, *Henry Moore*, 1943, plate 18, and Read, *Henry Moore*, 1944, p.214.

31 Norbert Lynton, '*Family*', in *Celebrating Moore*, 1998, pp 150–51.

32 'A Sculptor's Drawings', *The Times*, 9 June 1953.

33 Berthoud, *Henry Moore*, 2003, p.179.

34 Grigson, *Axis*, January 1935, pp 9–10.

35 See Walter Michel and C. J. Fox, eds, *Wyndham Lewis on Art*, London, Thames and Hudson, especially pp 413–14.

36 In conversation with David Mitchinson, 1980. Reprinted in Wilkinson, *Writings*, p.214.

37 Michael Chase, 'Moore on his Methods', *Christian Science Monitor*, Boston, 24 March 1967, reprinted in Wilkinson, *Writings*, p.214.

Chapter 4

1 Geoffrey Grigson, 'Paul Nash. A Metaphysical Artist', the *Listener*, 1 April 1948.

2 Henry Moore, intro., with commentary by Frances Carey, *A Shelter*

139 *Sculpture on Distant Hill*, 1972. HMF 73/74 (88). Pencil, charcoal, crayon, 25.4 x 17.6 cm (10 x 7 in). Henry Moore Family Collection

Sketchbook, London, 1988, p.9.

3 Carlton Lake, 'Henry Moore's World', *Atlantic Monthly*, no.209, Boston, 1 January 1962, p.40.

4 Adrian Lewis, 'Shelter Drawings', 1995, p.118.

5 Information from Ann Garrould, 13 January 2009.

6 Robert Melville, intro., *Henry Moore Shelter Sketchbook, 1940–1942*, Marlborough Fine Art, London, 1967. Some of the present author's comments on the shelter drawings have appeared in Andrew Causey, 'Another Look at Henry Moore's Shelter Drawings', in *Mythen – Symbole – Metamorphosen in der Kunst seit 1800*, gebr. Mann, Berlin, 2004.

7 Donald Hall, *The Life and Work of a Great Sculptor*, Gollancz, London, 1966, p.104.

8 David Sylvester, 'Henry Moore. The Shelter Drawings', *Graphis*, 14 March 1946, p.128.

9 See Robert Melville, 'Underground', *New Statesman*, 28 October 1966.

10 Henry Moore to Arthur Sale, 10 October 1940, IWM, Art file 16597.

11 Anon [Keith Vaughan], 'War Artists and the War', *Penguin New Writing*, no.16, 16 March 1943, p.113.

12 Eric Newton, intro., *War through Artists' Eyes*, John Murray, London, 1945, p.9.

13 Donald Newton, letter to *Times Literary Supplement*, 16 September 1994.

14 Constantine FitzGibbon, *The Blitz*, Allan Wingate, London, 1957, p.158 ff.

15 W. R. Valentiner, *Origins of Modern Sculpture*, Wittenborn, New York, 1946, p.141.

16 Frederick Wight, 'Henry Moore. The Reclining Figure', *Journal of Aesthetics and Art Criticism*, vol.6, no.2, December 1947.

17 Wilkinson, *Drawings*, 1984, p.321.

18 Grigson, *Henry Moore*, 1943, p.16.

19 In relation to Paul Nash's photographs, in 'Nature Imitates Art', *Architectural Review*, January 1935.

20 Raymond Mortimer, *New Statesman*, 17 February 1940, p.203.

21 Anon, 'Henry Moore at the Mayor Gallery', *New Statesman*, 18 February 1939.

22 Anon, 'Mr Moore's Drawings for Sculpture', *The Times*, 18 February 1939.

23 Clark, *Drawings*, 1974, p.83.

24 E. M. O'R. Dickey to Miss Lees (both of WAAC), 14 August 1941. IWM GP 55 104.

25 WAAC document of 24 May 1943. IWM GP 55 104.

26 WAAC to Lachertier Barbe, 96 Jermyn Street, 22 September 1944. IWM GP 55 104.

27 Home Office to E. C. Gregory at WAAC, 14 July 1945. IWM GP 55 104.

28 Garrould, *Complete Drawings*, vol.2, p.ix, and the author's interview with Ann Garrould, 13 January 2009.

29 The key commissions were for illustrations for Edward Sackville-West, *The Rescue. A Melodrama based on Homer's Odyssey*, orchestral score by Benjamin Britten, broadcast as a BBC radio drama, November 1943, and published in book form with illustrations by Henry Moore, Secker and Warburg, London, 1945; and Johann Wolfgang von Goethe, *Prométhée*, trans. André Gide, Henri Jonquières/P. A. Nicaise, Paris, 1951. Moore's drawings were made in 1949–50.

30 Robin Ironside, *Painting since 1939*, Longman, London, 1947, p.173.

31 Robin Ironside, 'Burne-Jones and Gustave Moreau', *Horizon* (London), vol.2, no.9, September 1940. Moore's work was occasionally reproduced in *Horizon*, starting with No.1, January 1940. A shelter drawing was reproduced in vol.3, no.15, March 1941.

32 Ironside, *Horizon*, September 1940.

33 Richard and Leonée Ormond, 'Victorian Painting and Classical Myth', in Allen Staley, ed., *Victorian High Renaissance*, Minneapolis Institute of Arts, 1978.

34 Read, *Henry Moore vol.1*, 1944, p.xxvii.

35 See above note 10.

36 Joseph Darracott, 'Interview with Henry Moore, typescript, 1975, p.5. IWM Department of Sound Records, 000785/01.

37 Herbert Read, intro., *Henry Moore*, Venice Biennale, 1948.

38 ibid.

39 Melville, *Sculpture and Drawings*, 1970, p.9.

40 Sweeney, 'Henry Moore', 1947, p.182.

41 Nikolaus Pevsner, 'Thoughts on Henry Moore', *Burlington Magazine*, February 1945.

42 Clark, *Drawings*, 1974, p.155.

43 Darracott, 'Interview with Henry Moore, 1975, p.5.

44 ibid, p.2.

45 Kenneth Clark, 'Henry Moore. A Note on his Drawings', Buchholz Gallery, New York, 1943.

46 Clark, *Drawings*, 1974, p.120.

47 Edward Alden Jewell, 'In the Realm of Art', *New York Times*, 16 May 1943.

48 Garrould, *Complete Drawings*, vol.3, p.163.

49 Berthoud, *Henry Moore*, 2003, p.181.

50 Clark, *Drawings*, 1974, p.120.

51 Wilkinson, *Drawings*, Tate Gallery, 1977, p.42.

52 The sculpture encased in plaster is reproduced in Penelope Curtis and Fiona Russell, 'Henry Moore and the post-war British Landscape: Monuments ancient and modern', in *Henry Moore. Critical Essays*, Ashgate, Aldershot, 2003, p.133, with the unlikely suggestion that it was encased with plaster and roped up thus in preparation for transport.

53 Clark, *Drawings*, 1974, p.120.

54 Valentiner, *Origins of Modern Sculpture*, 1946, p.139.

55 ibid, p.140.

56 ibid, p.141.

57 Clark, *Drawings*, 1974, p.155.

Chapter 5

1 Clark, *Drawings*, 1974, pp 291–2.

2 ibid, p.291.

3 ibid, p.291.

4 ibid, p.291.

Bibliography

This is a bibliography of material used here. The comprehensive list of publications is *Henry Moore Bibliography*, five volumes, ed. Alexander Davis, Henry Moore Foundation, 1992–4.

Andrews, Julian, *London's War. The Shelter Drawings of Henry Moore*, Lund Humphries, London, 2002

Anon, 'Mr Moore's Drawings for Sculpture', *The Times*, 18 February 1939

Anon, 'Henry Moore at the Mayor Gallery', *New Statesman*, 18 February 1939

Anon, 'Henry Moore', *New York Herald Tribune*, 16 May 1943

Anon [Keith Vaughan], 'War Artists and the War', *Penguin New Writing*, no.16, 16 March 1943

Anon, 'A Sculptor's Drawings', *The Times*, 9 June 1953

Anon, 'The Classical in Modern Art', *Drawing and Design*, New Series, vol.1 no.5, November 1926

Berthoud, Roger, *Life of Henry Moore*, de la Mare, London, [1987] 2003

Burstow, Robert, 'Henry Moore's "Open-Air" Sculpture: A Modern, Reforming Aesthetic of Sunlight and Air', in Jane Beckett and Fiona Russell, eds, *Henry Moore. Critical Essays*, Ashgate, Aldershot, 2003

Causey, Andrew, 'Henry Moore and the Uncanny', in Jane Beckett and Fiona Russell, eds, *Henry Moore. Critical Essays*, Ashgate, Aldershot, 2003

Causey, Andrew, 'Another Look at Henry Moore's Shelter Drawings', in Helga and J. Adolf Schmoll gen. Eisenwerth and Regina Maria Hillert, eds, *Mythen – Symbole – Metamorphosen in der Kunst seit 1800, Festschrift für Christa Lichtenstern*, Gebr. Mann, Berlin, 2004

Clark, Kenneth, Kenneth Clark papers, Hyman Kreitman Study Centre, Tate 8812.1

Clark, Kenneth, *Henry Moore. Forty Watercolours and Drawings*, Buchholz Gallery, New York, 1943

Clark, Kenneth, *Henry Moore Drawings*, Thames and Hudson, London, 1974

Cowling, Elizabeth and Jennifer Mundy, *On Classic Ground. Picasso, Léger, de Chirico and the New Classicism, 1910–1930*, Tate Gallery, 1990

Cowling, Elizabeth and John Golding, *Picasso: Sculptor/Painter*, Tate Gallery, London, 1994

Cowling, Elizabeth, *Picasso. Style and Meaning*, Phaidon, London, 2002

Darracott, Joseph, Interview with Henry Moore, 1975, typescript, IWM, Department of Sound Records, 000785/01

Elsen, Albert, 'Henry Moore's Reflections on Sculpture', *Art Journal*, vol.26 no.4, Summer 1967

Fischer, Wolfgang, Henry Moore Interview, 13 July 1971, in *Henry Moore 1961–1971*, Staatsgalerie Moderner Kunst, Munich, 1971

FitzGibbon, Constantine, *The Blitz*, with drawings by Henry Moore, Allan Wingate, London, 1957

Fry, Roger, 'Negro Sculpture', in J. B. Bullen intro., *Vision and Design*, [1920] 1981

Fry, Roger, *Cézanne, A Study of his Development*, Hogarth Press, London, 1927

Garrould, Ann, *Henry Moore Drawings*, Thames and Hudson, London, 1988

Garrould, Ann, ed., *Henry Moore. Complete Drawings,* seven volumes, Henry Moore Foundation in association with Lund Humphries, London, 1996–2003

Giedion-Welcker, Carola, *Moderne Plastik. Elemente der Wirklichkeit, Masse und Auflockerung*, Girsberger, Zurich, 1937

Giedion-Welcker, Carola, 'Prehistoric Stones', *Transition*, 27, April–May 1938

Golding, John, 'Picasso and Surrealism', in *Picasso in Retrospect*, Paul Elek, London, 1973

Green, Christopher, *Cubism and its Enemies*, Yale University Press, New Haven and London, 1987

Greenberg, Clement, 'Art', *The Nation*, 8 February 1947, reprinted John O'Brian, ed., *Clement Greenberg. The Collected Essays and Criticism, vol.2, Arrogant Purpose, 1945–1949*, University of Chicago Press, 1986, pp 125–8

Grierson, John, 'The New Generation in Sculpture', *Apollo*, November 1930

Grigson, Geoffrey, 'Painting and Sculpture Today', in Geoffrey Grigson ed. and intro., *The Arts Today*, John Lane, the Bodley Head, London, 1935

Grigson, Geoffrey, 'Comment on England', *Axis*, no.1, January 1935

Grigson, Geoffrey, 'Henry Moore and Ourselves', *Axis*, no.3, July 1935

Grigson, Geoffrey, *Henry Moore*, Penguin Books, London, 1943, reprinted in *The Harp of Aeolus. Collected Essays*, Routledge, London, 1948

Grigson, Geoffrey, 'Authentic and False in the New Romanticism', *Horizon*, (London), vol.17 no.77, March 1948

Grigson, Geoffrey, 'The Drawings of Henry Moore', typescript, Henry Moore Archive, *c*.1951

Haldane, J. B. S., *The Philosophical Basis of Biology*, Doubleday, Doran, New York, 1931

Hall, Donald, 'An Interview with Henry Moore', *Horizon* (New York), vol.3 no.2, November 1960

Hall, Donald, *Henry Moore. The Life and Work of a Great Sculptor*, Gollancz, London, 1966

Halliday, Nigel Vaux, *More than a Bookshop. Zwemmer's and Art in the Twentieth Century*, Philip Wilson, London, 1991

Hedgecoe, John, *Henry Spencer Moore. Photographed and edited by John Hedgecoe, Words by Henry Moore*, Nelson, London, 1968

Hedgecoe, John, *Henry Moore. My Ideas, Inspiration and Life as an Artist*, Ebury Press, London, 1986

Imperial War Museum Archive, 'Henry Moore 1941–1948', File GP 55 104

Imperial War Museum Archive, WAAC minutes, File Art 16597

Ironside, Robin, 'Burne-Jones and Gustave Moreau', *Horizon* (London), vol.2 no.9, September 1940

Ironside, Robin, *Painting since 1939*, Longman, London, 1947

James, Philip, *Henry Moore on Sculpture*, Macdonald, London, 1966

Jeffery, Celina, 'Leon Underwood and Primitivism in Twentieth-Century British Art', unpublished PhD thesis, University of Essex, 2002

Kelly, Julia, 'The Unfamiliar Figure: Henry Moore in French Periodicals of the 1930s', in Jane Beckett and Fiona Russell, eds, *Henry Moore. Critical Essays*, Ashgate, Aldershot, 2003

Kosinski, Dorothy, ed., *Henry Moore. Sculpting the Twentieth Century*, Dallas Museum of Art with Yale University Press, New Haven, 2001

Lake, Carlton, 'Henry Moore's World', *Atlantic Monthly*, no.209, 1 January 1962

Lewis, Adrian, 'Henry Moore's Shelter Drawings', in P. Kirkham and D. Thomas, *War Culture*, Lawrence and Wishart, London, 1995

Lichtenstern, Christa, 'Henry Moore and Surrealism', *Burlington Magazine*, vol.123 no.944, November 1981

Lichtenstern, Christa, *Henry Moore. Work – Theory – Impact*, London, Royal Academy of Arts, 2008

Luquet, G.H., *The Art and Religion of Fossil Man*, Yale University Press and Oxford University Press, New Haven and Oxford, 1930

Maldonado, Guitemie, *Le Cercle et l'amibe. Le biomorphisme dans l'art des années 1930*, Institut National d'histoire de l'art, Paris, 2006

Meadows, Bernard, 'Bernard Meadows Remembers Henry Moore', *Apollo*, vol.128 no.320, p.243

Melville, Robert, 'Communities of Statuary, in *Henry Moore. Figures in Space. Drawings*, Institute of Contemporary Arts, London, 1953

Melville, Robert, 'Underground', *New Statesman*, 28 October 1966

Melville, Robert, intro., *Henry Moore Shelter Sketchbook 1940–42*, Marlborough Fine Art, London, 1967

Melville Robert, *Henry Moore, Sculpture and Drawings, 1921–1969*, Thames and Hudson, London, 1970

Miller, Edward, *That Noble Cabinet. A History of the British Museum*, André Deutsch, London, 1973

Mitchinson, David and Stallabrass, Julian, *Henry Moore: 1940–1986*, Academy Editions, London, 1992

Mitchinson, David, *Henry Moore. Unpublished Drawings*, Abrams, New York, [1971]

Mitchinson, David, ed. and intro., *Celebrating Moore*, Lund Humphries, London, 1998

Moore, Henry, Henry Moore Library and Archives, Henry Moore Foundation

Moore, Henry, 'Contemporary English Sculptors. Henry Moore', *Architectural Association Journal*, May 1930

Moore, Henry, 'On carving. A Conversation: Henry Moore with Arnold J. Haskell', *New English Weekly*, 5 May 1932

Moore, Henry, statement in Herbert Read, ed., Unit One. *The Modern Movement in English Architecture, Painting and Sculpture*, Cassell, London, 1934

Moore, Henry, 'Mesopotamian Art', the *Listener*, vol.13 no.334, 5 June 1935

Moore, Henry, 'The Sculptor Speaks', the *Listener*, vol.18 no.449, 18 August 1937

Moore, Henry, and others, 'Mr Wyndham Lewis's Works', letter to *The Times*, published 22 December 1937

Moore, Henry, 'Primitive Art', the *Listener*, vol.25 no.641, 24 April 1941

Moore, Henry, *Henry Moore. Complete Sculpture*, six volumes, Lund Humphries, London, 1944–88

Moore, Henry, *Henry Spencer Moore, photographed and edited by John Hedgecoe, words by Henry Moore*, Thomas Nelson, London, 1968

Moore, Henry, intro., with commentary by Frances Carey, *A Shelter Sketchbook*, British Museum Publications, London, 1988

Mortimer, Raymond, 'The Leicester Galleries', *New Statesman*, 17 February 1940

Mundy, Jennifer, 'Biomorphism', unpublished PhD thesis, Courtauld Institute, University of London, 1986

Newton, Donald, letter, *Times Literary Supplement*, 16 September 1994

Neve, Christopher, *Leon Underwood*, Thames and Hudson, London, 1974

Newton, Eric, *War through Artists' Eyes*, John Murray, London, 1945

Patin, Sylvie, 'The Collectors of Cézanne's Early Works, in Lawrence Gowing, *Cézanne, The Early Years*, Royal Academy, in association with Weidenfeld and Nicolson, London, 1988

Pevsner, Nikolaus, 'Thoughts on Henry Moore', *Burlington Magazine*, February 1945

Pevsner, Nikolaus, 'The Truth of the Shelters', *Architectural Review*, November 1945

Pound, Ezra, *Gaudier-Brzeska, A Memoir*, New Directions Books, New York, [1916] 1970

Read, Herbert, *Art Now. An Introduction to the Theory of Modern Painting and Sculpture*, Faber and Faber, London, 1933

Read, Herbert, *Henry Moore, Sculptor. An Appreciation*, A. Zwemmer, London, 1934

Read, Herbert, 'The Drawings of Henry Moore', *Art in Australia*, vol.4 no.3, September–November 1941

Read, Herbert, ed. and intro., *Henry Moore. Sculpture and Drawings, 1921–1948*, Lund Humphries and A. Zwemmer, London, 1944

Read, Herbert, *Sculpture and Drawings by Henry Moore*, Venice Biennale, 1948

Read, Herbert, *The Philosophy of Modern Art*, Faber and Faber, London, 1952

Read, Herbert, *Henry Moore. A Study of his Life and Work*, Thames and Hudson, London, 1965

Russell, John, *Henry Moore*, Penguin Books, Harmondsworth, 1968

Russell, Vera and John, 'Conversations with Henry Moore', *Sunday Times*, 17 and 24 December 1961

Schapiro, Meyer 'The Nature of Abstract Art', *Marxist Quarterly*, January–March 1937, reprinted in Meyer Schapiro, *Modern Art. Nineteenth and Twentieth Centuries*, George Braziller, New York, 1978

Seymour Jr, Charles, *Tradition and Experiment in Modern Sculpture*, American University Press, Washington DC, 1949

Soby, James Thrall, *Contemporary Painters*, Museum of Modern Art, New York, 1948

Spender, Stephen, intro., *Henry Moore. Stonehenge*, Ganymed Original Editions, London, 1974

Steinberg, Leo, 'The Eye is Part of the Mind', *Partisan Review*, vol.20 no.2, March–April 1953

Stevens, Frank, *Stonehenge Today and Yesterday*, HMSO, 1919

Stonebridge, Lyndsey 'Bombs, Birth and Trauma: Henry Moore's and D. W. Winnicott's, Prehistory Fragments', in Jane Beckett and Fiona Russell, eds, *Henry Moore. Critical Essays*, Aldershot, Ashgate, 2003

Sutton, Denys, 'Henry Moore. A Sculptor's Vision', *New York Times*, 23 March 1959. Reprinted in James, *Henry Moore on Sculpture*

Sweeney, James Johnson, *Henry Moore*, Museum of Modern Art, New York, 1946

Sweeney, James Johnson, 'Henry Moore', *Partisan Review*, vol.14 no.2, March–April 1947

Sylvester, David, 'Henry Moore. The Shelter Drawings', *Graphis*, vol.2 no.14, 14 March 1946

Sylvester, David, intro., *A Retrospective Exhibition of Drawings by Henry Moore*, Arts Council of Great Britain, 1948

Sylvester, David, 'Henry Moore's Drawings', *Britain Today*, no.151, November 1948

Sylvester, David, *Henry Moore. Sculpture and Drawings, 1923–1948*, Wakefield City Art Gallery and Manchester City Art Gallery, 1949

Sylvester, David, *Sculpture and Drawings by Henry Moore*, Tate Gallery, London, 1951

Sylvester, David, 'Henry Moore Talking', the *Listener*, 29 April 1963

Sylvester, David, *Henry Moore*, Arts Council of Great Britain [Tate Gallery exhibition catalogue], London, 1968

Valentiner, W. R., *Origins of Modern Sculpture*, Wittenborn, New York, 1946

Wight, Frederick, 'Henry Moore, The Reclining Figure', *Journal of Aesthetics and Art Criticism*, vol.6 no.2, December 1947

Wilkinson, Alan, *The Drawings of Henry Moore*, Tate Gallery and Art Gallery of Ontario, 1977

Wilkinson, Alan, *The Moore Collection in the Art Gallery of Ontario*, Art Gallery of Ontario, 1979. Revised edition, 1987, as *Henry Moore Remembered*

Wilkinson, Alan, *The Drawings of Henry Moore*, Garland, New York, 1984

Wilkinson, Alan, ed. and intro., *Henry Moore. Writings and Conversations*, Lund Humphries, London, 2002

140 *Sailing Boat*, 1981. HMF 81 (406). Watercolour, wash, charcoal, chinagraph, chalk, 22.7 x 29 cm (9 x 11½ in). Private Collection

Acknowledgements

I have had unstinting help from the staff of the Henry Moore Foundation, looking at the extensive collection of the Foundation's notebooks and drawings with David Mitchinson, the curator, and Laura Robinson, conservator, as well as working in the Library and Archive aided by Michael Phipps. Most of my picture research has been done for me by Emily Peters and Emma Stower. David Mitchinson and Martin Davis have read the whole text and contributed significant improvements. I am grateful to others who have shown me their Moore drawings, especially Michael Parke-Taylor, curator of the Henry Moore collection at the Art Gallery of Ontario. My understanding of Moore's drawings was stimulated by Professor Christa Lichtenstern's 1981 article 'Henry Moore and Surrealism' and subsequently by looking at Moore drawings with her in Manchester. Professor Lichtenstern's book *Henry Moore. Work – Theory – Impact* (2008) was published too late for me to make use of the learning and enlightening interpretations that are evident even from a quick reading. I have benefited at different times from conversations about Moore with Sir Alan Bowness, Ann Garrould, the late Margaret McLeod, Mary Moore, the late David Sylvester and Alan Wilkinson.

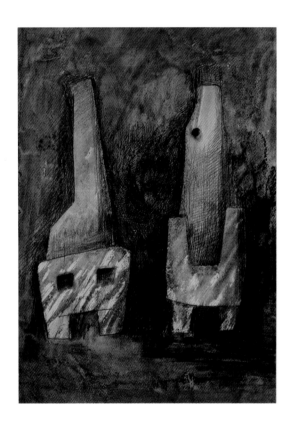

Index